OPEN
SEASON

OPEN SEASON

An Artist's Sporting Year

Rodger McPhail

Airlife
in association with
The Tryon Gallery
ENGLAND

Illustrations © Copyright 1986 Rodger McPhail

Text © Copyright 1986 Tony Jackson

ISBN 0 906393 68 X

First published in 1986 by
Airlife Publishing Ltd. in association
with The Tryon Gallery Ltd., London.

Airlife Publishing Ltd.

7, St. Johns Hill, Shrewsbury
SY1 1JE England

Printed in England by
Livesey Ltd., Shrewsbury.

INTRODUCTION

A hot August sun shimmers across the golden landscape. White, cotton-wool clouds drift slowly under the pale blue vault of sky and only the lightest breeze, a puff of warm air, ripples the drooping, heavy heads of ripe barley. Storms have flattened the corn in odd pockets, the heavy thunder rain beating the stems into tangled, flattened mats. The distant, shimmering woods are green-black, the fresh verdure of spring long past and there is a moist, hot smell under the unstirring branches, a sense of waiting, of almost sensual expectancy. Only the hum, the continual background drone, of flying insects breaks the silence. At the side of the dusty, flint-scattered track by the edge of the corn, grasshoppers chirrup, backlegs scraping a soporific chorus, while Common Blues flicker like specks of thrown confetti and Meadow Browns and Gatekeepers test the ripening blackberry bushes; in the sunlit glades of the deep woodland, Silver Washed Fritillaries and White Admirals, deep rich brown and black and white, dance on flickering wings through the motes of green-splashed light.

There are woodpigeon in the sky. Battleship grey, plump and purposeful, white wingbars flashing as they hover over the laid corn before landing; they, above all others, are true birds of the countryside known and loved by the shooting man for the sport they offer through the seasons, detested by the farmer for their voracious greed.

For several hours through the long, hot hours of midday, the pigeon have sat in the shade of the oakwoods, drowsily digesting the morning's spoils, crops crammed with filched grain. Now, in the late afternoon, the vanguard are dropping from the sky, swinging wide over the cornfield then abruptly swooping in against the gentle wind, wings beating like a windhover as they drop the final yard. A dozen are in, grey turtle backs sturdily thrusting through the battered stems, rose-red beaks daintily picking the spilt grains; suddenly the sky is alive with pigeon, birds which, from afar, have spotted the distant movement as white wingbars signal the feast.

The artist sits in comfort by the side of the cornfield. In front of him stems of elder, bitter smelling and fly repellant, form a screen while camouflage netting is draped from the broken branches. A small, compact figure, the sandy hair hidden by a green cap, his blue eyes absorb the detail, one hand moving swiftly across the sketchpad with deceptive ease. He is totally absorbed by the scene in front, one he knows and loves so well.

The moment transcends all. That brief, vital impression which he knows and feels through eye, brain and hand, which he hopes will convey, for as long as it lasts on canvas, the quintessence of the countryside.

Rodger McPhail was born at Westhoughton, Lancashire in 1953 and although there was no history of artists in his family, the germ of genius — for such he is — must have been ever-present. His father, a Scottish coach trimmer, was a fine musician, taking great joy in the violin. Rodger still has his father's fiddle and modestly claims to play it with more enthusiasm than skill.

His childhood was conventional. The family moved to Coventry and he was sent to the local Grammar school, but deep passion for the countryside was already aroused and, like many another boy of artistic inclination, academic studies were neglected, most of his schooldays being spent in the art room or catching grass snakes and snaring rabbits in the school woods. The climax came when he was nearly expelled for shooting a grey squirrel with an air rifle when he should have been studying Latin!

In those early days, when only sixteen, he sent some sketches and water-colours to *Shooting Times* magazine on a venture. It was immediately apparent that here was a quite exceptional talent and I can still recall the excitement in the knowledge that a young artist of remarkable, almost precocious skill, had suddenly emerged. I still have and treasure an early water-colour which Rodger produced of a brace of redlegged partridges.

It was now obvious that his career would be in art. He spent a year at art college in Coventry and then three enjoyable years at Liverpool art school where he was supposed to study graphic design but spent the greater part of the course arranging wild parties.

Just before Rodger went to Liverpool I took the opportunity to introduce him to the Hon. Aylmer Tryon of the famous Tryon Gallery in London. Aylmer was impressed and by the time Rodger had finished at Liverpool he had already undertaken several commissions and since then has established a mutually happy and successful relationship with the gallery.

Since those early days Rodger has travelled all over the world painting. In fact his first commission immediately after leaving Liverpool art college (where, incidentally, he was one of the few students to fail his diploma!) was to Spain to paint partridge shooting. Since then he has painted in America, Hungary, Italy, Holland and Mauritius and always the sporting theme, whether shooting or fishing, has remained paramount. He has had three major exhibitions and has illustrated several books, whose authors have included Lord Home, Mike Harding the comedian, and P. G. Wodehouse.

I have known Rodger since he was sixteen and can perhaps claim to have "discovered" him. Apart from his startling talent, I have always been deeply impressed by his modesty and dry, sometimes even mordant, sense of humour. His great strength is his ability to keep his feet firmly planted on the ground and to remain quite unspoilt by the adulation and the flattery which is inevitable.

I have not the slightest doubt that Rodger McPhail will be recognised as one of the greatest sporting artists of this century. Bold claim, perhaps, but I believe that this assertion can fully be justified. You have only to glance through the pages of this book to accept, as I do, that here is a rare and enviable talent.

"Open Season" is more, far more, than just a collection of pretty pictures. It is a statement in paint of all that is best in our wonderful countryside and why, and how, fieldsports play such an indispensable role in the well-being of its flora and

fauna. Dull words, these last, for the beasts, birds, fish, insects and flowers, for the trees and the hedges, for the grasses and the heathers of our land. There is no country in the world which, in such a tiny landscape, has such a variety of constantly changing scenery, and such thriving populations of wild birds and animals, and it is worth taking a brief moment to wonder at the reasons.

The pressures in this century have grown with dispassionate energy, the needs of the people predominating, whether for housing, manufacturing or food. Hundreds of thousands of acres have been destroyed, hedges ripped out and ponds drained. Chemicals have polluted the land, washing into drains and pools, killing birds, beasts and complete microcosms of life and yet . . . there are still trout and salmon in the rivers, grouse are on the purple moors and pheasants strut the coverts in mailed glory; the wild geese winnow through the skies by the thousand and teal and mallard flight at dawn and dusk as they have always done.

Of course there have been losses but none have been due to pressure from rod, gun or hound. The grey partridge has declined, its loss due largely to chemical sprays which have destroyed the insect life on which it depends, and the grubbing-up of hedgerows and odd, wild corners of farmland, its shelter and nesting sites. The otter, too, has almost vanished leaving only a viable population in the West of Scotland. Again, its demise was due almost entirely to pollution and the encroachment of man into its hitherto wild, unspoilt haunts. Hares appear to come and go, though by and large the population has declined alarmingly, due mainly to chemicals and disease. We in this country have never appreciated the hare; content, sadly, to treat it as a pest. Now that its ranks have been thinned perhaps it will achieve the status of game animal, one worthy of being treated with respect. On the Continent the hare is a beast of the chase and accorded due recognition.

Yet these losses, none of them to be laid at the door of the sportsman, have been offset by population explosions. The collared dove, unknown here until the early fifties, has now spread throughout Britain and become such a grain-stealing pest that it has been placed on the shooting list. Rabbits, after the near total extinction of myxomatosis, which first struck in 1954, have returned to almost pre-war numbers; Brent geese have built up their population and moved inland to feed, to the annoyance of farmers; Canada geese thrive; polecats and pine martens are more than holding their own whilst foxes, despite shooting, snaring and trapping are still survivors, though it is debatable whether they would not have been wiped out in many areas were it not for the protection afforded by hunting.

And this, of course, is the paradox, the apparent contradiction, which the ordinary man or woman in the street fails to comprehend. How, the question is posed, can you preserve and benefit a species by killing it? The answer has to evoke the language of the scientist, of population studies, of disease, of imbalance of species and of culling but all this is dry, arid stuff. The fact is that the admittedly selfish wish to pursue birds and beasts for sport has quite simply meant that we will take whatever steps are necessary to ensure that there is a sufficient population to enable us, each season, to take a tithe and leave a breeding colony for the future. The balance of the countryside in Britain is critical, weighted scales which can so easily be tipped by foolish, if well-meaning, over-protection.

Here then, within these pages is condensed the meaning of our countryside and its sport as seen and understood by one man, an artist who patently knows the

creatures he paints because he is totally involved with them. Rodger is a wildfowler, a pigeon shooter, a deer stalker and a game shot. He knows the frustrations and sudden excitements of the angler and his acute and observant eye has captured the detail, the moments of apparent trivia, but which all go towards making the whole.

A fieldsportsman, yes and a conservationist too, for Rodger understands the real meaning of that much overworked and abused word. Today's trendy will call himself a conservationist in the fond belief that by total preservation of life he is assisting a species. It is, in fact, the shooting man, the angler and the follower of hounds who are the real conservationists, a fact recognised and admitted to by a great many of those who, if they have no wish to participate in fieldsports, understand their value.

Now sit back by the fireside with a whisky to hand, the old dog curled up at your feet and as the wind rattles the casement and sends the log flames flickering, slowly turn the pages of "Open Season" and recapture these golden moments on field, foreshore, river and lake.

This book marks, I believe, a fresh departure in the field of country and fieldsports publishing in this country and I personally, greatly look forward to the next volume. Who knows, perhaps Rodger will take a look at sport on other shores?

Tony Jackson March 1986

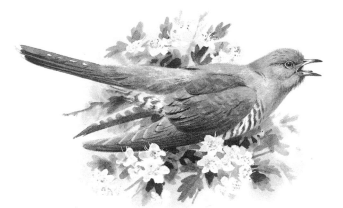

SPRING

Late March and there is a stir of expectancy in the air. Winter, with its long, cold grey days is now becoming a memory as the days lengthen and the countryside rouses from its long sleep.

For the fisherman it is a time of renewed hope and anticipation. The rivers and lakes, the reservoirs and lochs, are the centre of his thoughts; tackle has long been ready, flies have been tied — the season is under way.

Few fishermen would deny that a south country chalkstream, in April or May, is the pinnacle of their ambition. Banks and meadows, bushes and trees, are filmed in fresh foliage, the willows drooping their pale green leaves above the clear, bubbling water where trout, brown-spotted and alert, hang poised against the current. To stalk such a fish and delicately to present a home-tied dry March Brown, to watch the rise and feel the drive and pulsating energy of that first spring trout, is to know and understand the sheer joy of angling in its most refined form. For the observant and thinking fisherman the capture of his quarry is a part, but not the whole, of the angling scene. He is surrounded by the natural landscape. Even a blank day will have its compensations — the sound of the first cuckoo echoing across the fields, a grass-snake undulating across the stream or a heron stalking the shallows in lesser competition.

Suddenly, the first travellers from distant lands will have arrived. A swallow swoops and courses across the water while chiffchaffs and warblers rustle through the leaves and sing their plaintive notes by bank and meadow. Perhaps the most emotive call of all is the double note of the cuckoo; its voice may herald the edge of summer but its piratical habits are less than nice.

Now in the tall elms, where they still survive, rooks, dark-blue and glossy of coat, sway with the breeze and quarrel over twigs and nests, their caws a raucous background to the spring scene; hares circle and stand up to box as the fever of the season courses through their blood and everywhere the cycle of breeding is in full swing. Buds and flowers, bright and fresh in their renewed livery, push forth and the tiny life of the countryside is abustle as it prepares for a new generation. Fox cubs roll and play, fighting miniature battles under the nettles, while high in the hills, on the rolling moors, grouse chicks, active from the moment they are hatched, scramble and creep after their mother in a never-ending search for insect life.

In a few short weeks there will be hungry mouths agape as nestlings squawk for food; for parents it is a time of unrelenting search and capture, of guidance and protection. Some youngsters, born into a harsh environment, are equipped to cope almost at once with the hazards of weather and predation. Ptarmigan and grouse chicks will run with their parents as soon as the last chick has hatched, mallard ducklings can swim and scuttle across the surface and the roe fawn can stand within minutes of birth.

For the gamekeeper spring is a time of intense activity. Hen pheasants will already have been caught up for the laying pens, incubators have been prepared and the first batches of eggs will be

filling the trays. Pens will have been repaired, a fresh rearing field site chosen and brooders checked. Predators must not be neglected for the control of crows, magpies, stoats and rats is essential if the game and other wildlife is to have a fair chance of survival. The trap line has to be inspected everyday, for predation control is the key to a successful shoot.

It is a time of action, too, for the river keeper. Weed must be cut and an attempt made to catch and remove coarse fish; banks will have to be checked, footbridges and groynes inspected and dead branches and hazards to casting cut back. There are vermin, too, which must be attended to. Mink traps must be set, for this alien weasel has spread rapidly and causes fearful havoc amongst native wildlife, and where they are present, pike must be snared and removed from trout streams, for these two fish cannot live in harmony.

One of the worst dangers to game and small bird life in general is the magpie. Bold, exceedingly crafty and increasing throughout the country, this pied robber demands the attention of keepers and shooting men wherever it is seen. Only the crow can match it as a predator, but its numbers are now probably exceeded by magpies . . . ever alert and watchful. A partridge nest, however carefully it may be concealed, is always a prize for this pied nest-robber.

A dying art until recent years, taxidermy is now booming as sportsmen realise that their trophies can be preserved in a lively, realistic fashion. New, modern methods and materials have finally vanquished the Victorian image of badly stuffed, glassy-eyed horrors lining gloomy halls. Today's taxidermist uses glass-fibre forms for large mounts and, if he is really advanced, will be involved with freeze-drying techniques and casts of muscles. Taxidermy is now an art of the highest order, rapidly becoming recognised as such.

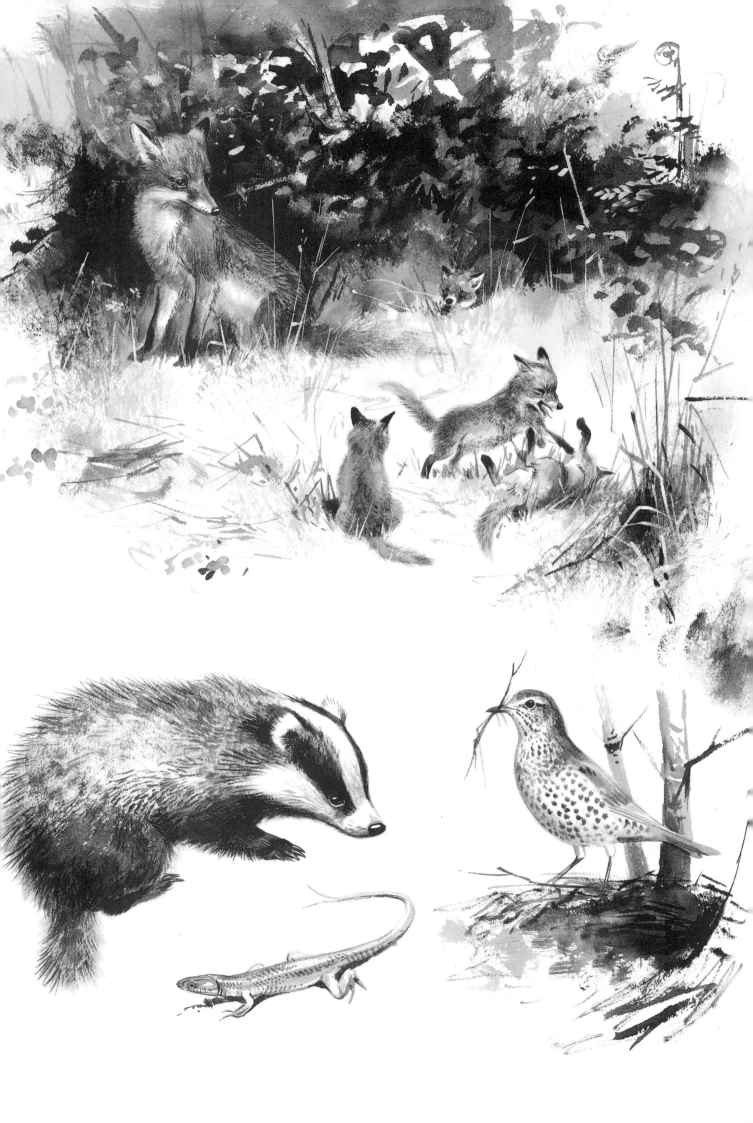

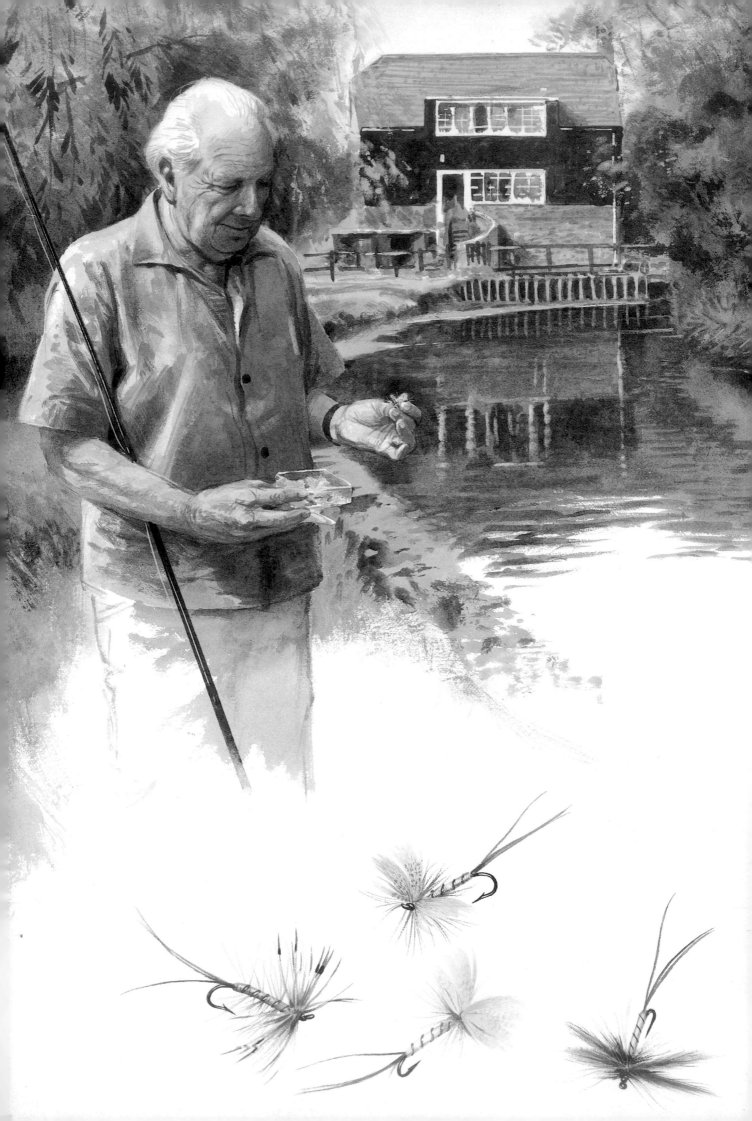

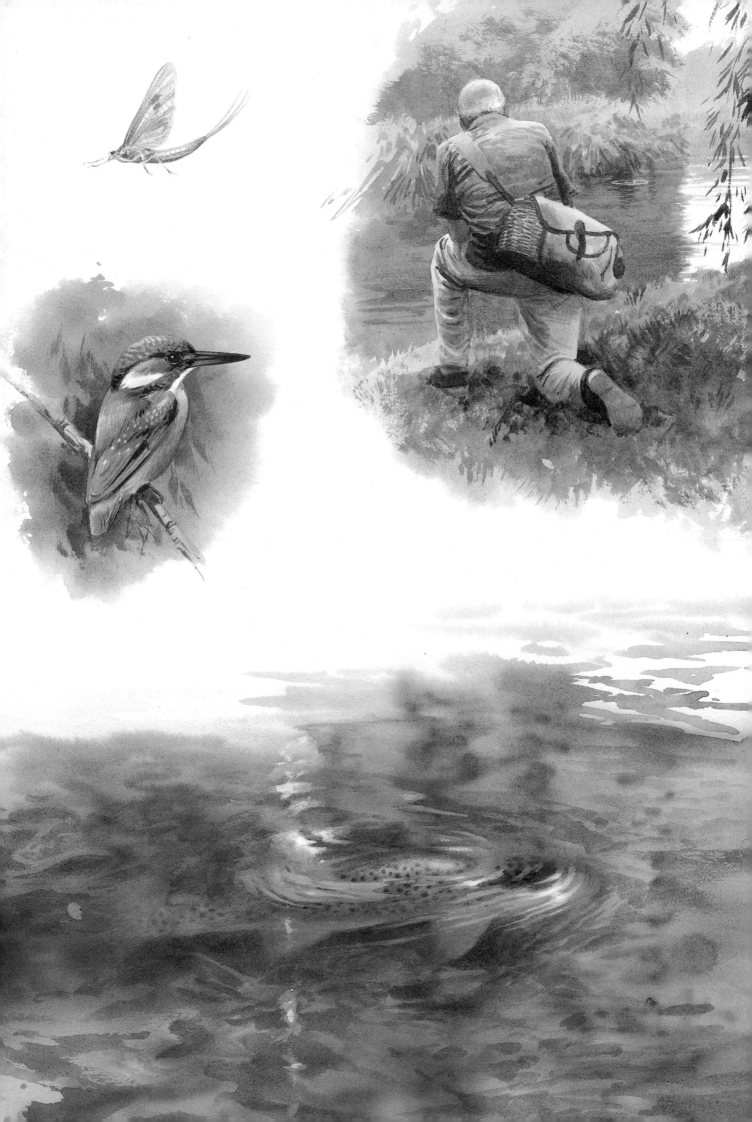

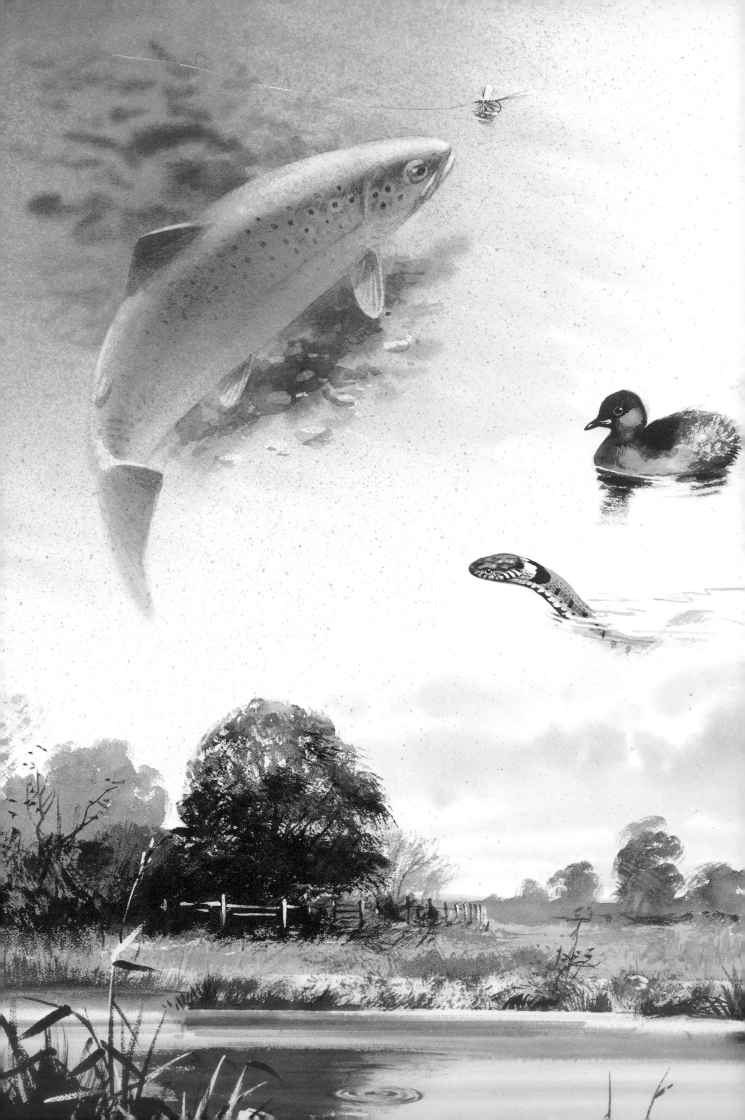

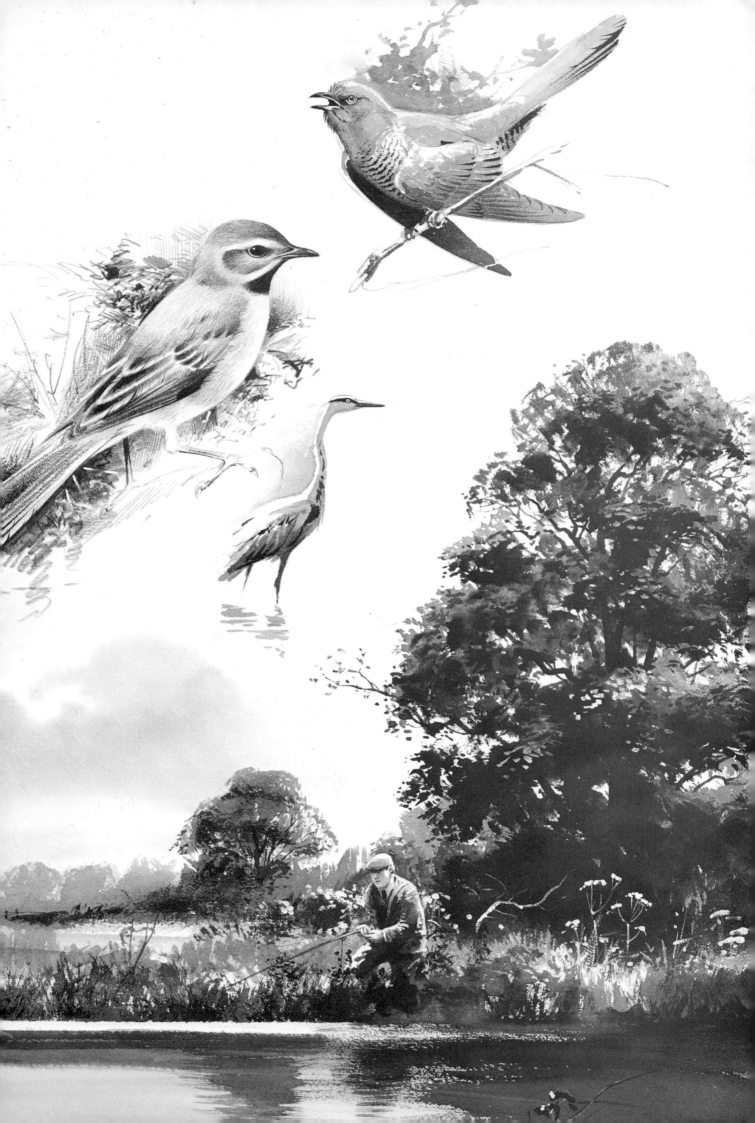

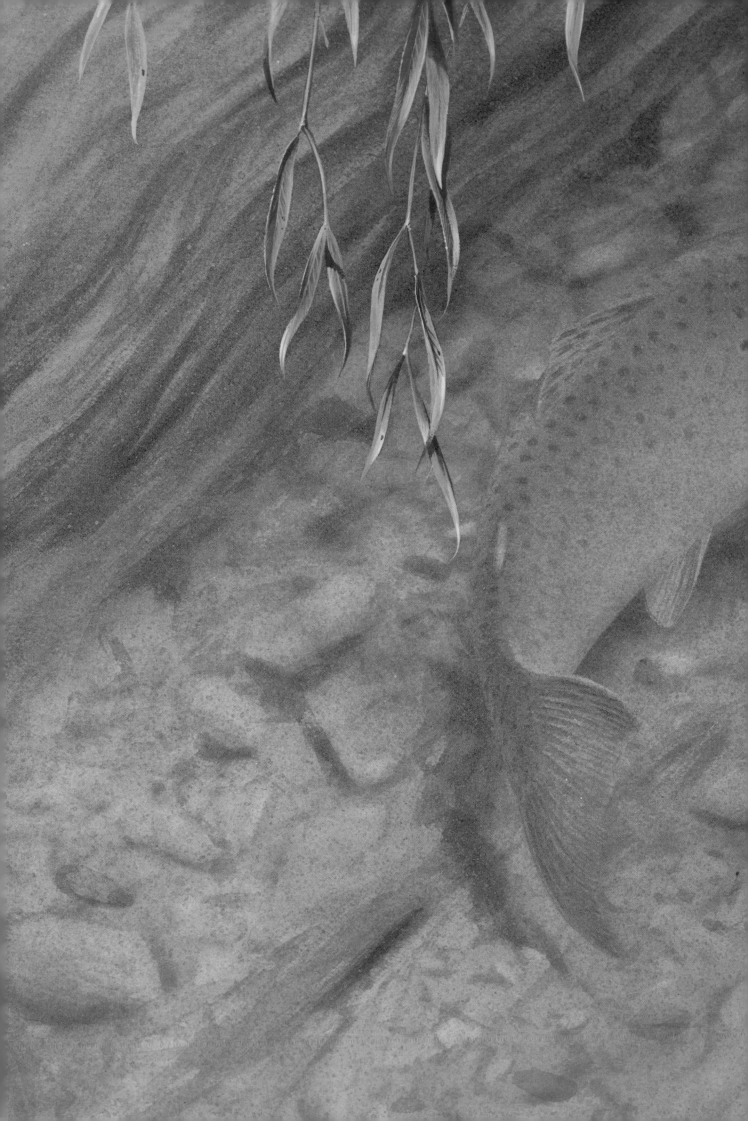

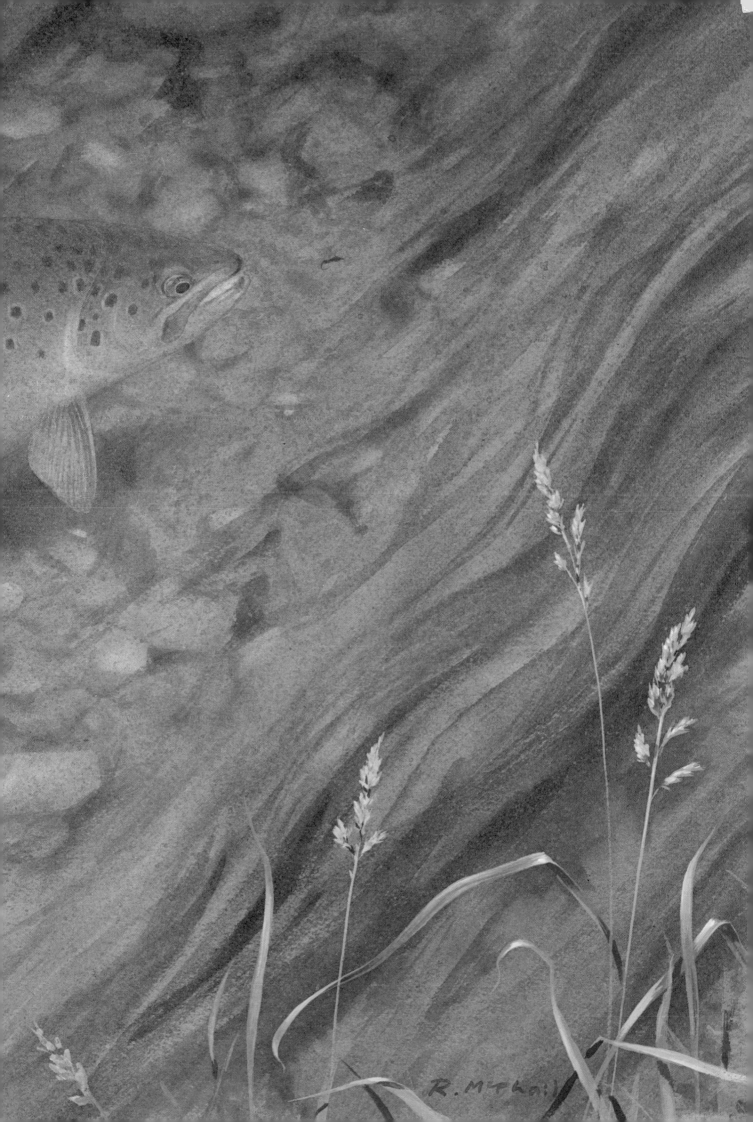

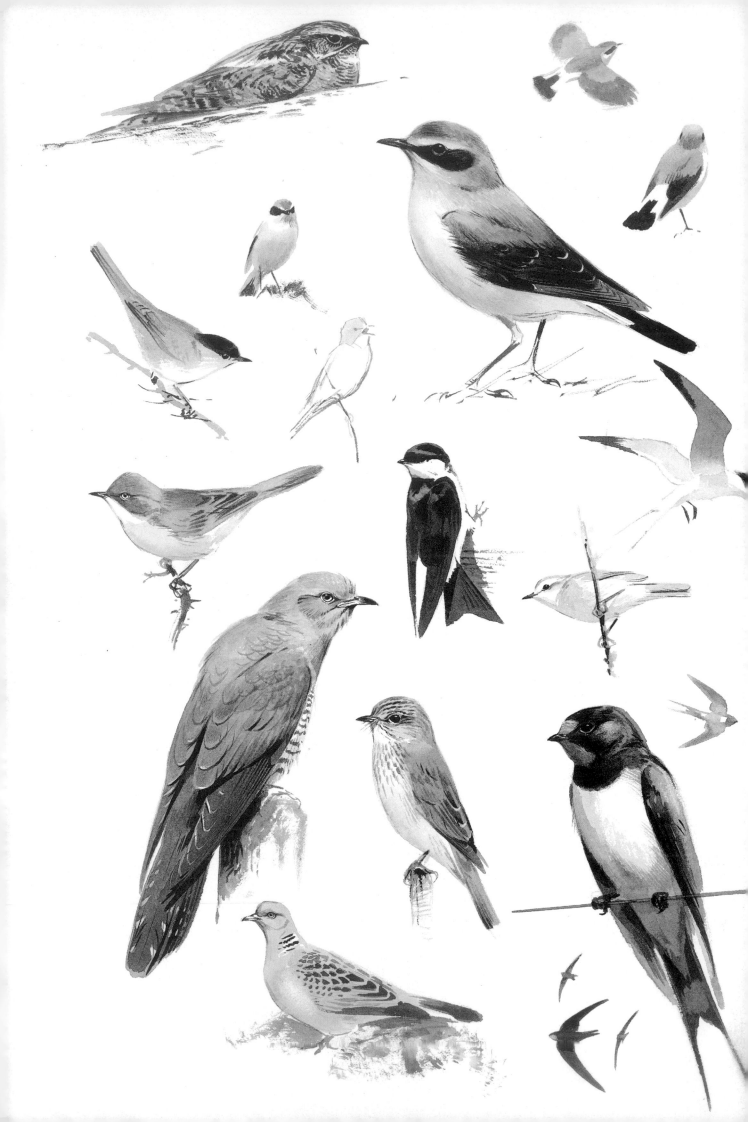

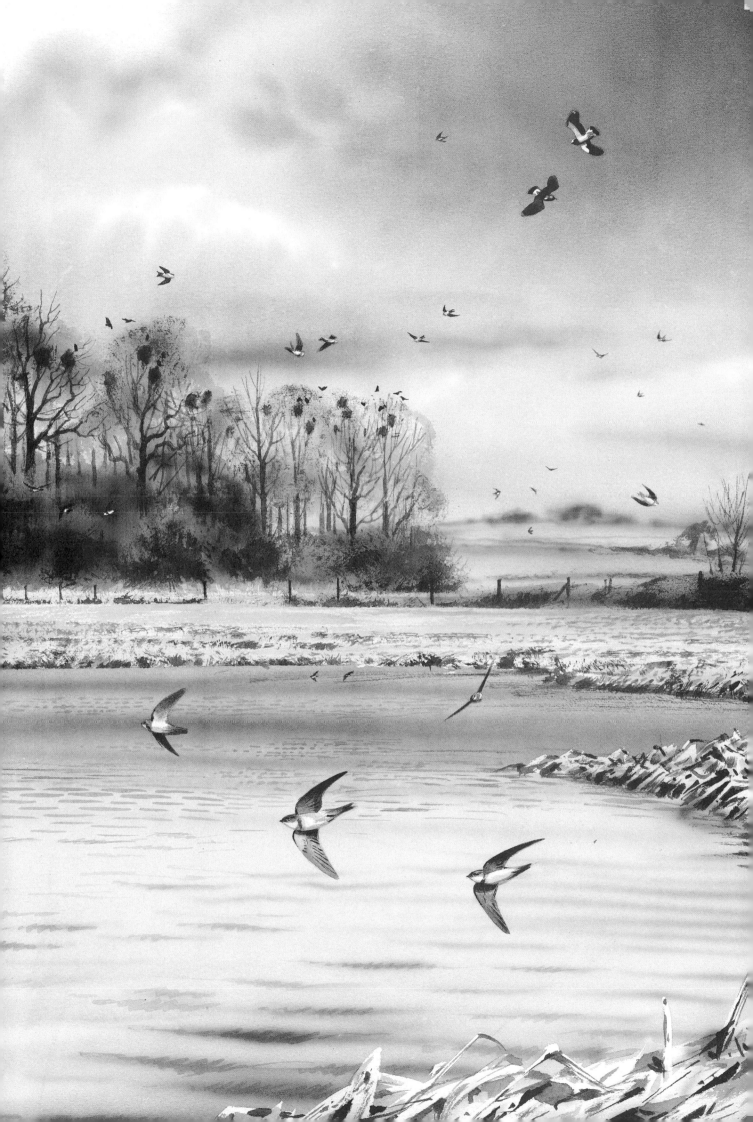

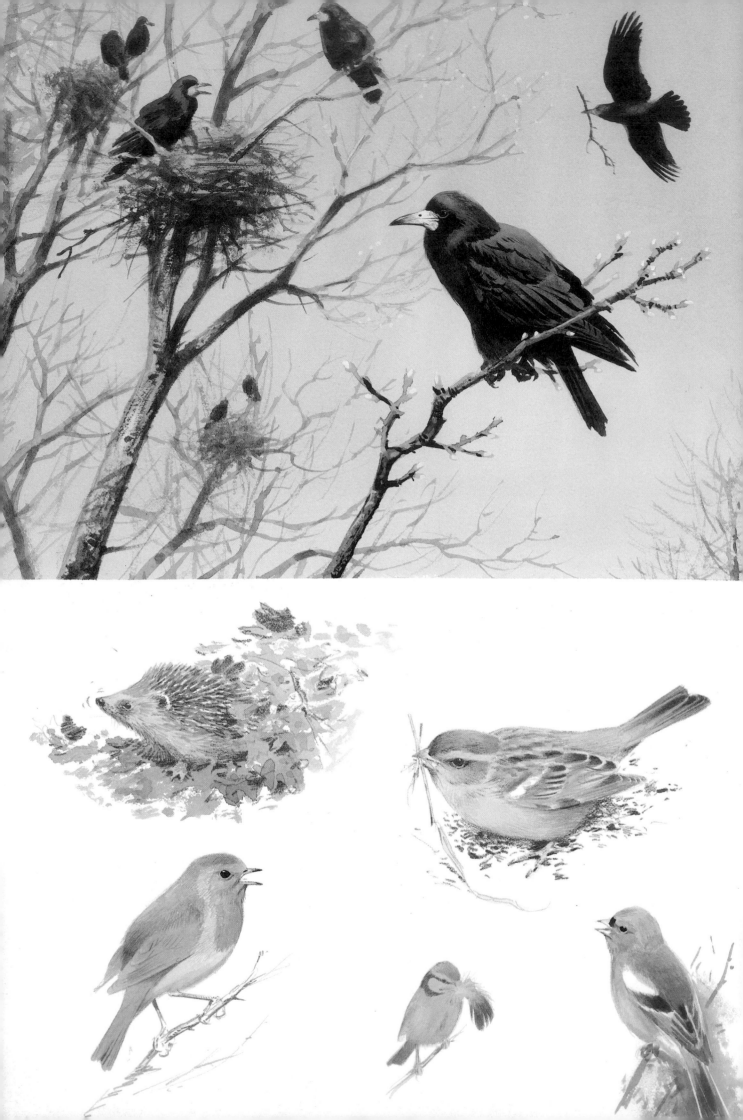

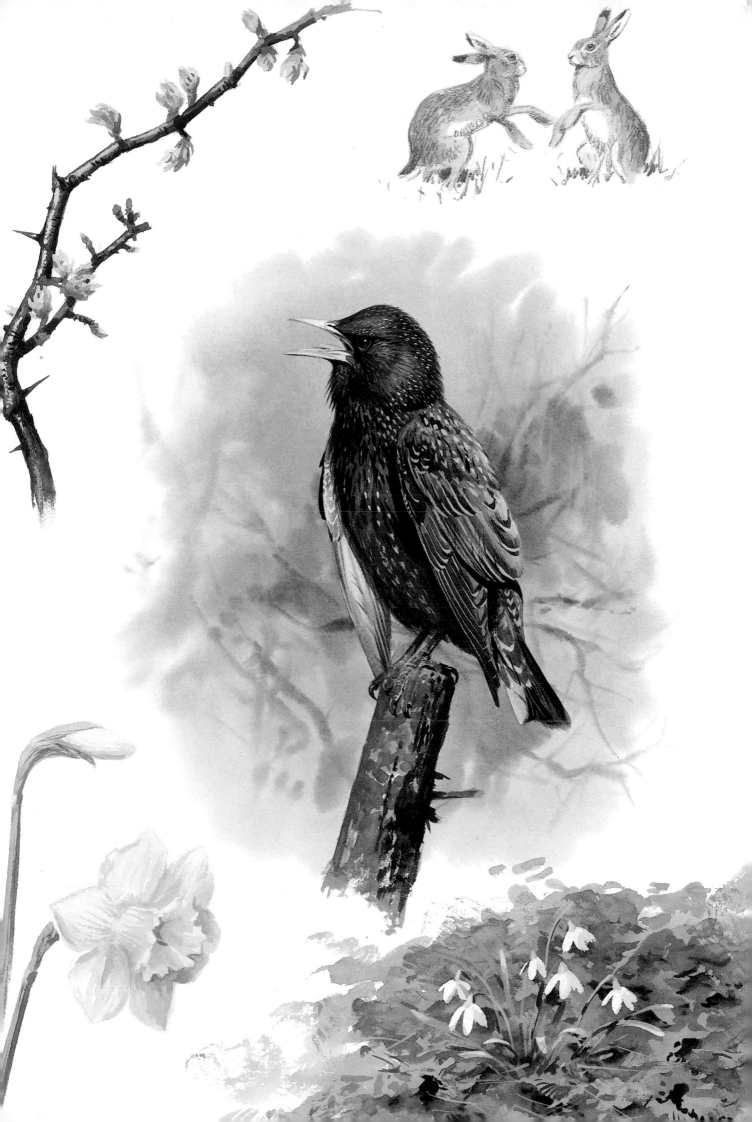

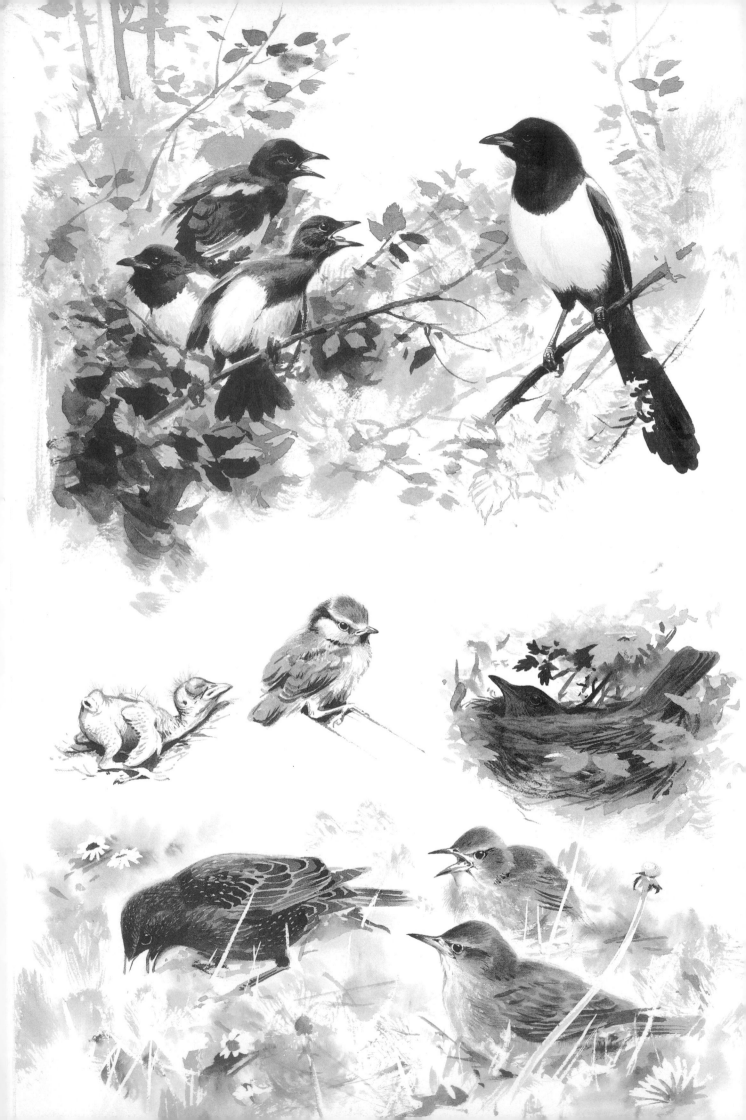

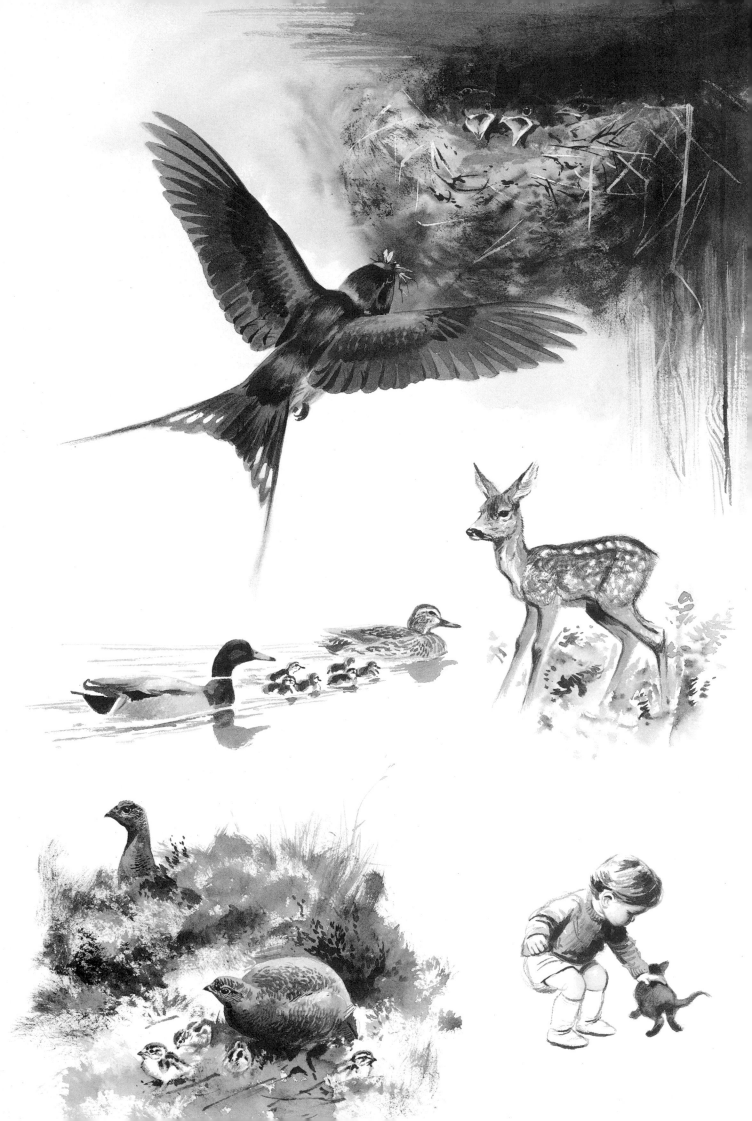

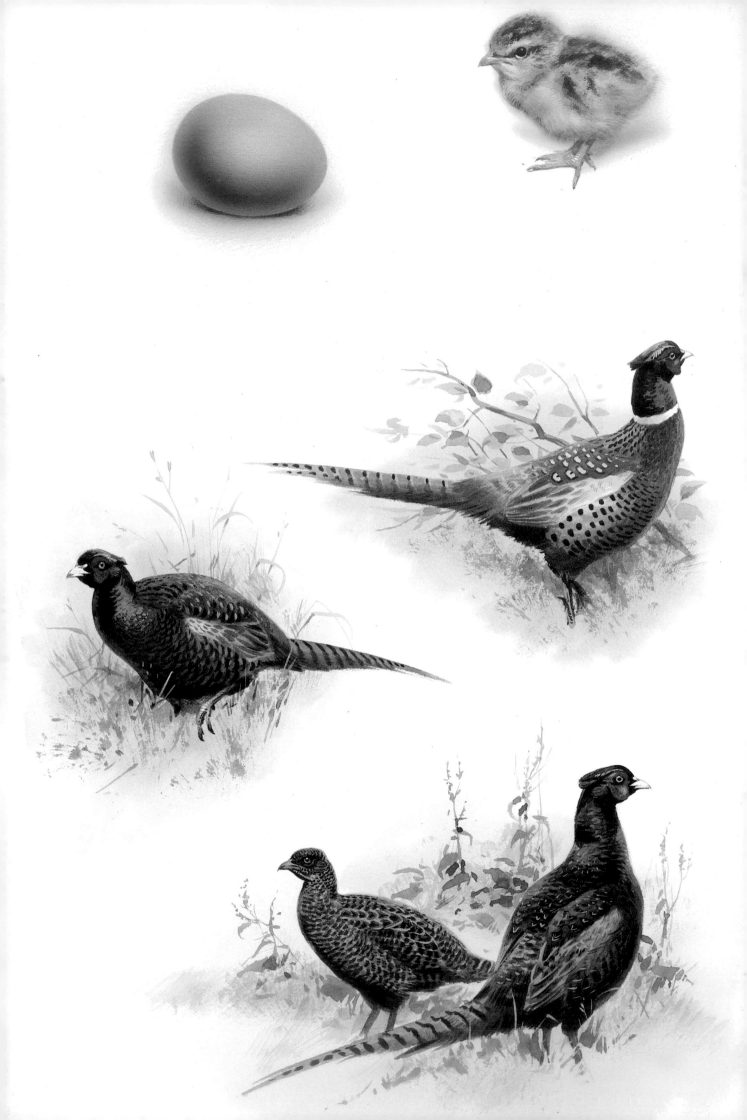

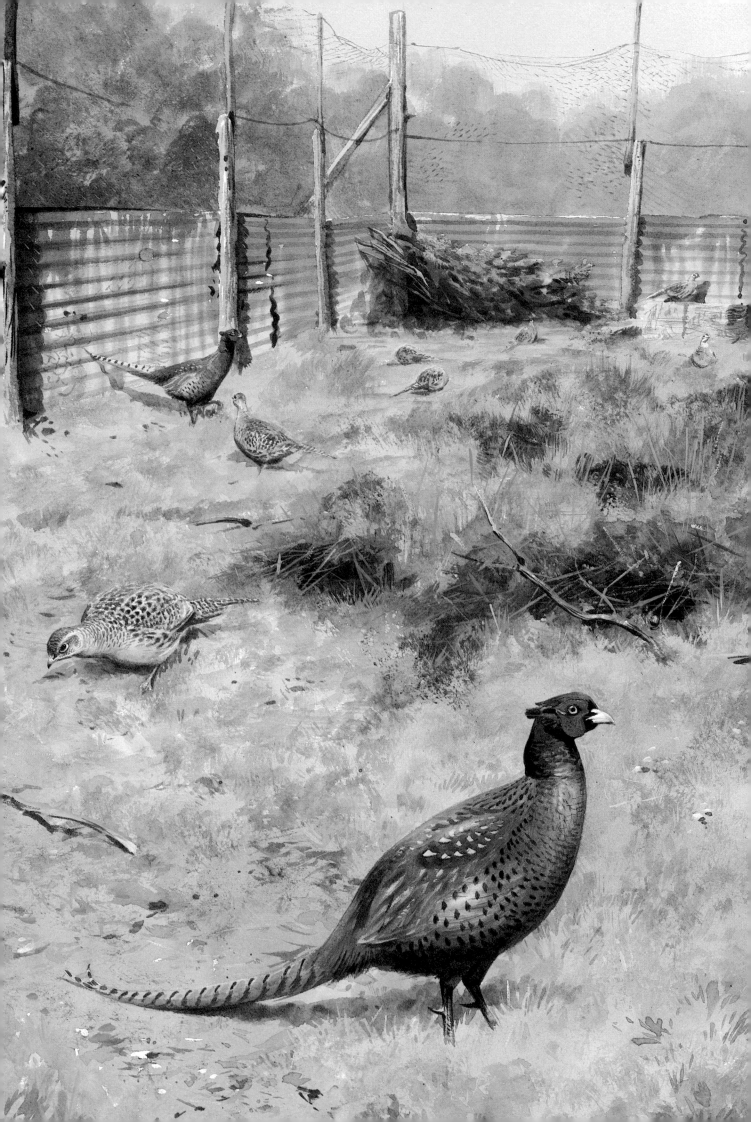

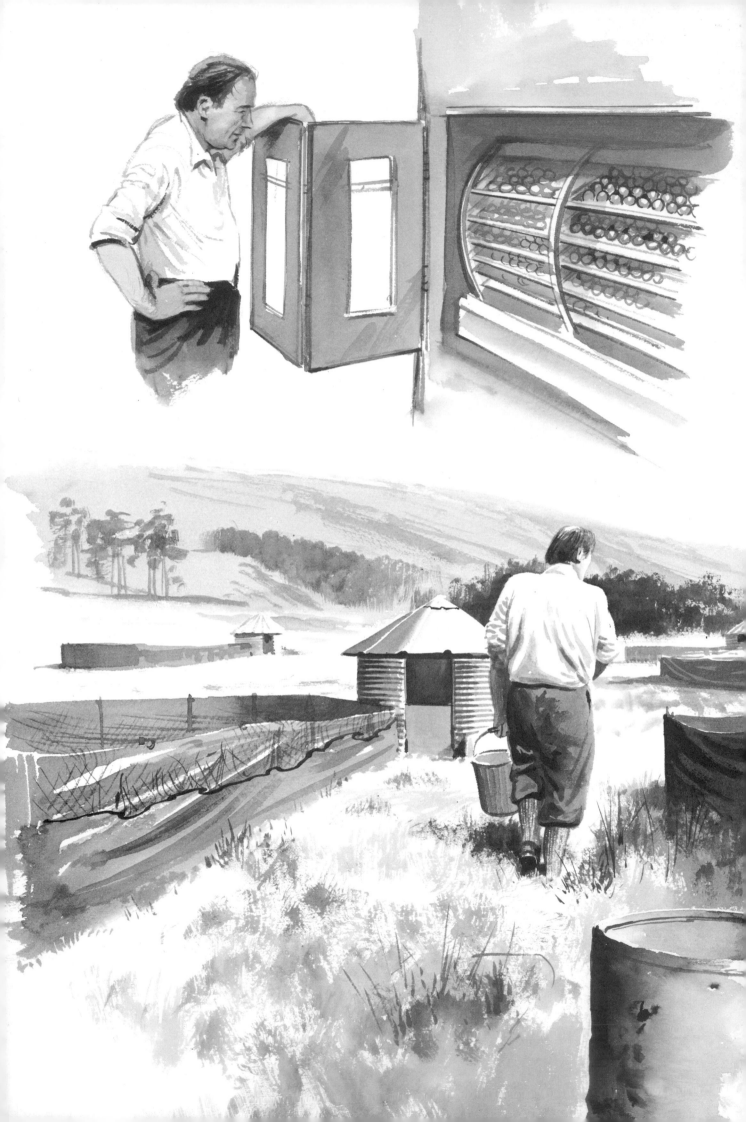

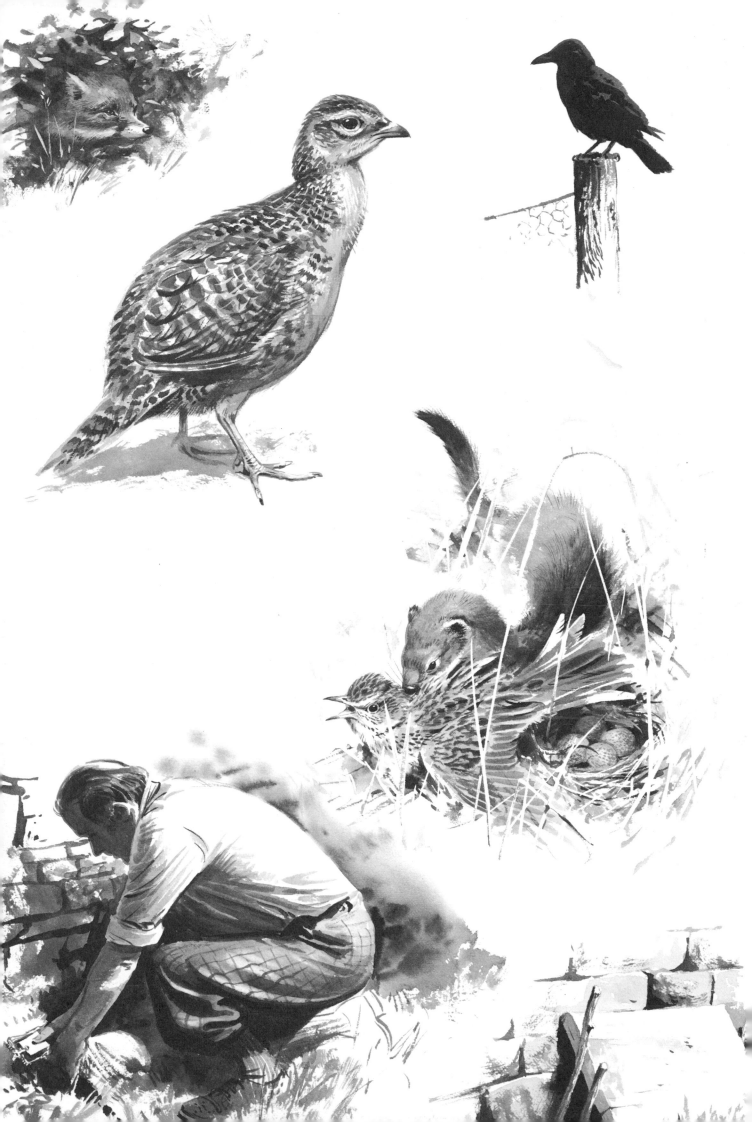

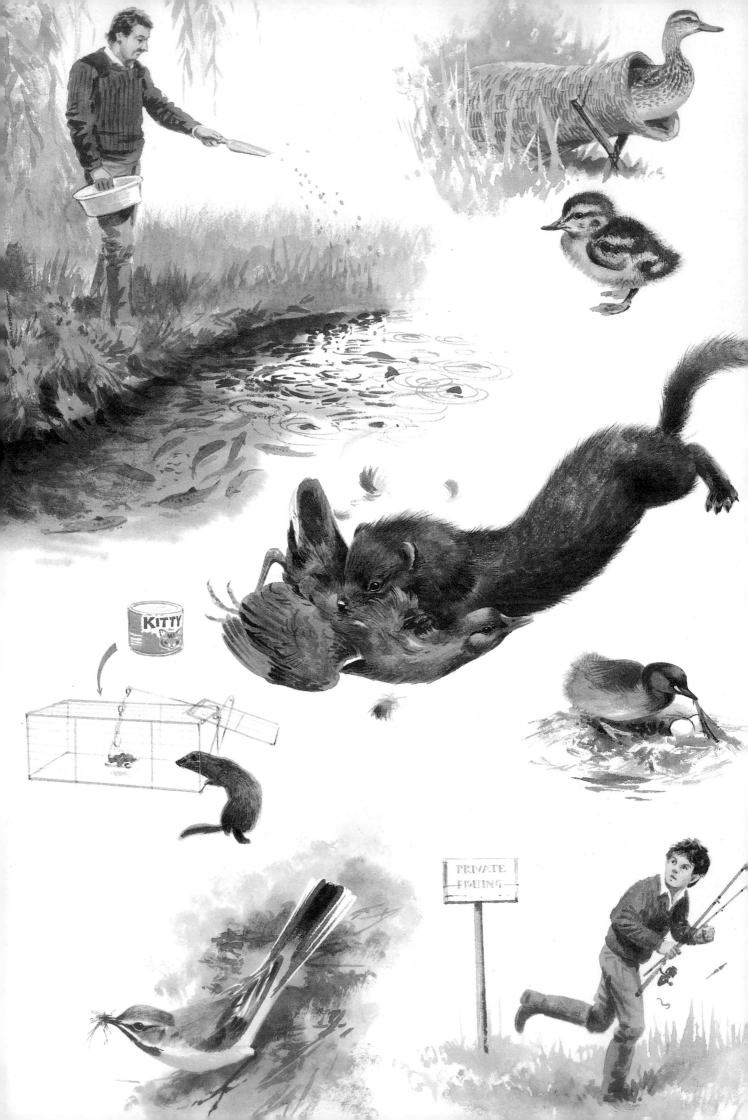

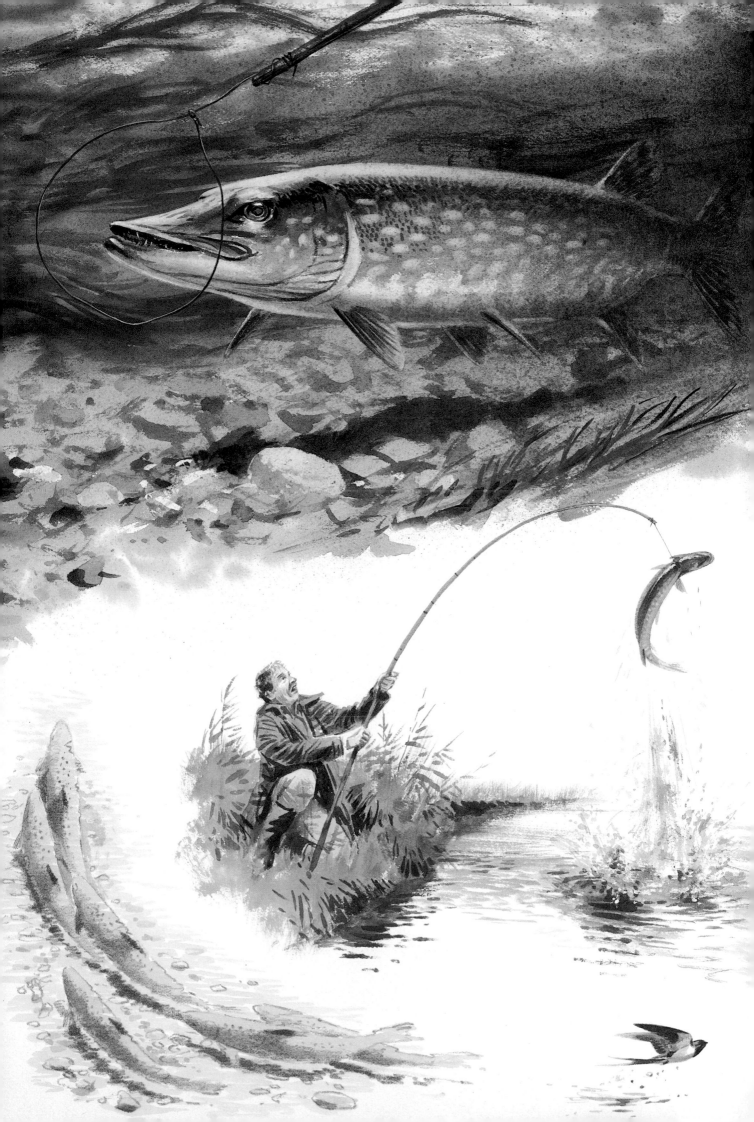

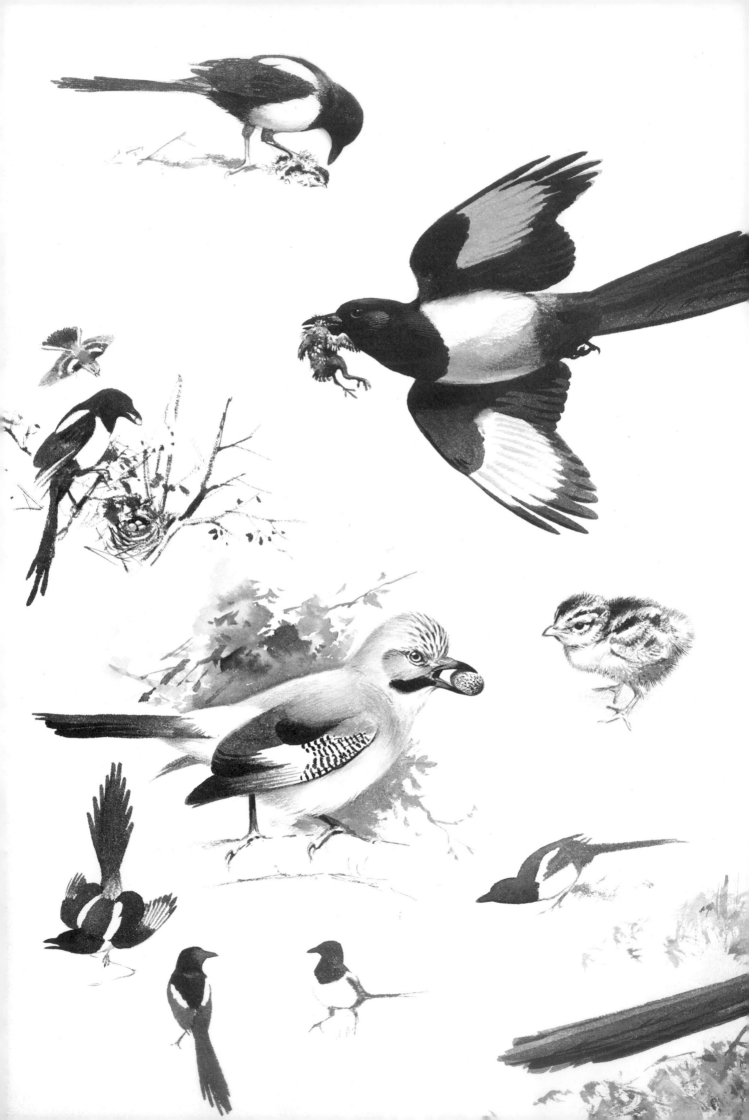

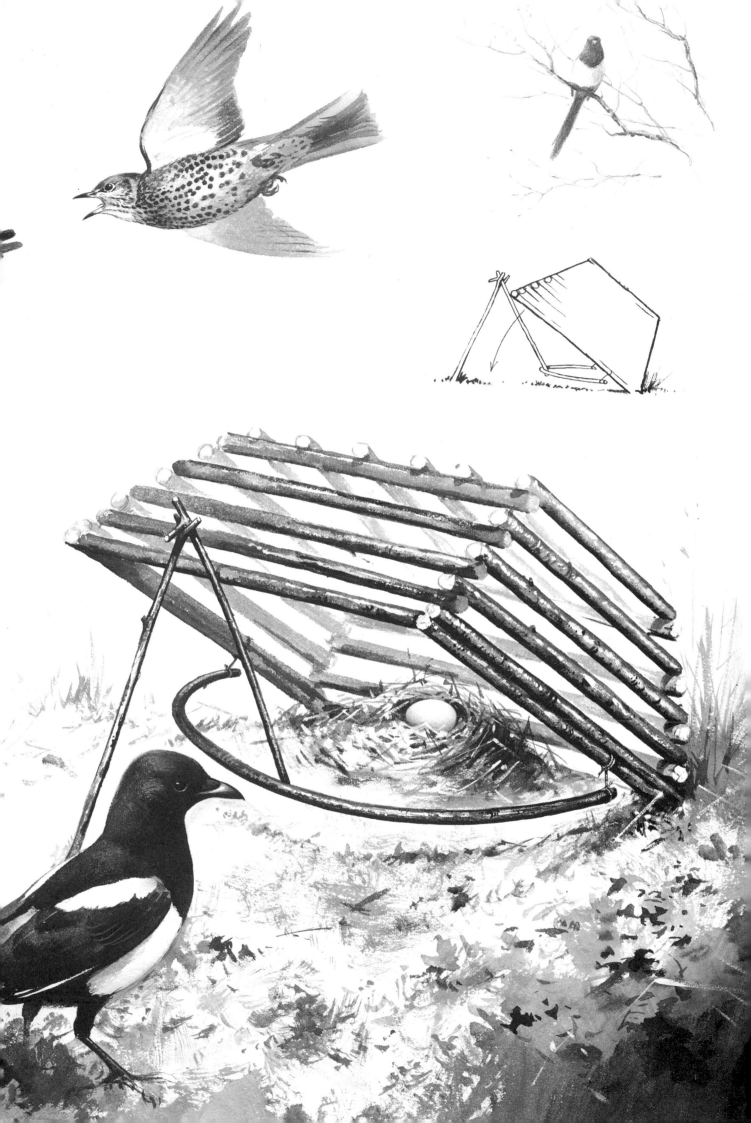

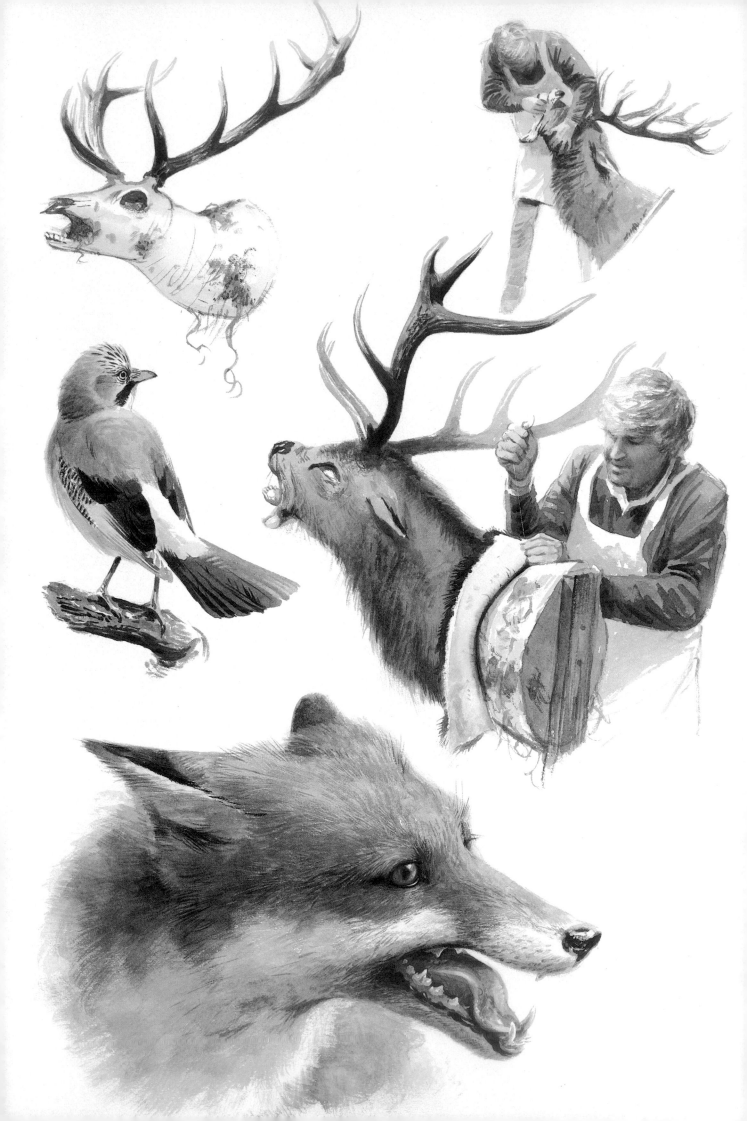

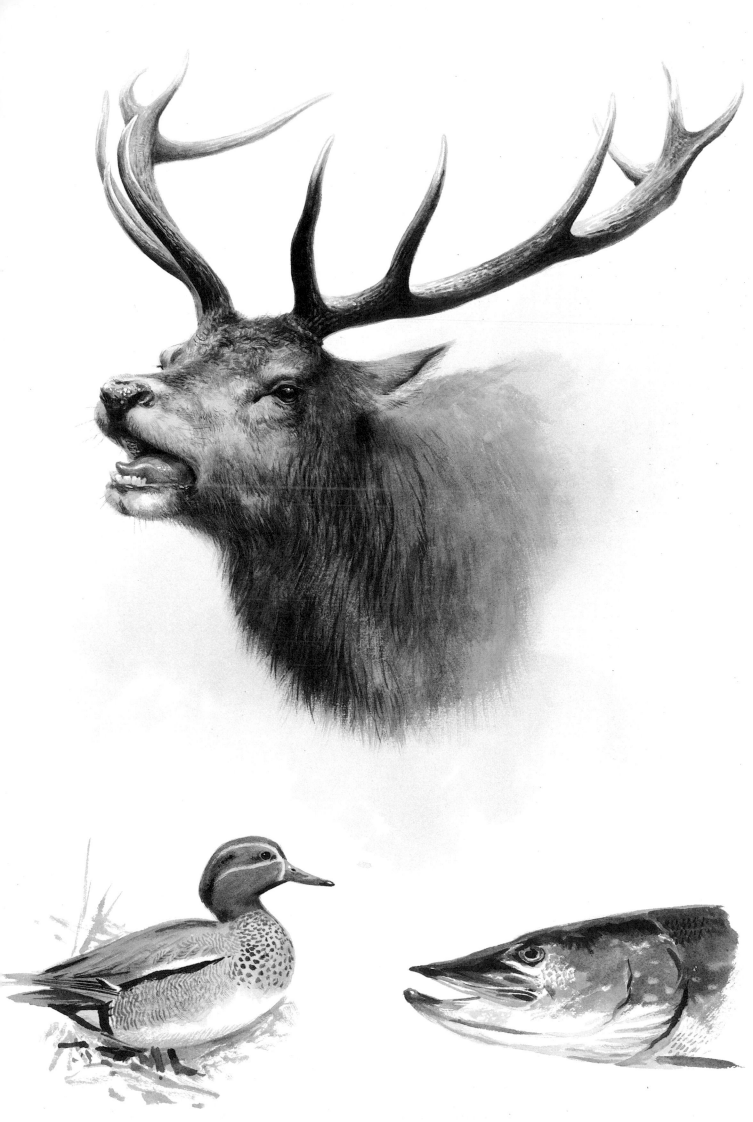

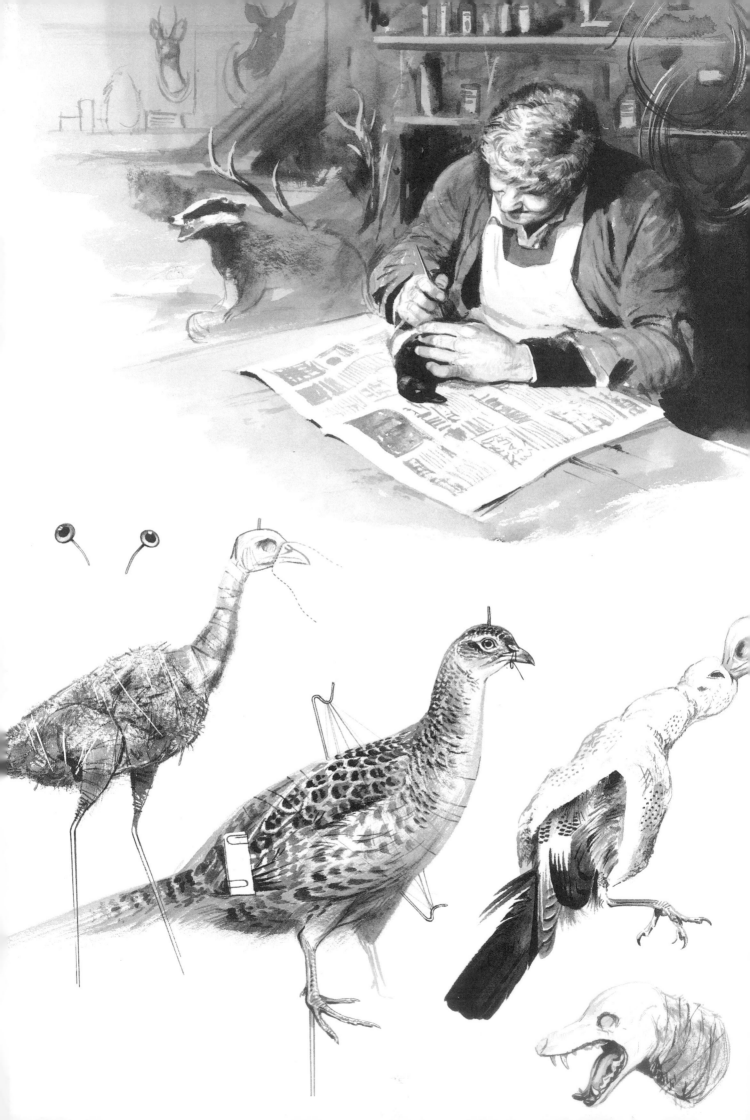

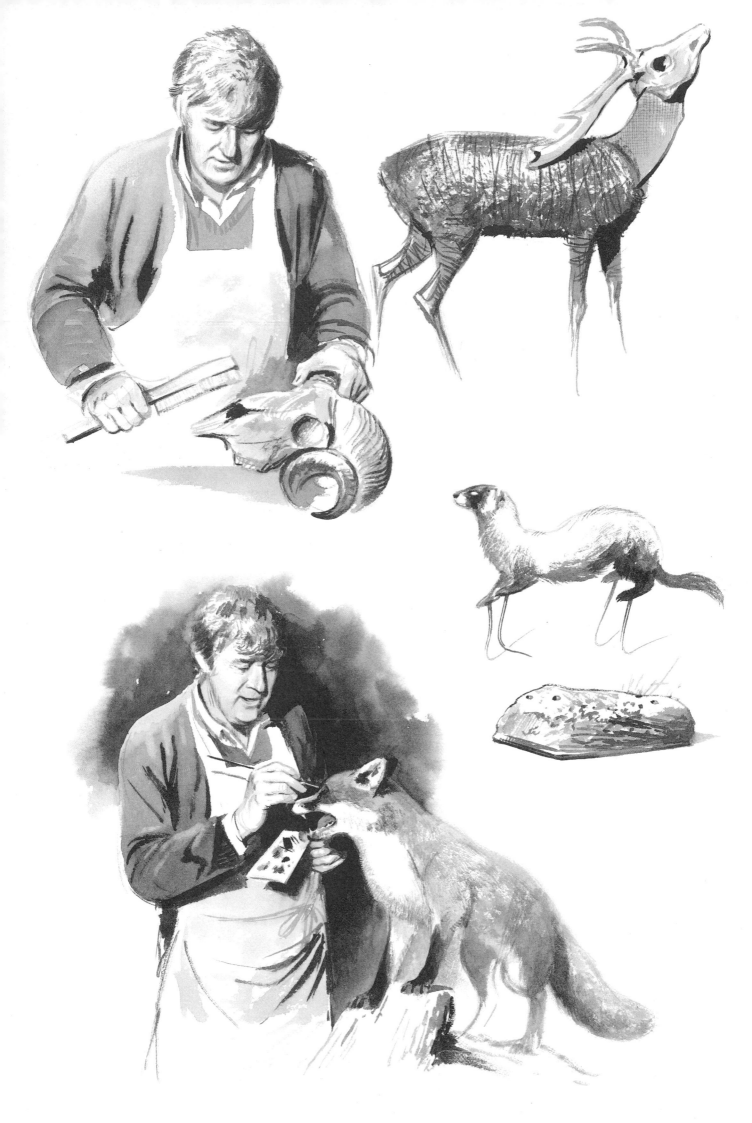

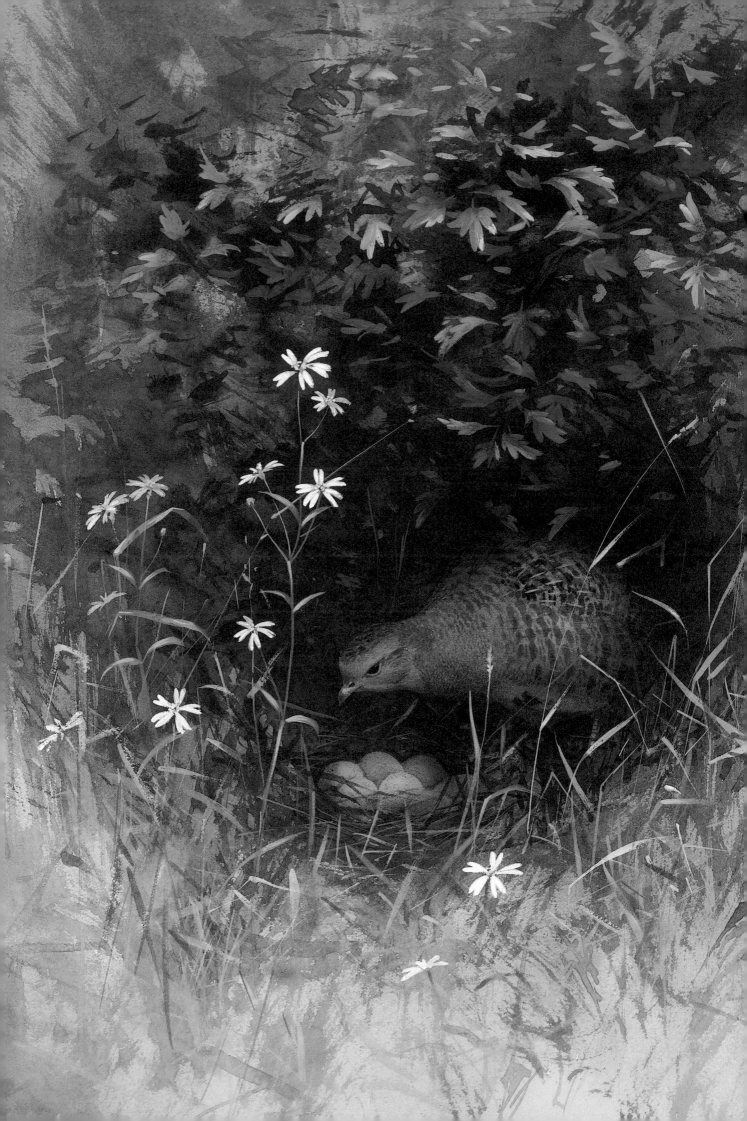

SUMMER

Where does spring end and summer begin? April, light-hearted and fresh, slides into full-leafed May and the chestnuts have lit their candles, white and pink against the vivid green leaves. May is a month of hope and aspiration; the long, drowsy summer months lie ahead and the chill of winter is forgotten.

The summer nights have a special magic known only to the sea-trout fisherman. From dusk 'till well after midnight he will stalk the dark stretches of river, casting his fly over the long glides of black, foam-flecked water in the hope of a bar of silver, a fighting, tugging sea-trout. A lonely but exciting time, for his only companions may be the odd nightjar hawking for moths across the water or perhaps the shuffling of a badger meandering by the river side.

The middle of June, the 16th to be precise, is a date looked forward to with eager anticipation by not thousands but literally millions of anglers. On that date the coarse fishing seasons opens. I always associate carp and tench with the opening date. Tench in particular, for the handsome brown-bronzed fish is a denizen of secret, reed-fringed, early summer pools. To creep in the dark, through dewy, wet paths and over hidden stiles, to crouch by the inky margin, waiting for the first hint of dawn and to listen to the furtive night sounds, is to know and understand the appeal of coarse fishing.

It is the lure of the unknown. Whether you fish by the edge of a factory-girt canal or on an idyllic, lily-starred lake, the float, cocked and red, is the focus of total concentration. The slight ripple, the bob and sudden plunge beneath the surface and then, with luck and skill, the solid thump as the hook drives home and the fish, a good one, dives, embraces a world of excitement.

The coarse fisherman will, if he is observant, see nature relaxed and living its quiet, unpretentious life. He will see the reed-bunting clinging to a stalk, the vole busily feeding, the pied wagtail flirting its tail. Silent and barely moving the angler becomes a part of the natural world.

From the green umbrella and maggots of the coarse fisherman, a frozen figure by a placid river or pool, to the rock-strewn slides and white water of a Scottish river, where the salmon, *the* fish, are running, is indeed a wide gulf, yet both the coarse fisherman and the game angler are field sportsmen. Coarse fish and salmon are reared and distributed, pollution is fought, disturbance kept, wherever possible, to a minimum. For the salmon fisherman in particular it is a disheartening and uphill battle for he is beset by commercial interests. His toll of fish is a minute fraction of the vast numbers caught at sea and he can only pray that a few fish will escape the drift nets in the estuaries to fight their way up the river to spawn. The dangers for the salmon, apart from the angler's fly or lure, do not end when it reaches the mouth of the river. The poacher, that unpleasant creature whose sole concern is to line his pocket at the expense of the salmon, will throw drag lines with hooks across the pools in the hope of foul-hooking a fish or, far worse, poison the water, killing every living creature. He is indifferent, callous and cruel.

Spring runs have been diminishing in recent years, so much so that many fishermen have

thought it scarcely worth the effort and expense, preferring to wait for the late summer in the hope that there will be a last minute run. Occasionally, just once in a while, fortunes are reversed, the rains descend and the rivers are in boiling, brown-foamed spate. Then the fish run and the gloomy diehards who have long forecast the end of the salmon are forced to think again as splendid catches are reported from south country rivers, idling through the water-meadows to the grey and purple Highlands. Then, as the line swishes across the water and tightens into a fish it is all worthwhile and the days of fruitless wading and endless casting are at once forgotten.

There is a special magic in May and June for the roe stalker. Few sportsmen can get closer to nature. Abroad at first light and dusk, in a world largely unknown to the shooting man, he will see foxes, badgers, woodcock and hawks as he seeks the roebuck, changing from its winter grey to fox red.

The roe stalker is a man obsessed, captivated by this most beautiful of our six species of deer. For the stalker, management above all else, is the key to roe control and the improvement of stock. Bad heads, a surplus of youngsters and the right proportion of does to be culled all will be a part of the goal towards which he strives the year round. Only rarely will he take a good head, and then probably because the beast is aged and going back, and as he walks the woods and the fields there maybe a dog at the stalker's heels; perhaps a labrador, a terrier, a German shorthaired pointer or even a mongrel, silent and knowing, an invaluable and trusted companion, ready to track a wounded beast or to signal the presence of deer in the depths of summer woodland.

The dog, whatever its breed may be, is the common link, the bond, between all shooting men, the vital aid to reduce or eliminate totally suffering in the shooting field. But, as the gundog owner and handler comes swiftly to appreciate, a gundog can become a way of life. So much so that many shooting men and women derive greater pleasure from working their dogs in the field than from actually shooting.

Summer is the season for the gundog trainer. The long cool evenings, when the heat of the day has subsided, are ideal for basic training sessions and the shallows of pools are warm enough to entice the most fearful and reluctant of puppies, with the assistance of an older, water-loving dog.

These green and golden days are a time for butterflies. Vivid red and black, orange and blue, wings flicker across the grasses and garden and hedgerow flowers. Red Admirals hang poised on purple thistle heads while Peacocks seek brambles in the rides of cool woods. Perhaps one may be even so fortunate as to spot a rare large Tortoiseshell, sadly diminished since its food plant, the elm, has been nearly wiped out by disease.

The latter days of August, too, will see the first parties of guns on the moors, either walking-up over dogs or driving. It is often desperately poor scenting and gundogs have to contend with a blazing sun, exhausting heather and clouds of pollen which mask the scent of grouse.

The grouse moors in August and September, in Scotland or England, are sheer delight; magic places, where the purple heather, the humming of bees and the cloud shadows chasing each other across the hills merge into a sumptuous backdrop for the festival of the red grouse.

As the days perceptibly diminish and September hovers between summer and autumn, perhaps only the fly fisherman will deeply regret the passing days, in the knowledge that the long winter months lie ahead, dark weeks when the rod will lie idle and only fly-tying will alleviate the gnawing boredom.

But for the still-water fisherman, be he on loch or reservoir, there are still golden evenings and days to be matched against rainbow and brownie. There are few more relaxing moments than the silent peace of a late summer evening by the edge of a lake. Only the creak of a moorhen in the reeds or a cock pheasant clattering to roost disturbs the quiet. Trout are rising at a late hatch, ripples welling on the oil-flat surface, a woodcock flickers over and perhaps there will be a heart-stopping thump as the fly is taken and a good fish bores deep beneath the black water.

These are the moments, however ephemeral, which must be snatched and banked against the winter months ahead.

On the moors the field sport with the longest history of all, falconry, is still practiced. Spectacular, exhilarating and with a direct link to our distant past, to watch a seasoned peregrine working with a brace of setters is sheer poetry in action. The pointer locked on a grouse, the sudden flush and breathtaking stoop of the falcon as it homes on a bird is surely one of the most spectacular sights in the world of sport.

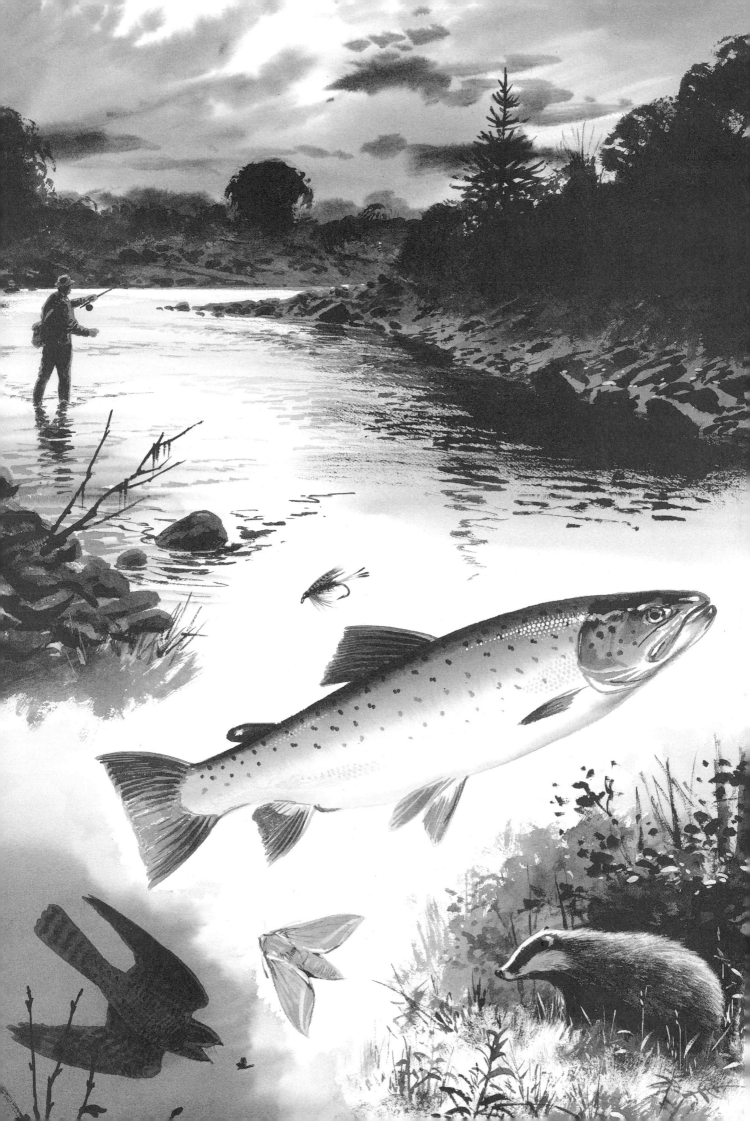

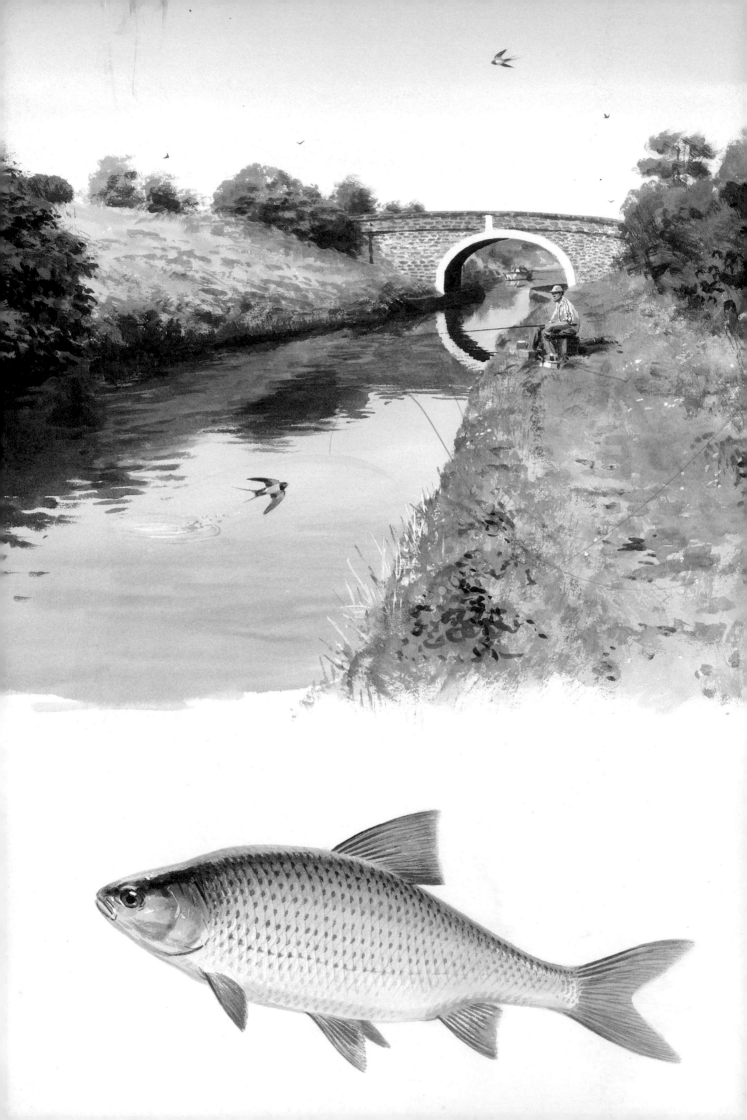

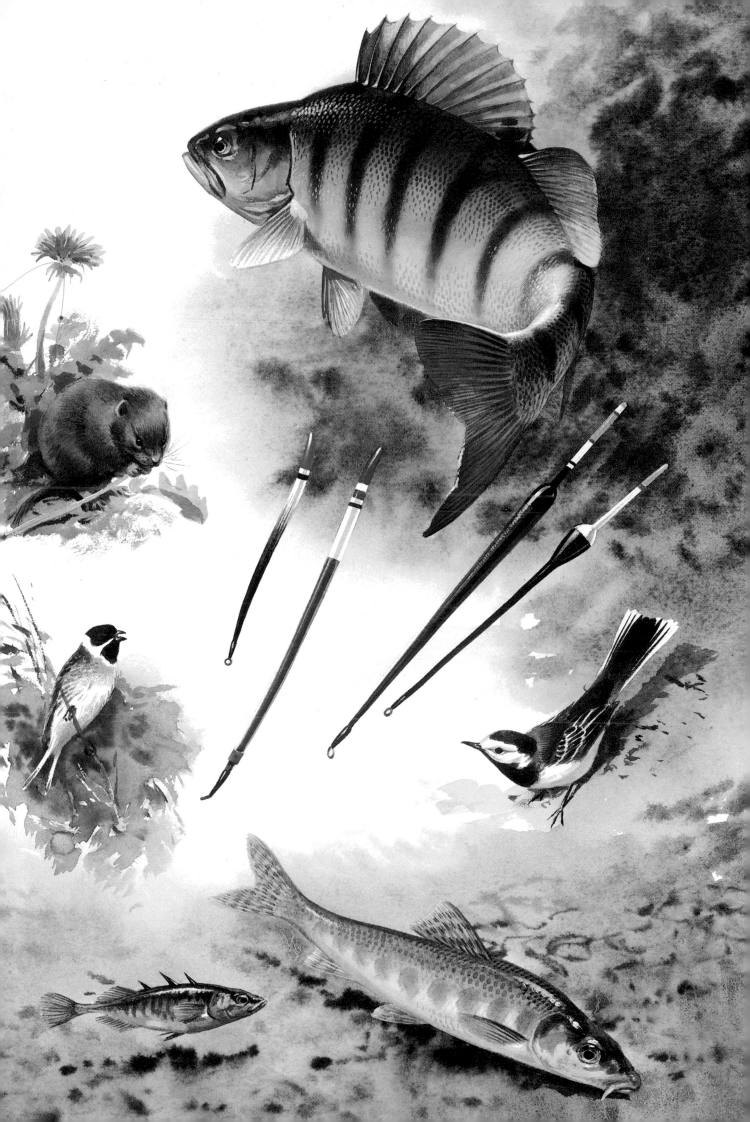

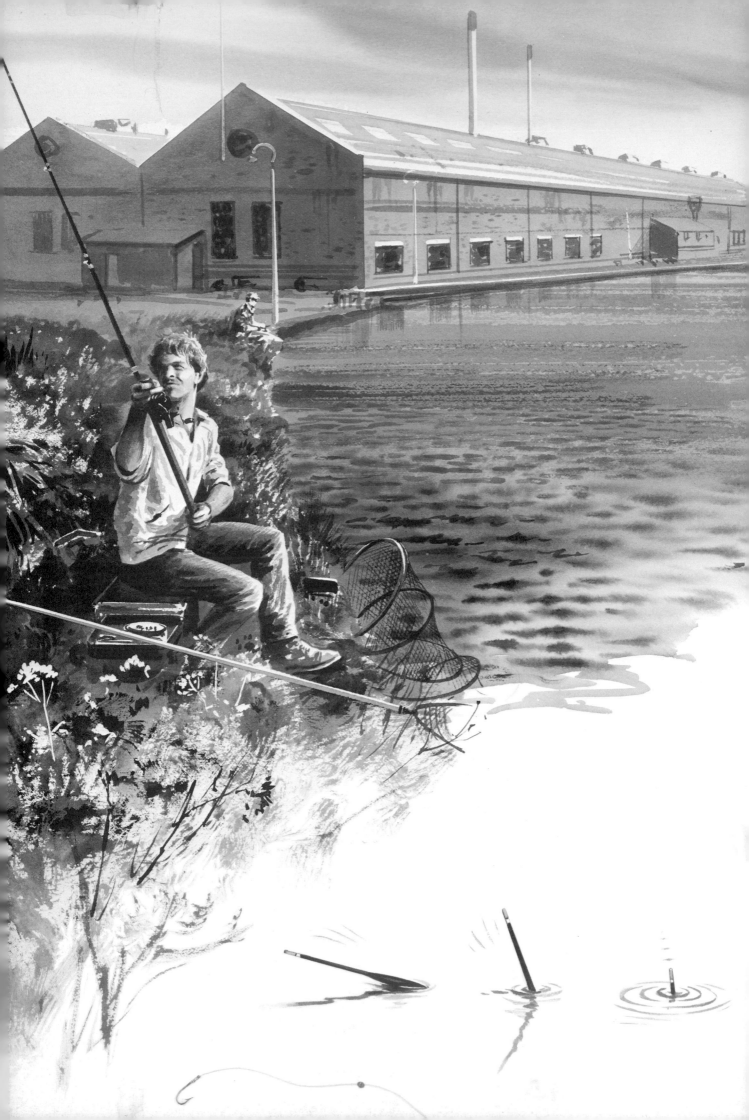

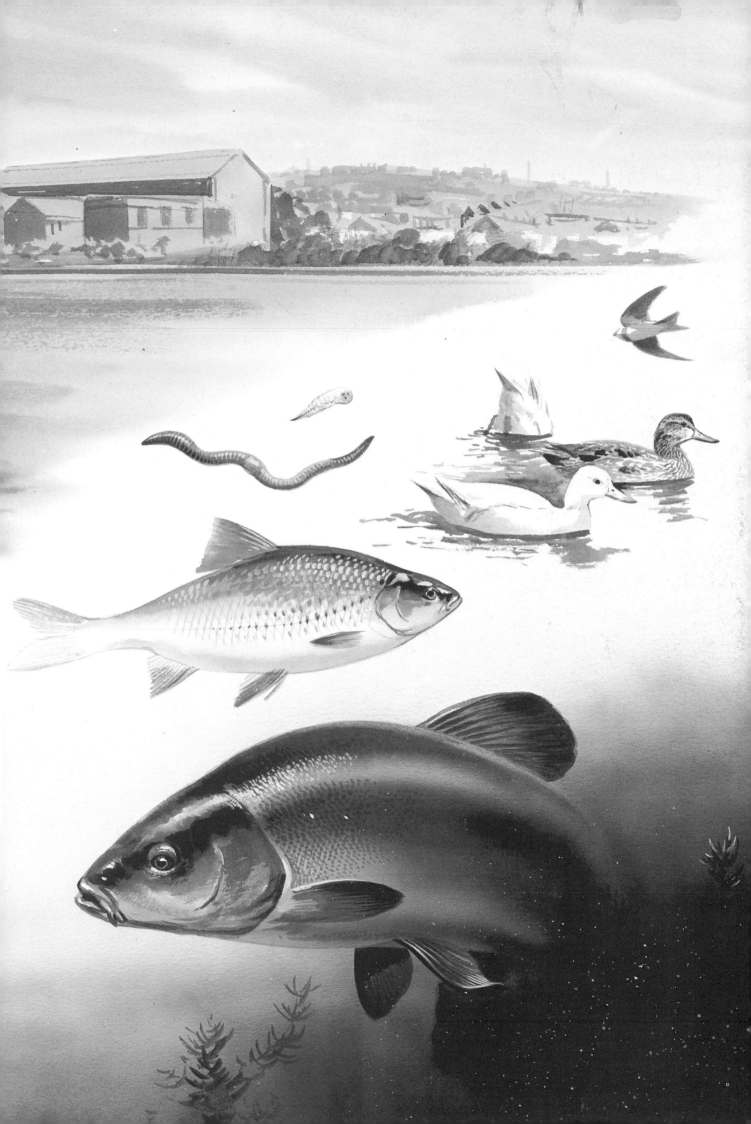

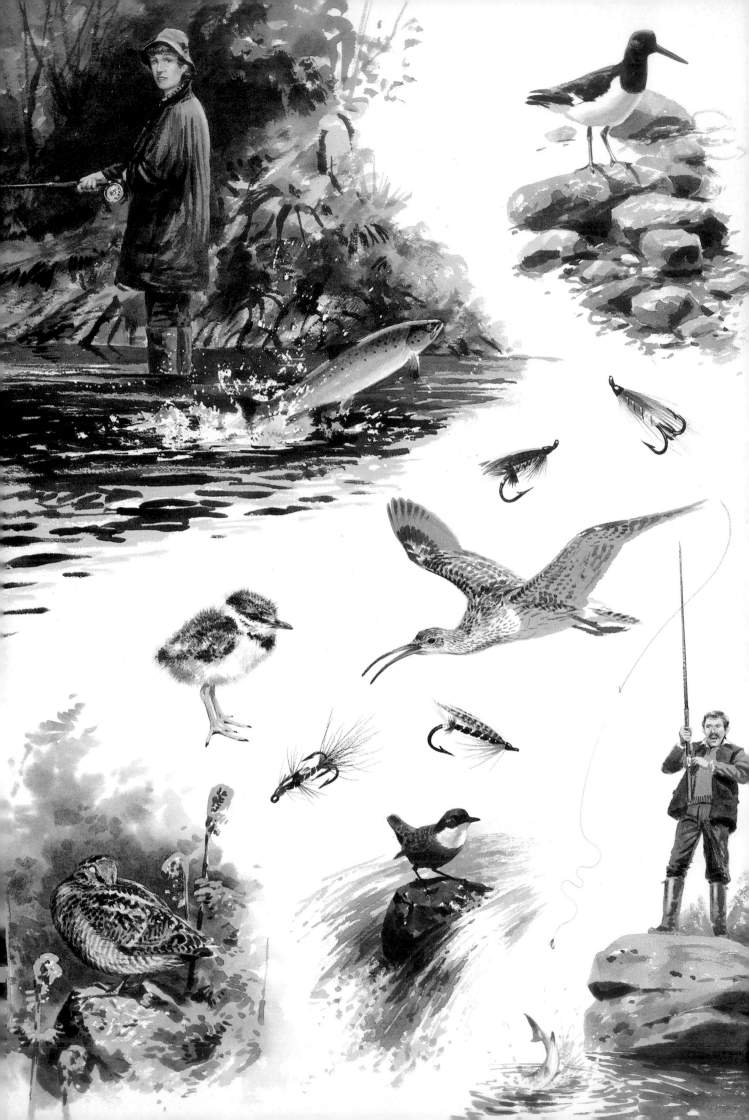

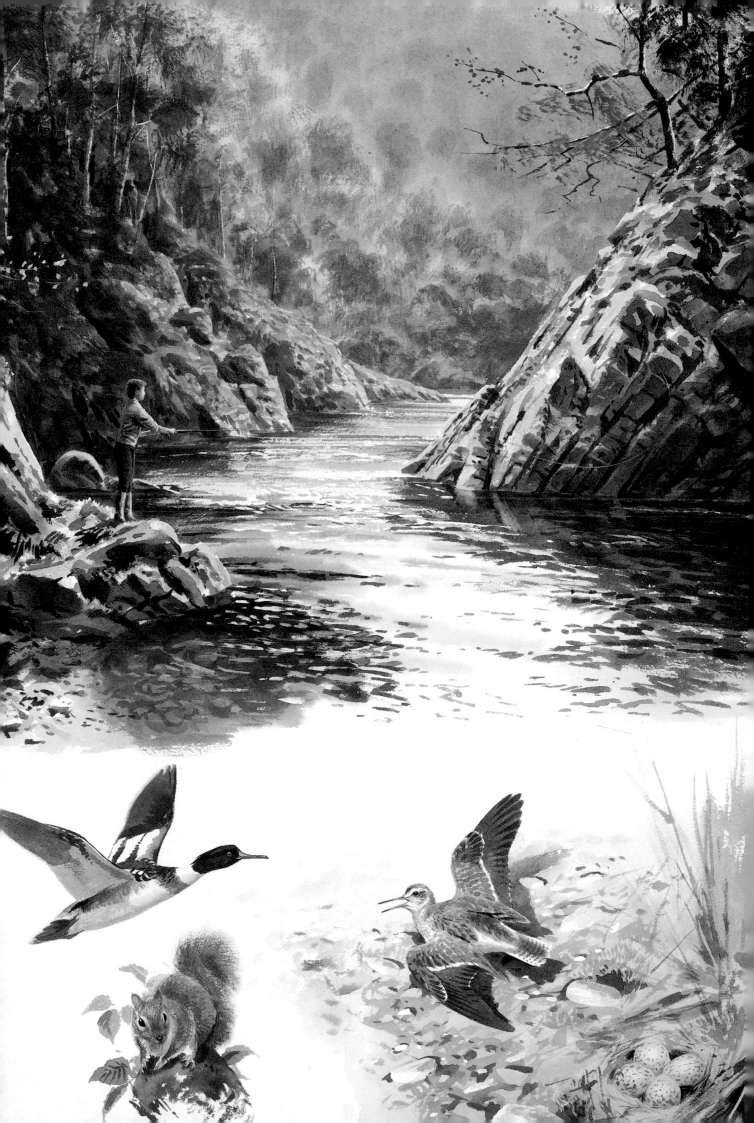

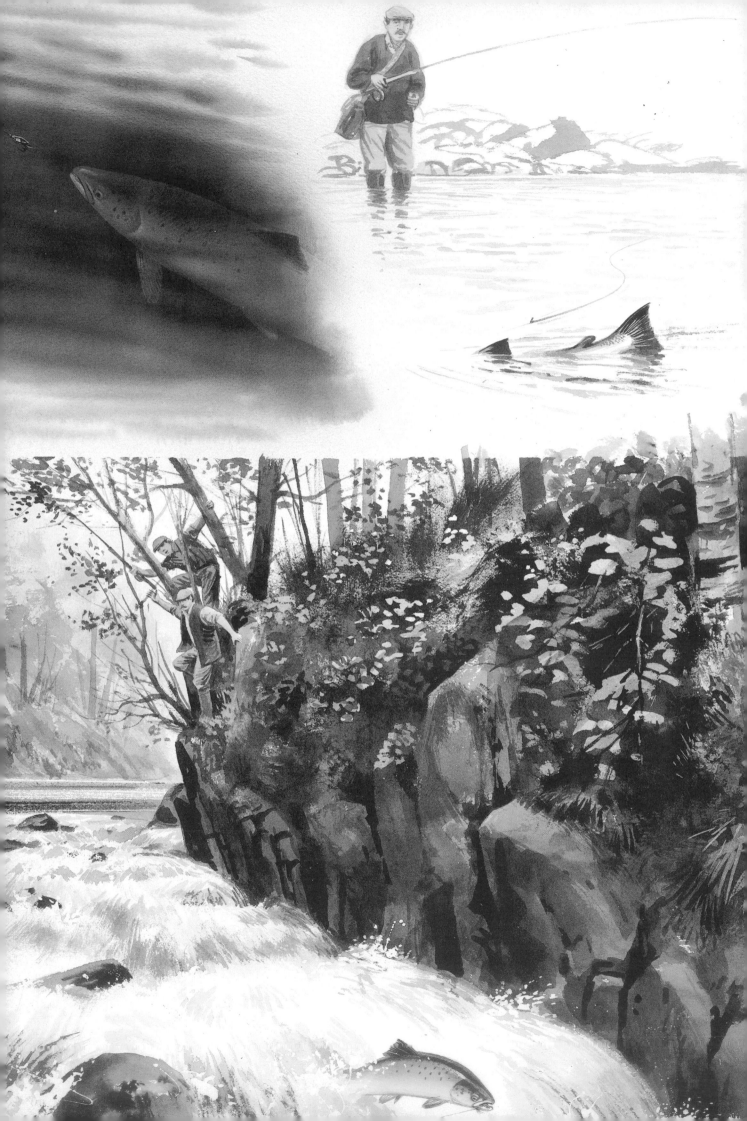

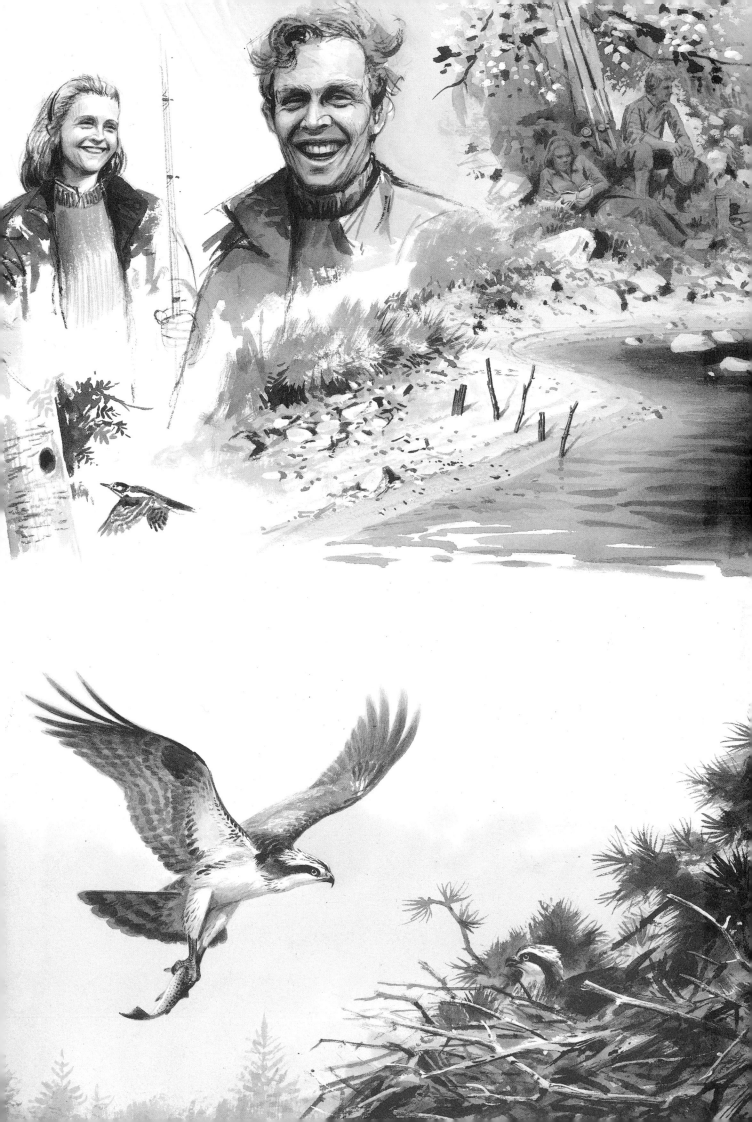

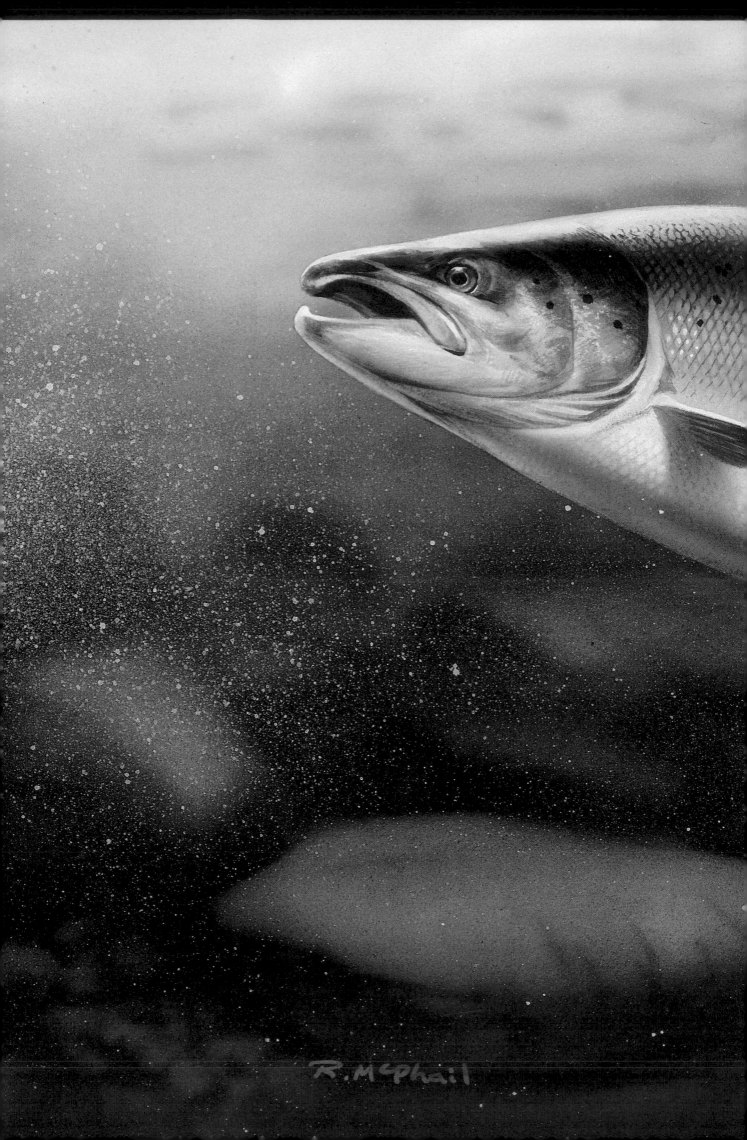

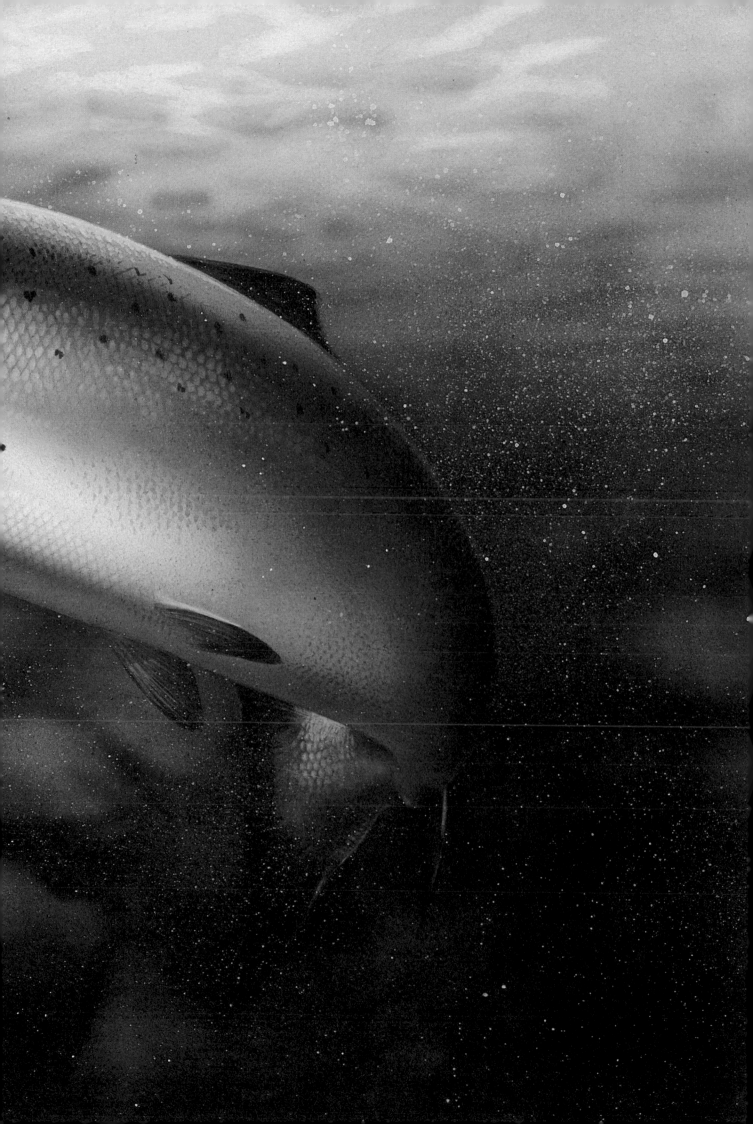

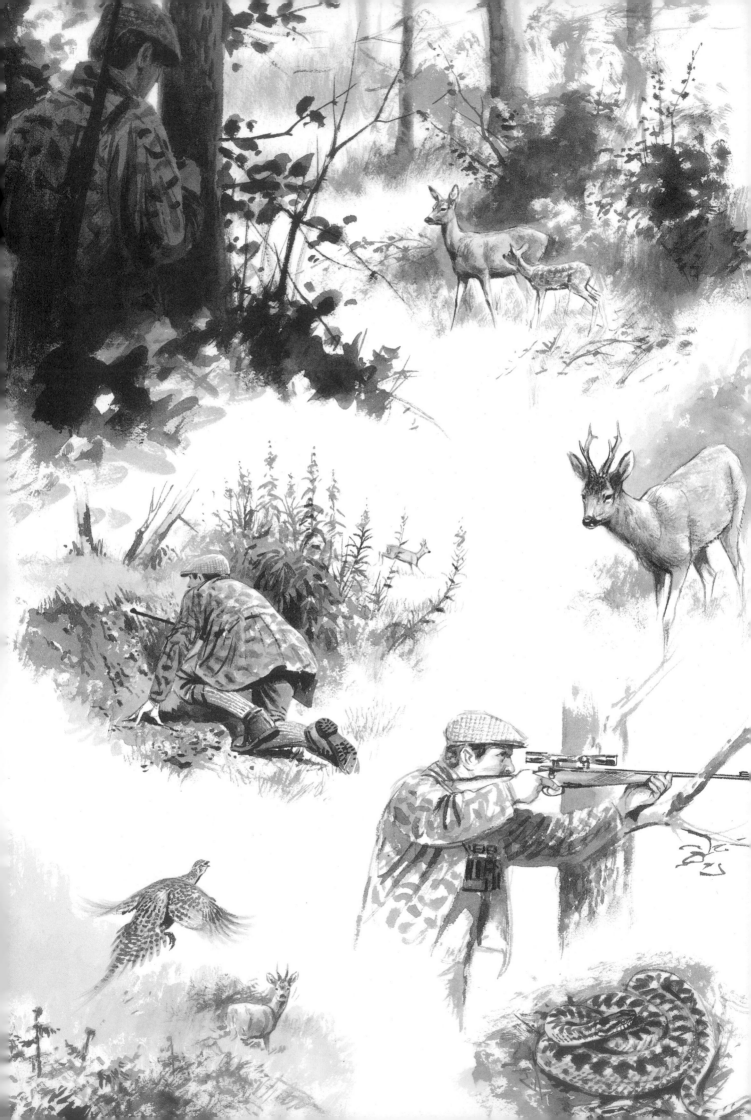

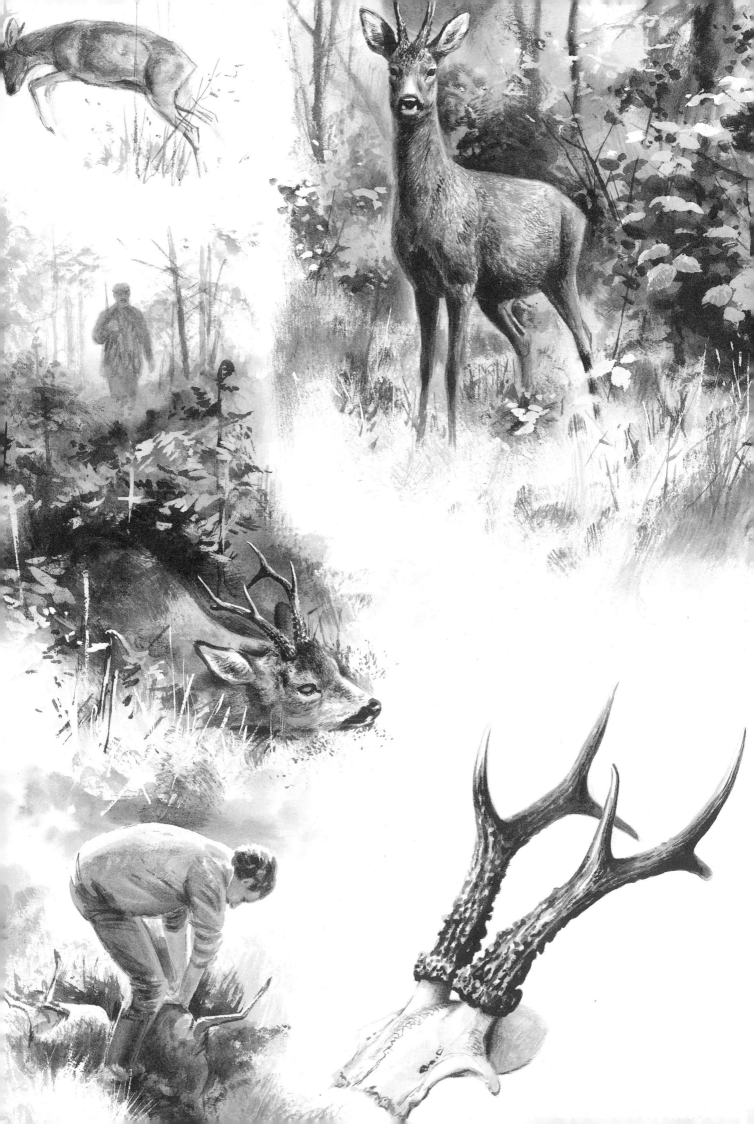

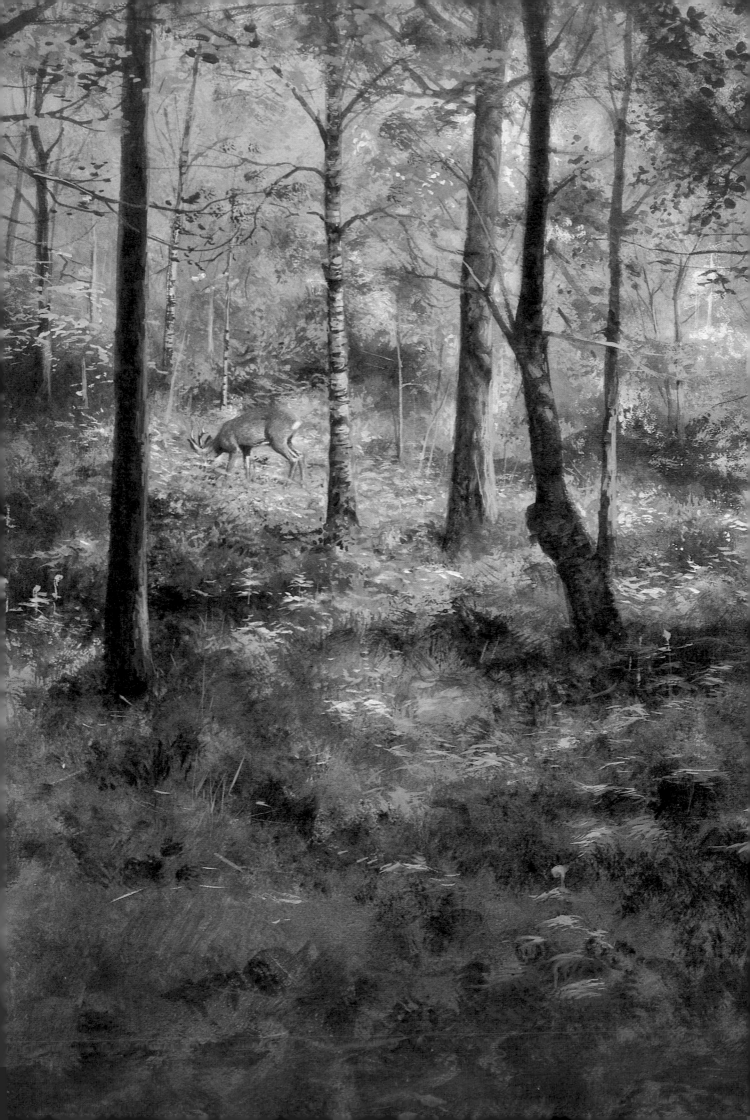

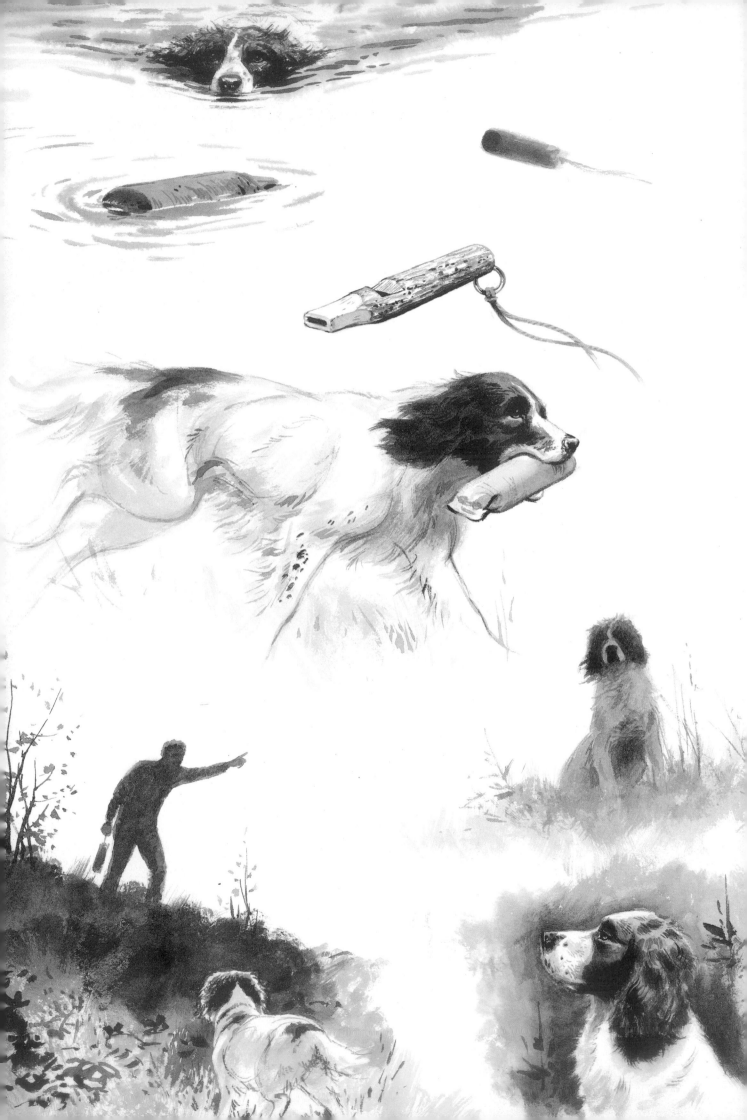

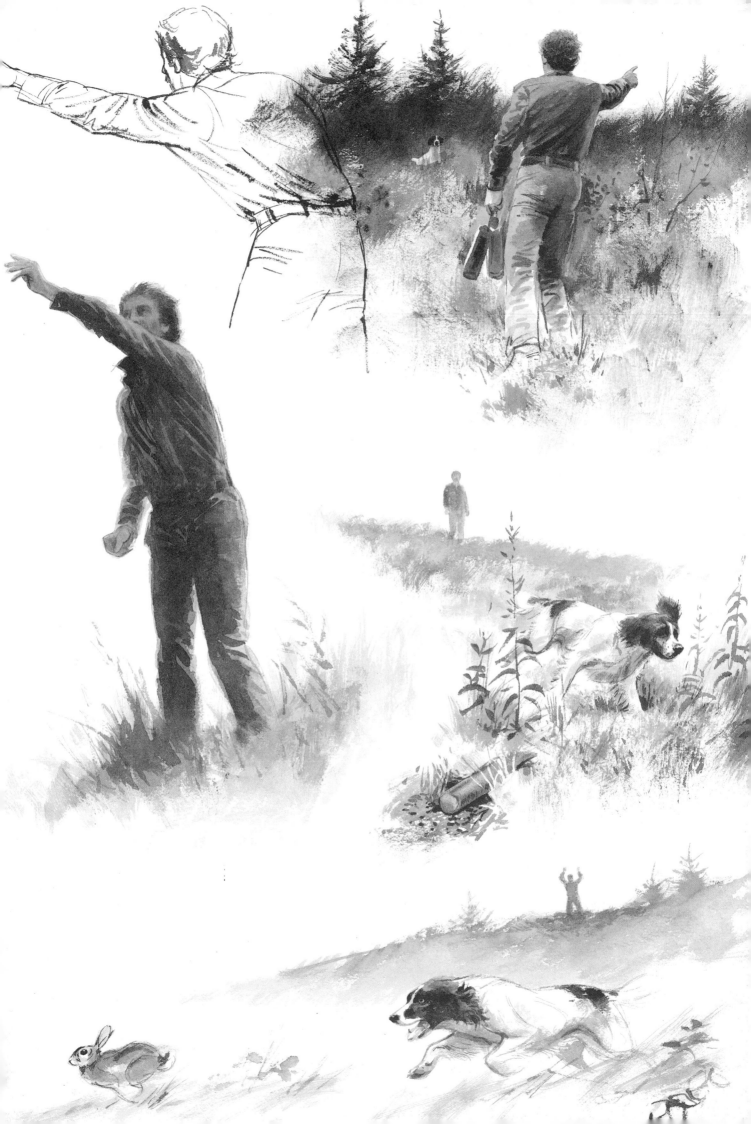

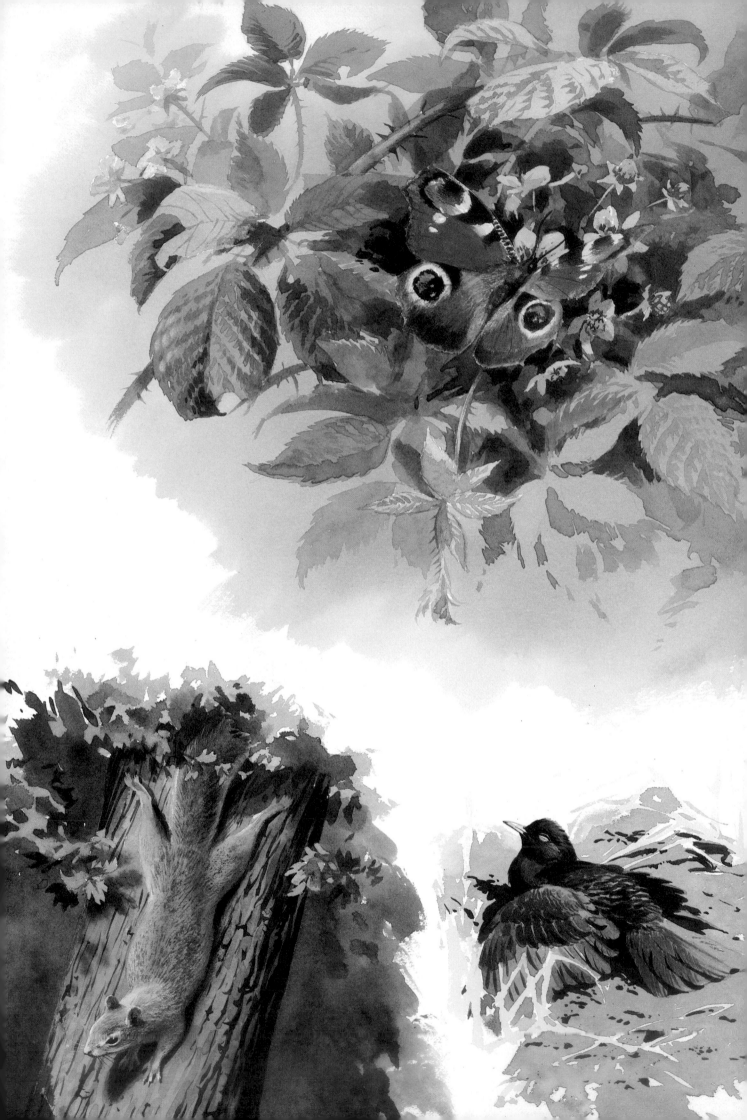

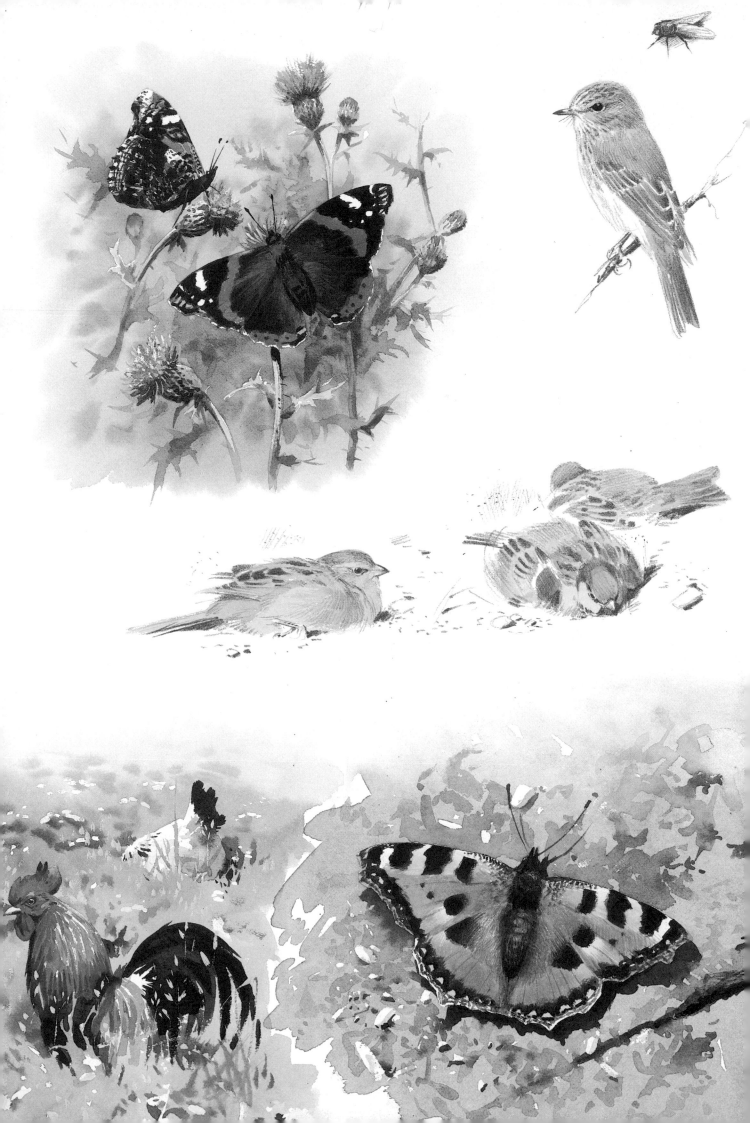

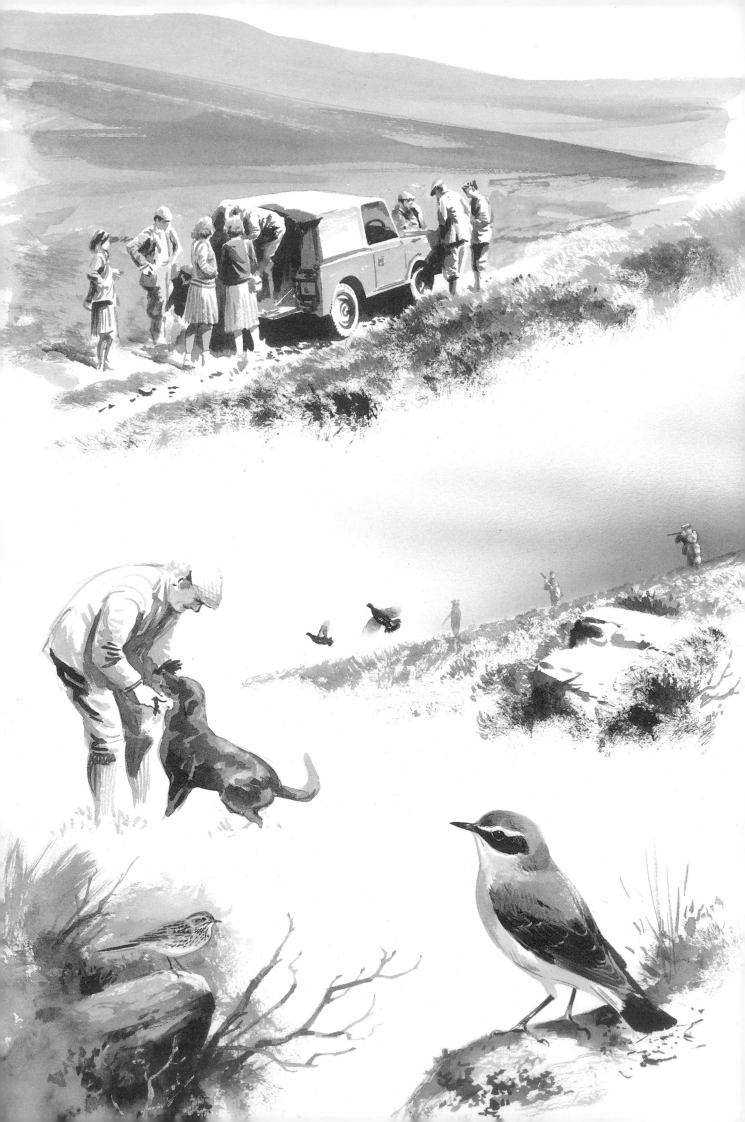

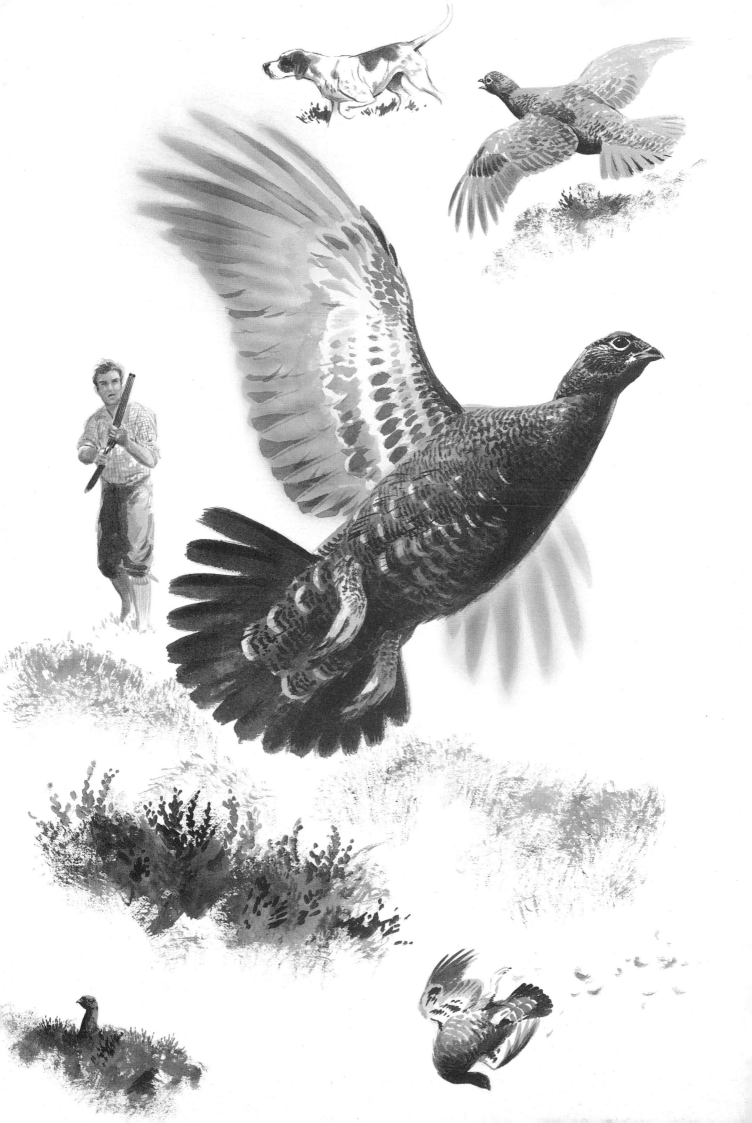

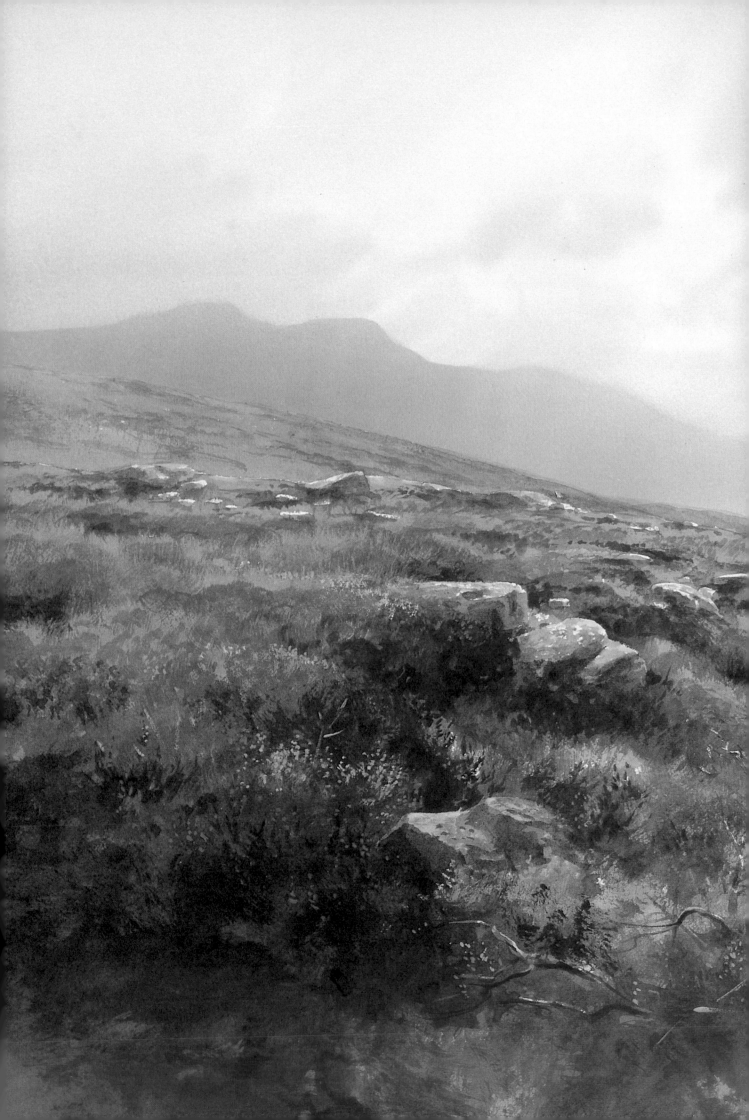

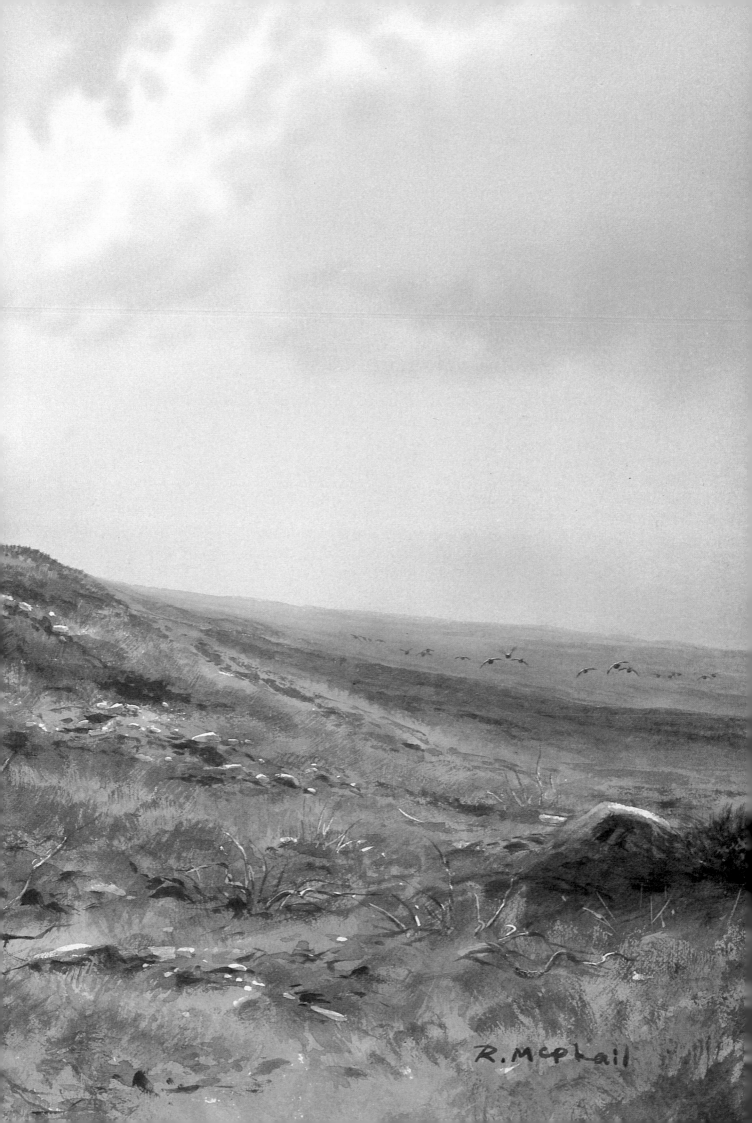

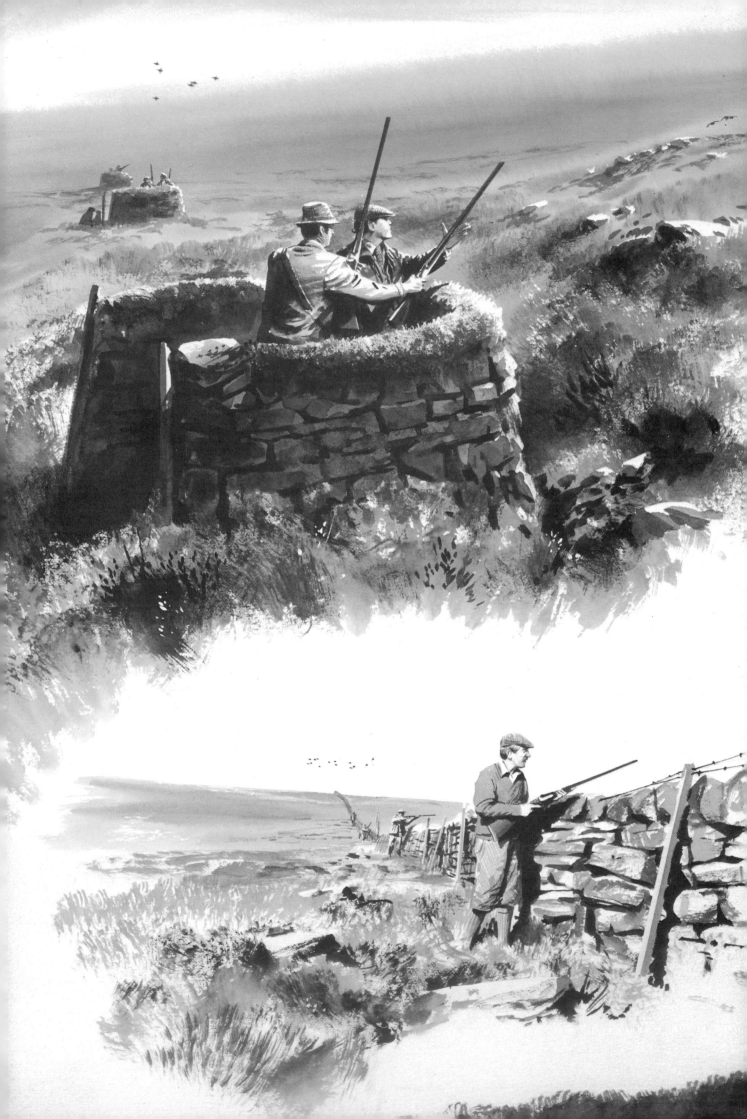

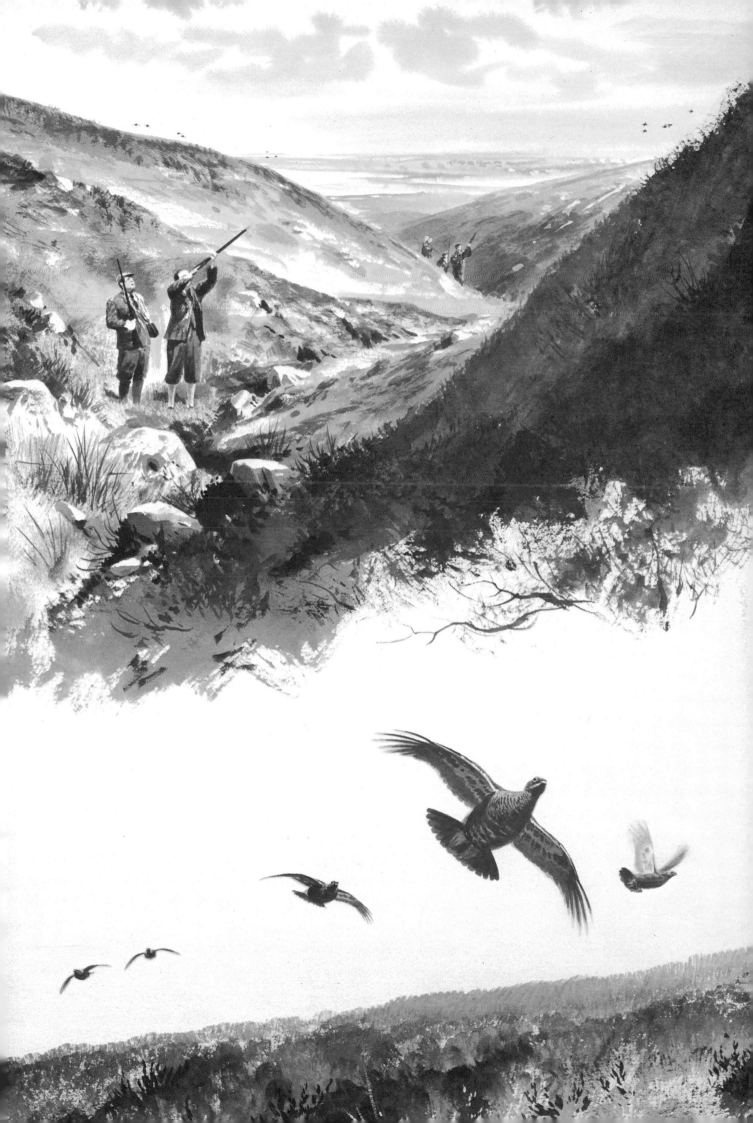

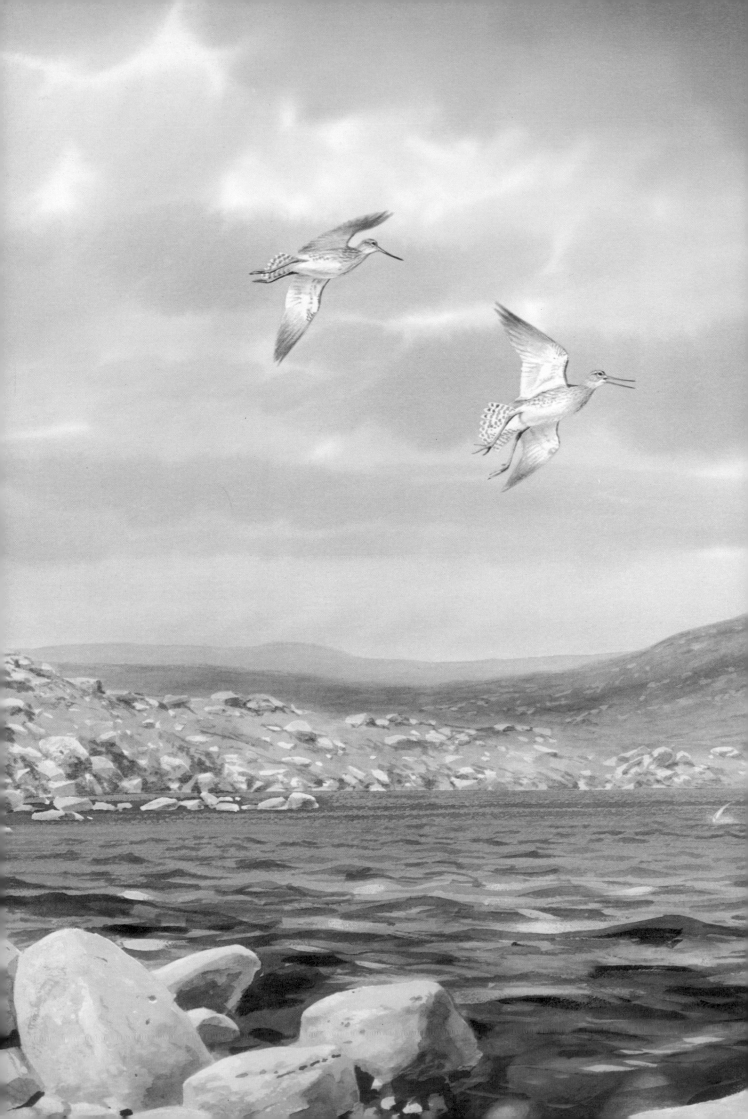

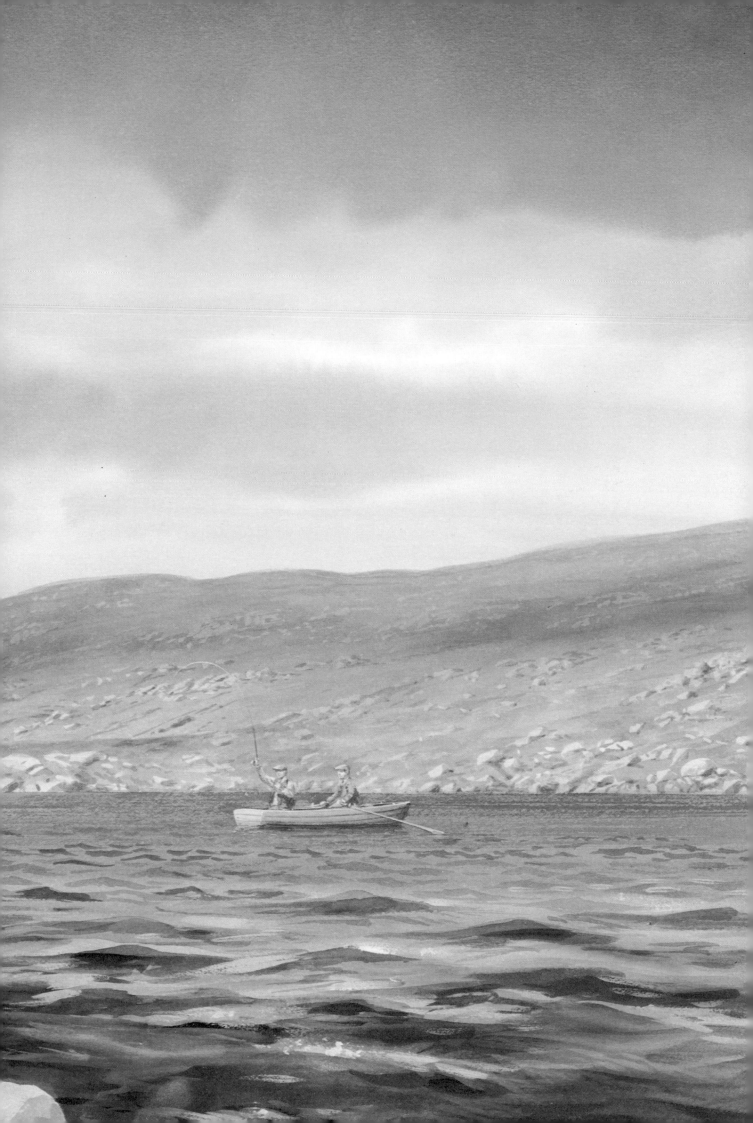

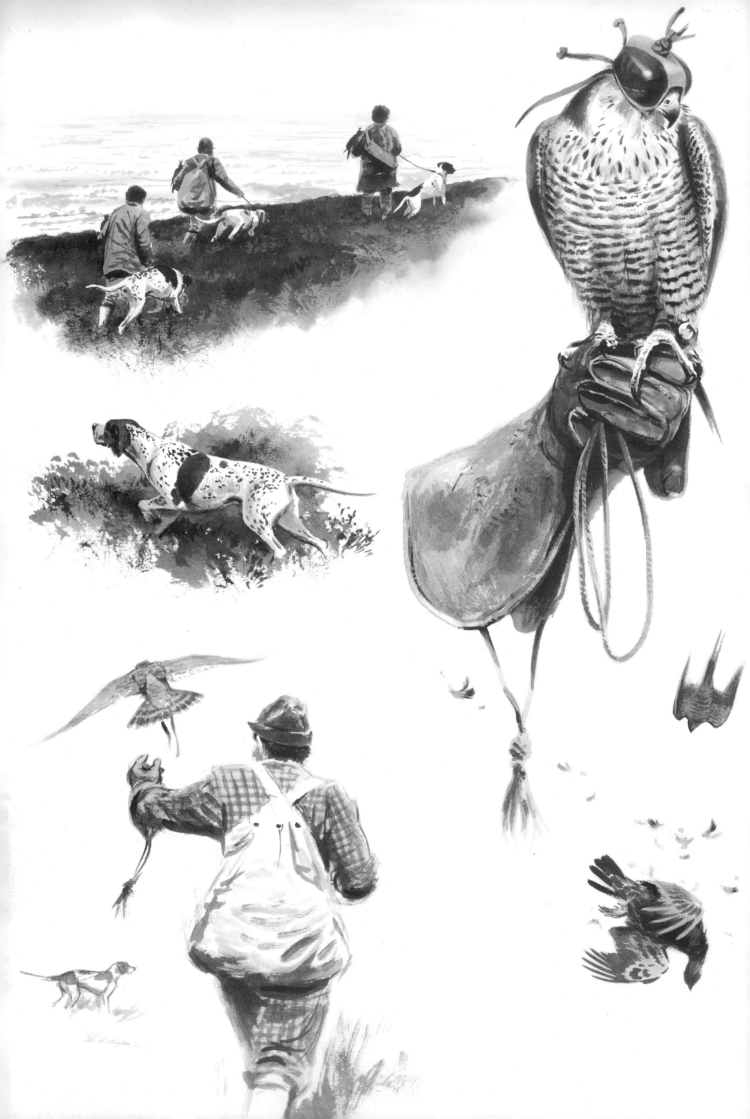

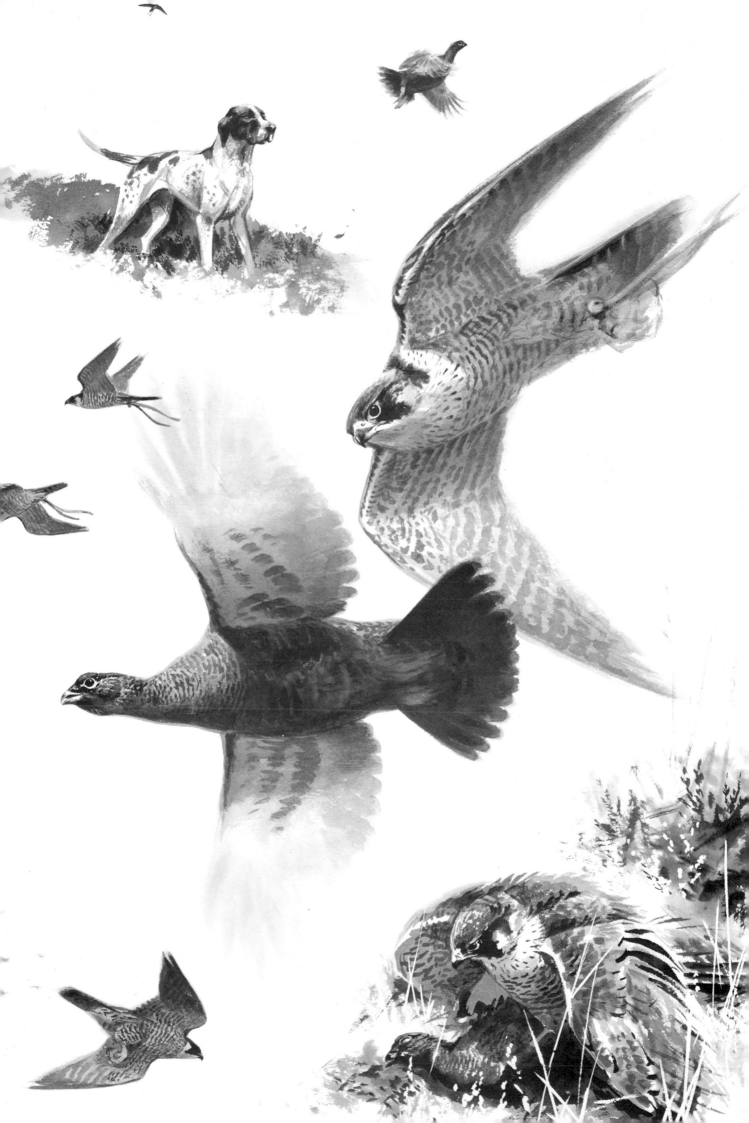

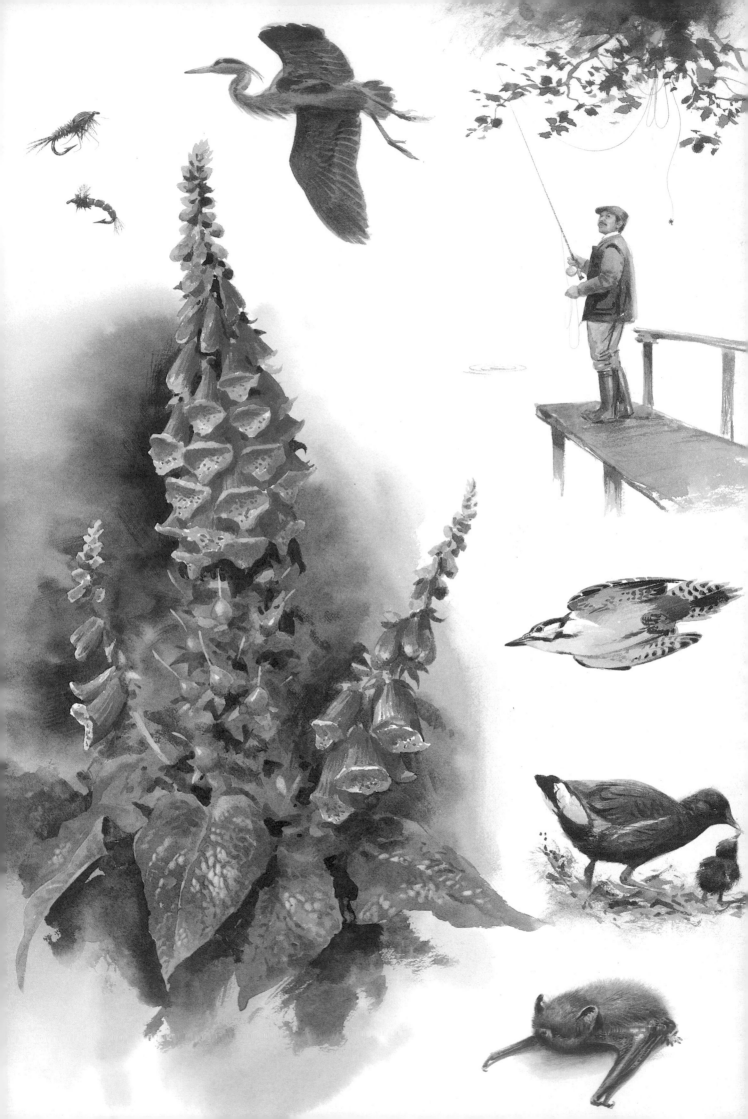

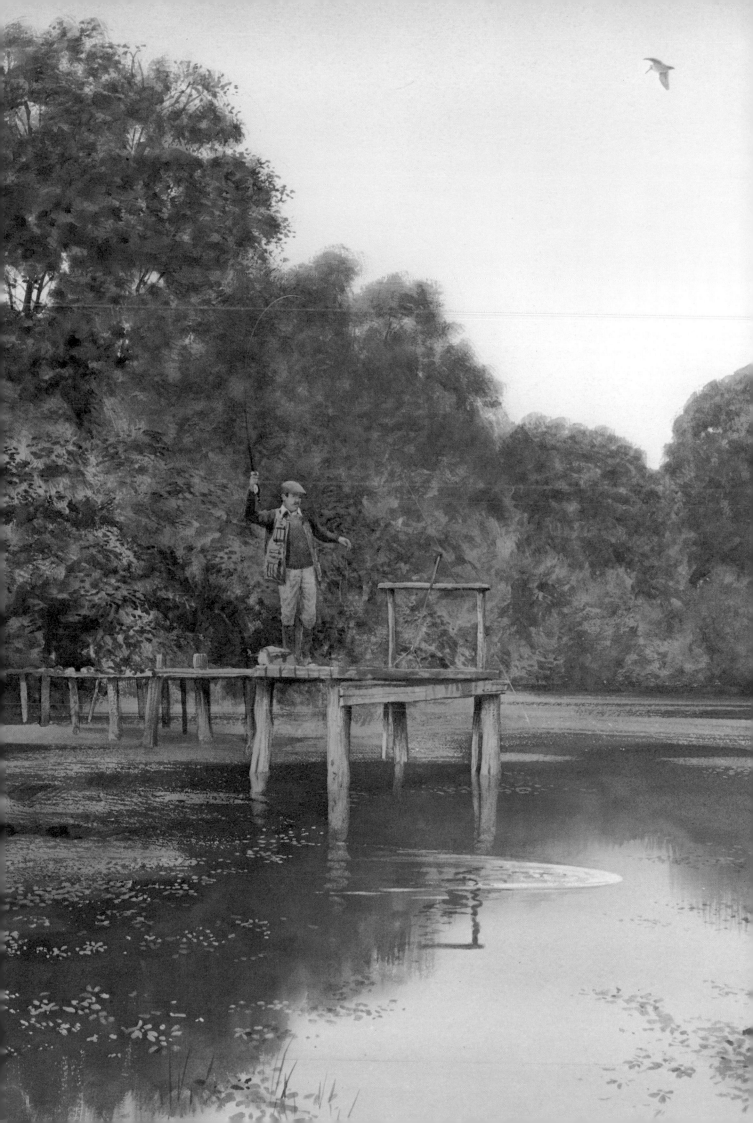

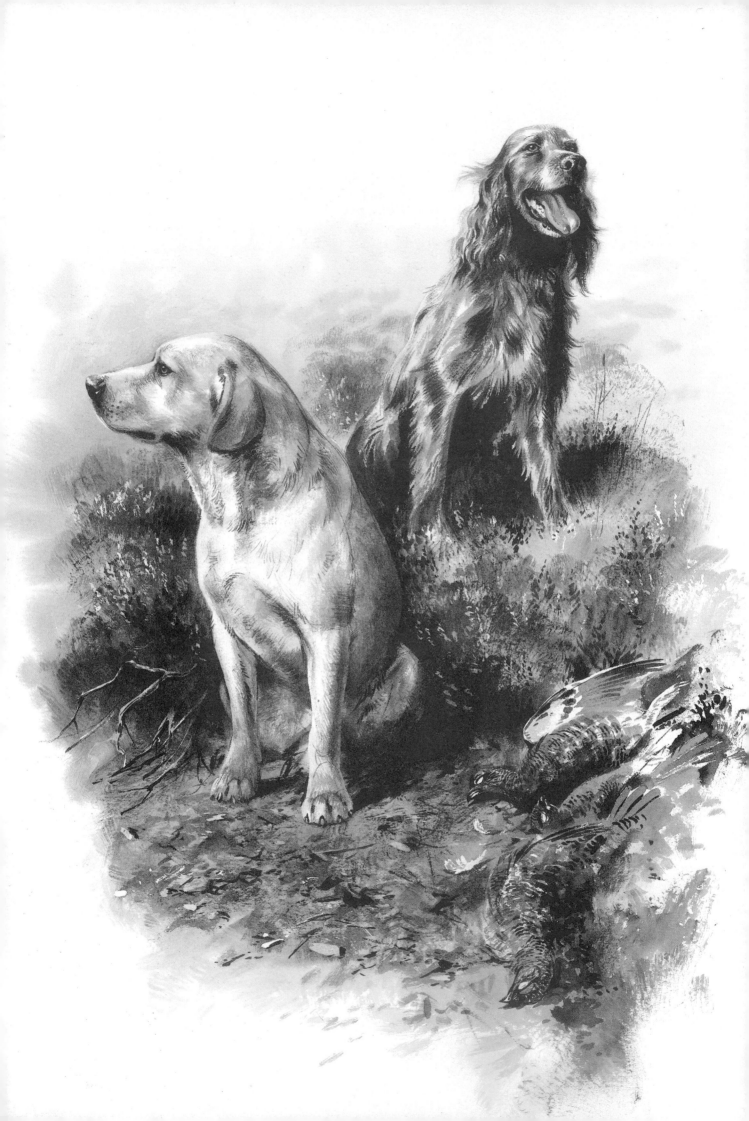

AUTUMN

Dry, sapless leaves flutter through the early winds of October and the first crisp frost spells summer's doom. Coursing — controversial, misunderstood and incredibly exciting — comes in to its own and soon the straining, thrusting longdogs will be matched against each other on the flat, open fields of the eastern counties where hares are still to be found in good numbers. Every effort is made to provide escape routes for the hares and it is only the competition between the two dogs which is of interest.

Turning on a sixpence, twisting at speed, red collar against white, a well matched couple will set the mounted judge a perplexing task.

Wherever there are flat, marshy fields — increasingly scarce, sadly — there will be found snipe in singles, in couples and, when the weather is really hard, they will rise in their dozens, scaaaping and flickering from drains, reed-beds and even bare plough. Back and forth they weave, stitching narrow lines across the autumn sky. For the sportsman, snipe can offer matchless sport and a special challenge.

October is the month of the red deer rut; then the roars, hoarse and guttural, echo across the glens and mountainsides as the stags, in the fevered excitement of the season, herd their hinds and challenge and counter-challenge would-be usurpers.

Now the stalking party is on the hill. Inevitably, in order to ensure the health of the herd, to reduce disease and to try to improve the quality of the beasts, a proportion of the deer must be shot each year. The majority, by far, will be poor beasts or aged stags which are past their prime as breeding stock whilst later, in the winter, some hinds will have to be culled to preserve a balance. This is what conservation is about — preservation through control.

Deerstalking on the hill has a unique fascination. The trophy at the end of the stalk, if it is successful, will probably be an ugly, weak six-pointer or a dangerous single-pointed switch, but that is of little consequence for the day will have been filled with incident and excitement. An eagle drifting on the thermals, searching for carrion or a blue hare, a peregrine falcon tearing through the air like a feathered bolt or ptarmigan, grey and white-flecked, croaking as they run and to merge with the grey rocks of the high tops . . . all these adventures go to make up the whole. There will be memories of painful crawls and of aching, tearing muscles as the high places are conquered and finally that mouth-drying moment when you ease into the last few yards and the rifle is handed to you. Now it is all up to you; hopefully in half-an-hour you will be tramping behind the pony for the long, last walk off the hill.

For shooting men of an older generation September was the month for grey partridges, for walking the stubbles behind a brace of pointers or standing back from the high belts as the coveys swept over, scattering in a starshell as they spotted the line. Partridges can still be driven, but the red birds somehow lack the panache of the English partridge and, sadly, the fine old days of the partridge manor are now only a fading memory.

So much has changed in the countryside. Hedges have been torn out to make vast prairies, field ponds have been drained or polluted, woods destroyed and ugly, garish buildings, the factories of farming, have replaced the mellow bricks and timbers of our ancestors' homesteads.

Yet, despite the destruction of land much remains for which to be thankful. Hounds still meet and, on early, misty autumn mornings, before the world is abustle, cubs will still be chivvied and the young entry taught their business. It is a time of learning for hunter and quarry. Young horses, too, must learn manners and to stand quietly by the covert-side as hounds draw through the tangle of bramble and dying bracken, for in a very few weeks they will be embroiled in the serious business of life.

From the low ground to the high. There, living amidst the barren, bleak grey rocks above the tree-top line, are to be found ptarmigan. Perhaps the most handsome of the grouse when in their winter plumage of pure white: they have two other changes of plumage through the year, ranging from mottled dark grey in spring to light grey in summer and autumn. If you would hunt ptarmigan then you must be fit and prepared to climb into the remote and dangerous mountains where a sudden white-out of snow can clamp down in seconds or swirling clouds destroy all sense of location.

Ptarmigan are extraordinarily adept at merging into their grey world of stone and scree. A pace or two forward, gun at the ready and not a sign of a bird and then the rocks in front seem to explode into grey fragments with flickering white wings as the birds curl away and down the side of the mountain. If you can come off the tops with a brace or two you will have done well and you will also know the meaning of real hunting.

The days now are cold, frosts have scattered the last leaves and there is a sudden iron in the ground. The stalwart, ever-optimistic salmon fisherman will brave the icy river for a last trial of endurance with the late run fish and he will know, as the grey geese cross the sky in vast skeins, that winter is upon him.

Duck, too, will be flighting into meres and pools; the first migrants from abroad, teal, wigeon and pintail, ever seeking softer, easier living, will be supplementing the stocks of home-reared wild duck. Is there any sport to compare with a brisk ten minutes at last light as teal and wigeon, mallard and pintail, tear and swish throught the sky, black blurs against the silver-grey clouds, weaving and sliding, paddles down as they drop into the reeds or amongst the decoys?

The cover that chocked ditch and bank has died back, rabbits are in the meadows and the ferrets come into their own on bright, cold mornings when you *know* they're going to bolt. What better entry into fieldsports for a youngster than the lesson learnt hard at the heels of an experienced ferreter? Patience and fieldcraft will be learned and he will understand that there is far more to sport than the simple ability to handle a gun. Above all he will learn to enjoy the pleasing companionship of an animal working for his benefit.

Like the ferreter, the terrierman too has to rely on the senses and ability of an animal to assist him in his work. Frequently engaged to assist the local hunt or, where there is no hunting, to help keep foxes in check wherever damage has been reported, the terrierman lives in his own busy, colourful world of Jack Russells, Borders, Lakelands and Patterdales. Each type has its own merits and long and earnest are the discussions and arguments as the protagonists stoutly defend and promote their choice through the shows in the summer. But now the terriers are expected to earn their keep and it is many months before the spade will be set aside. Autumn has ended and winter is upon us.

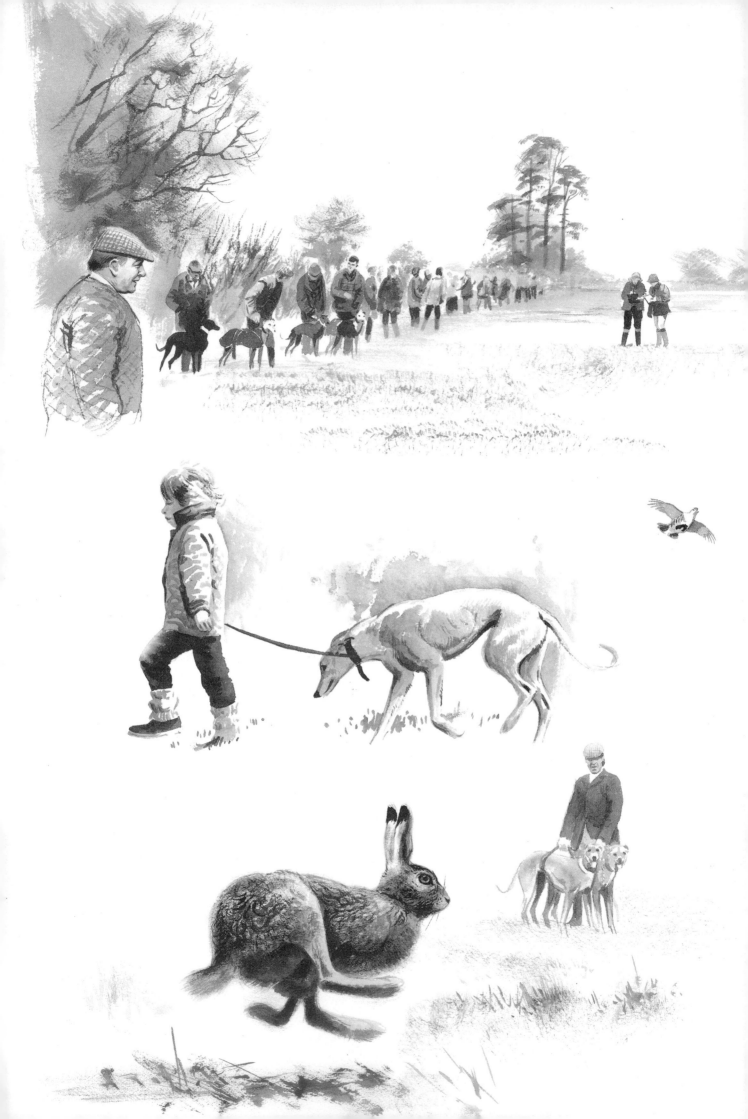

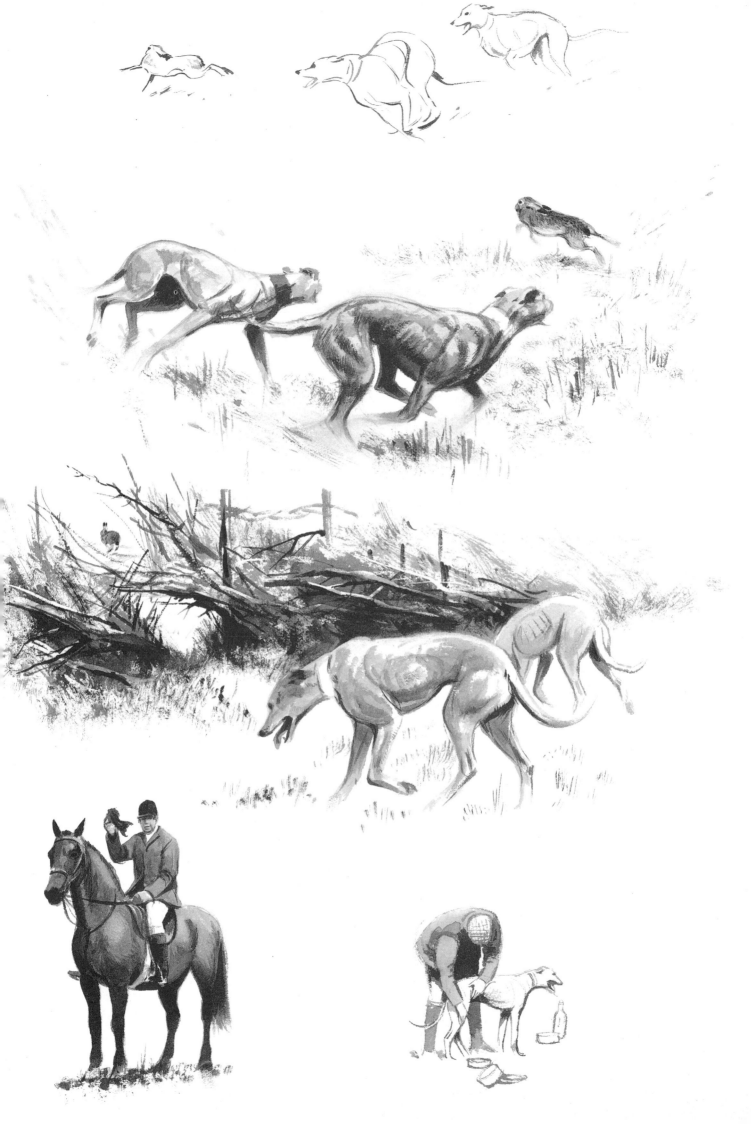

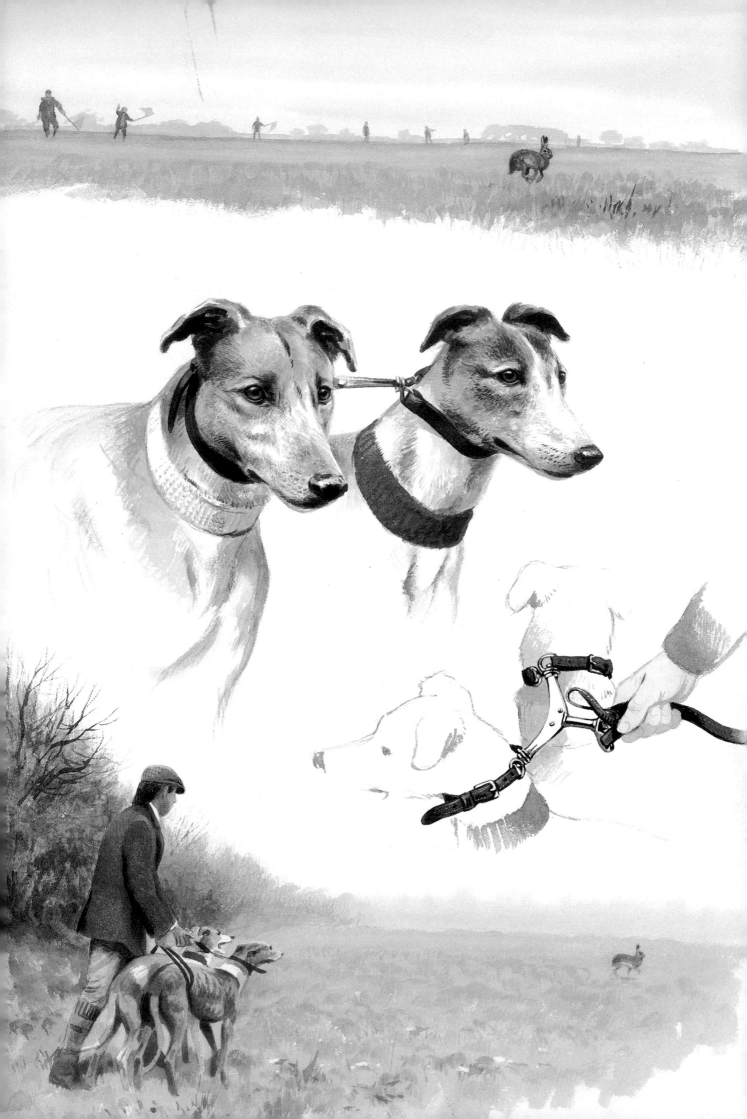

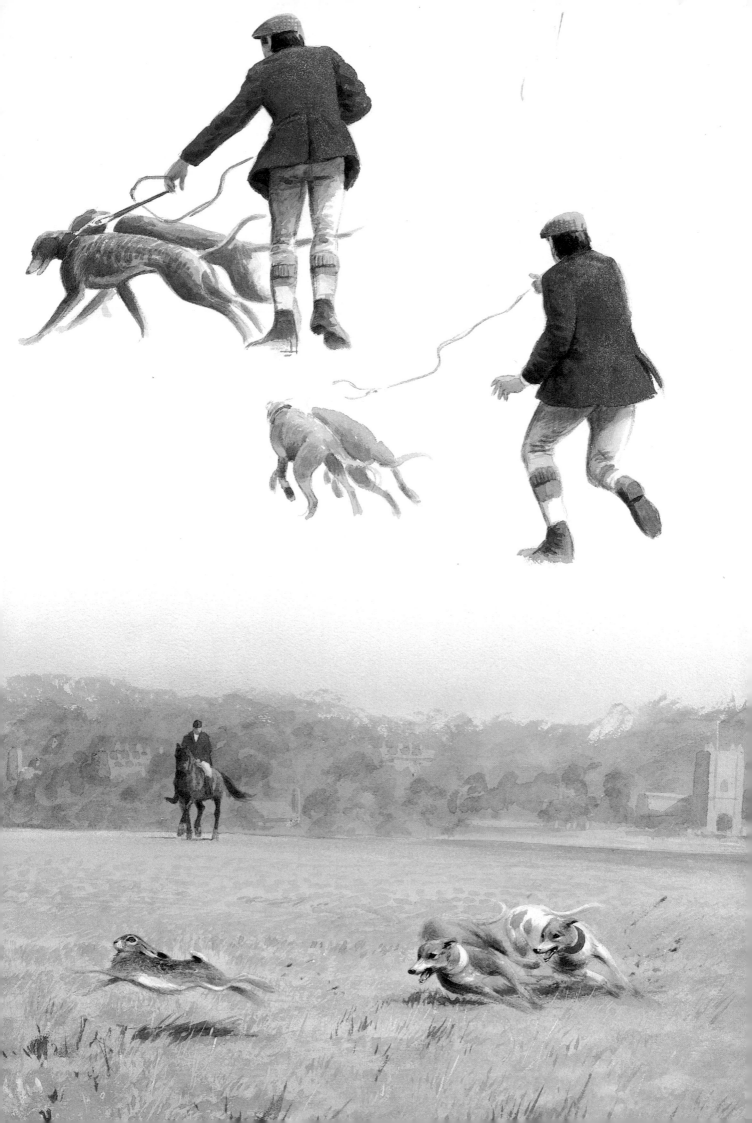

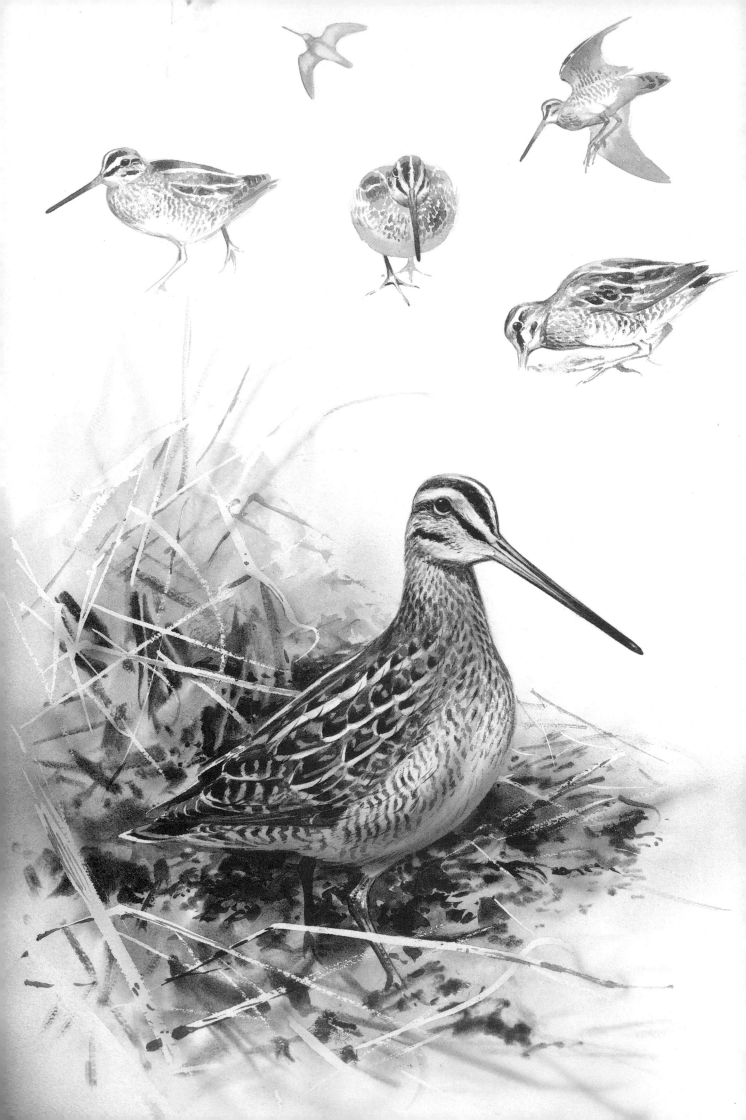

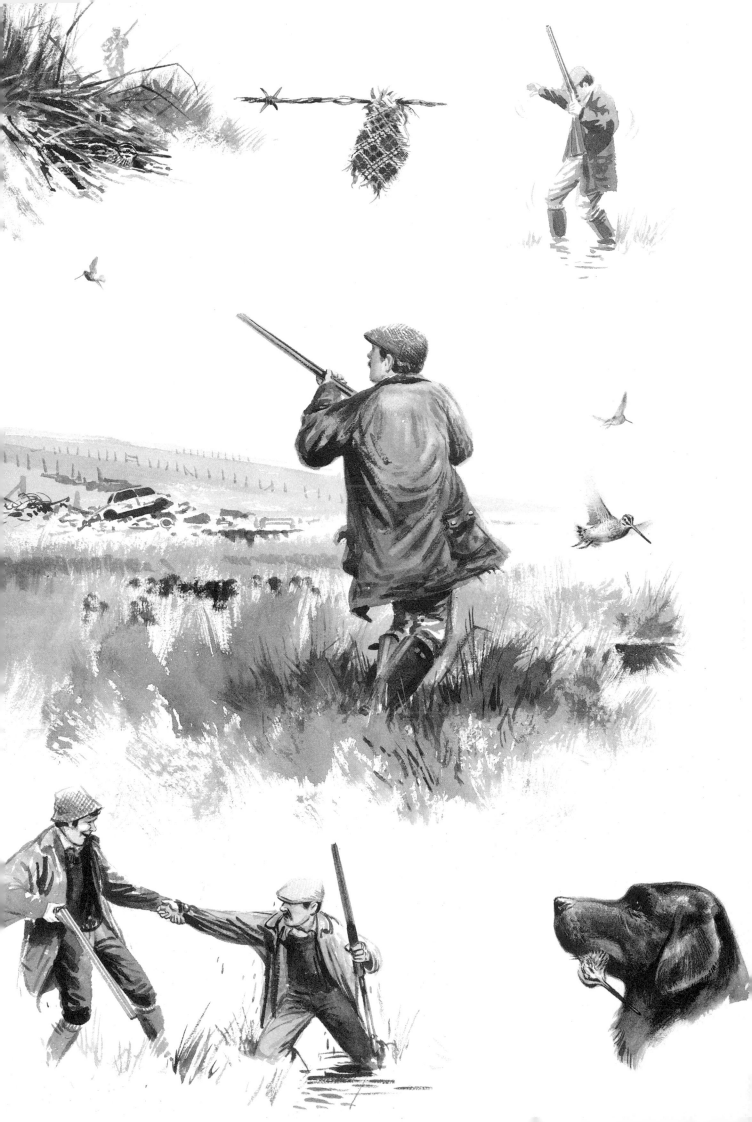

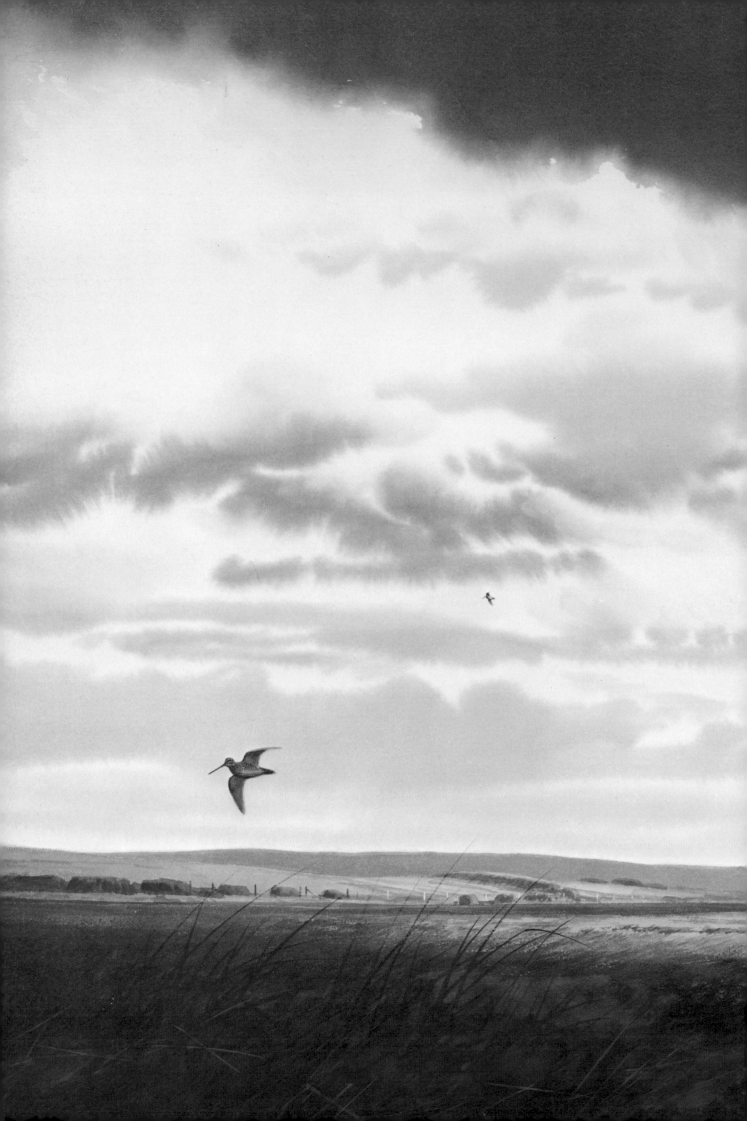

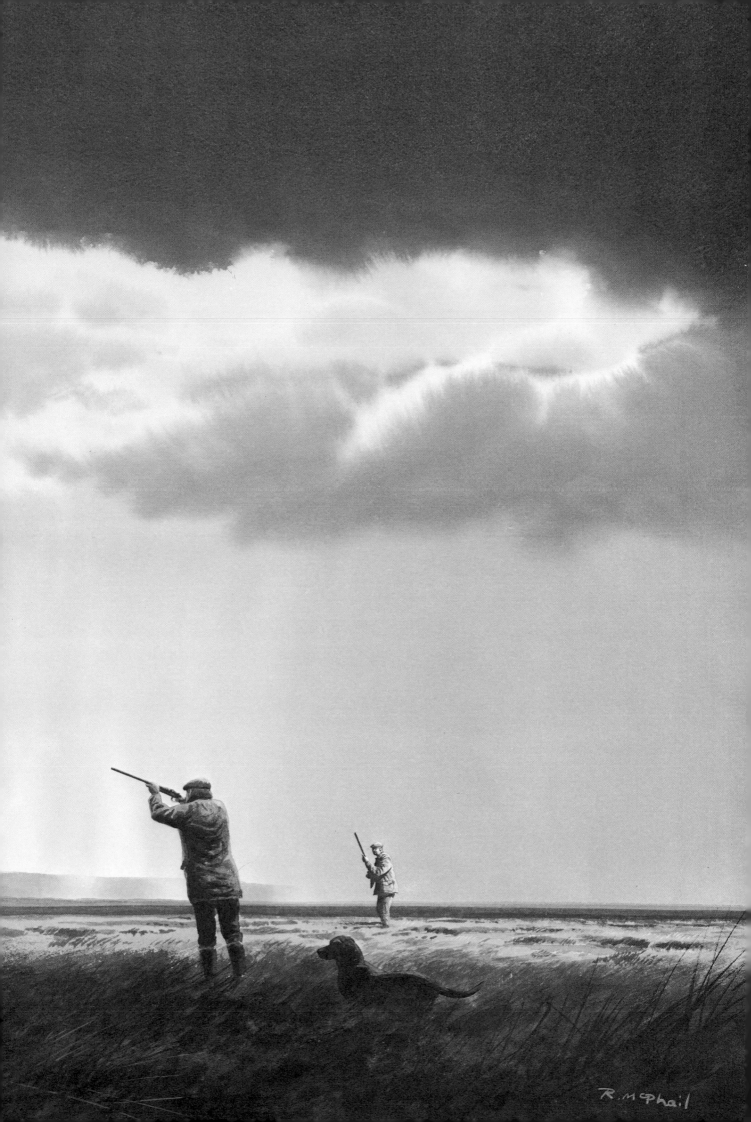

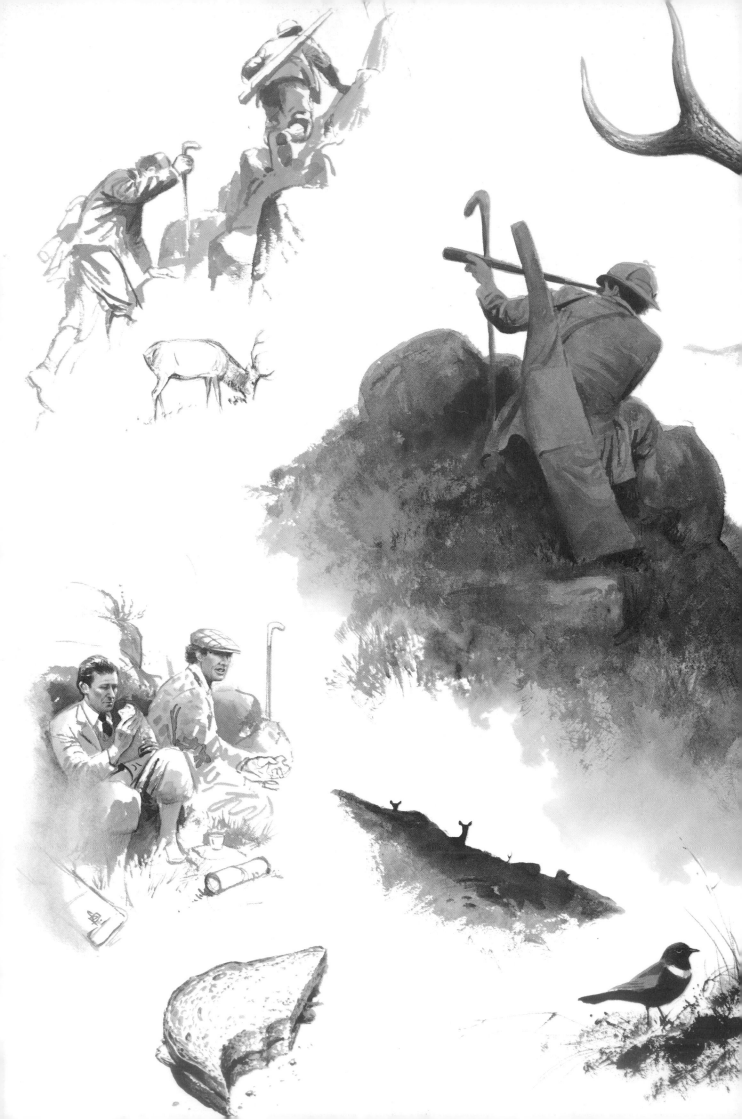

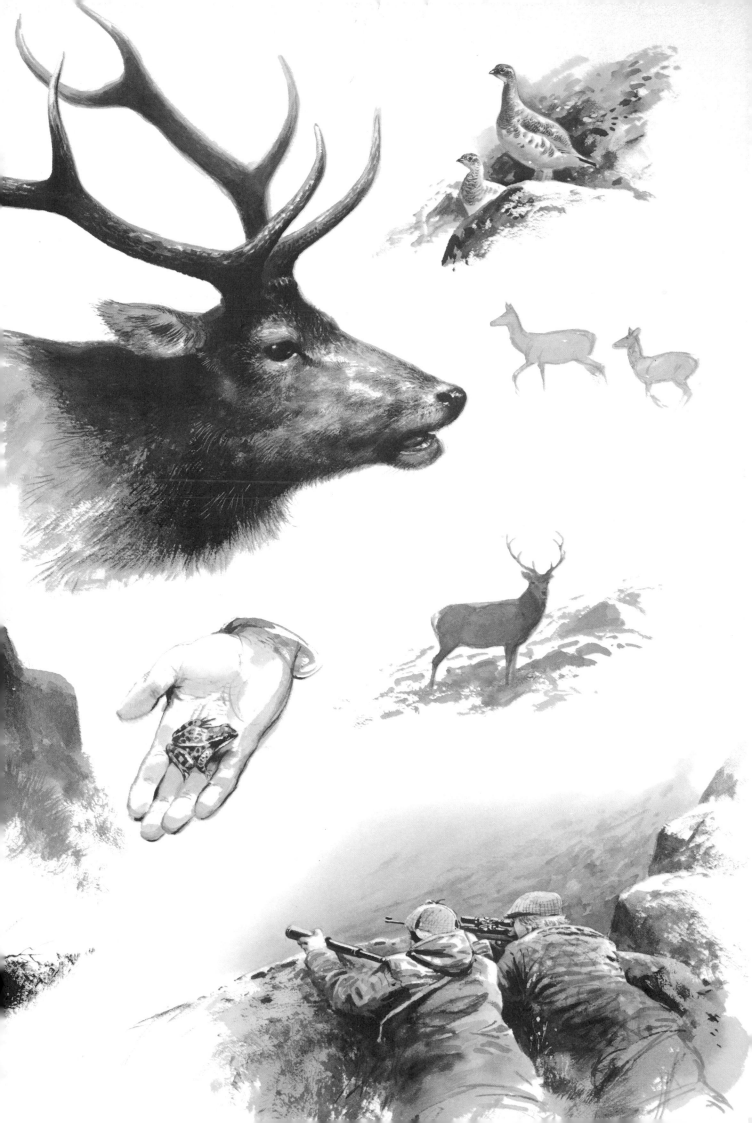

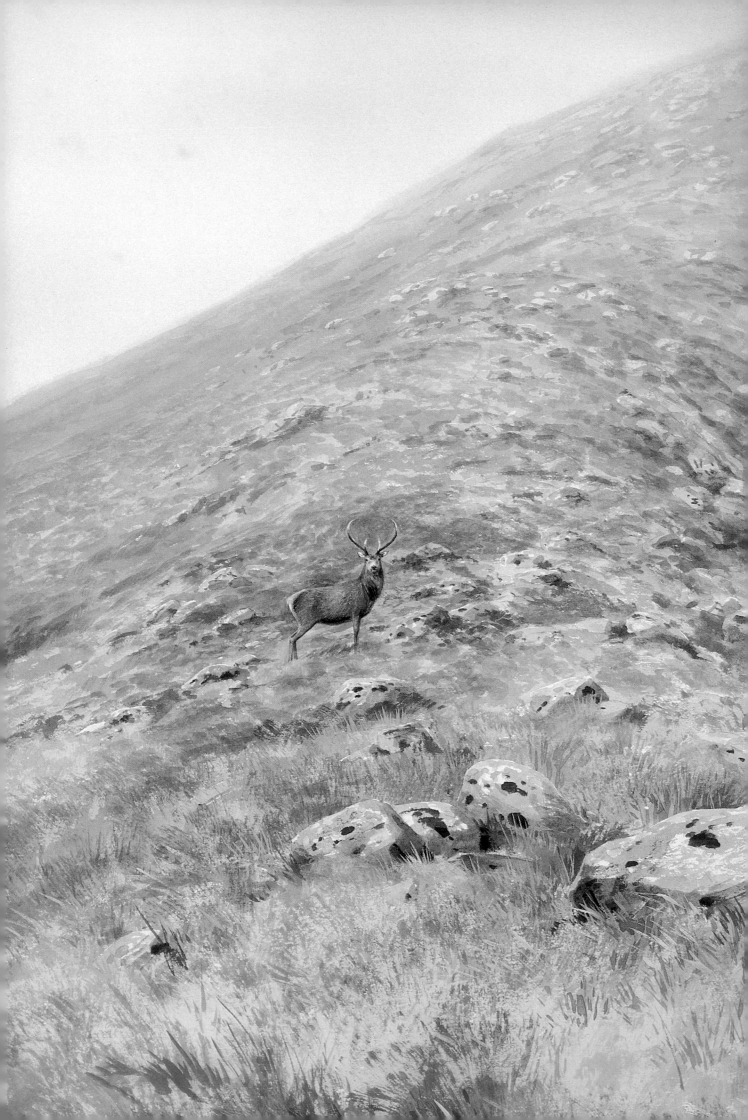

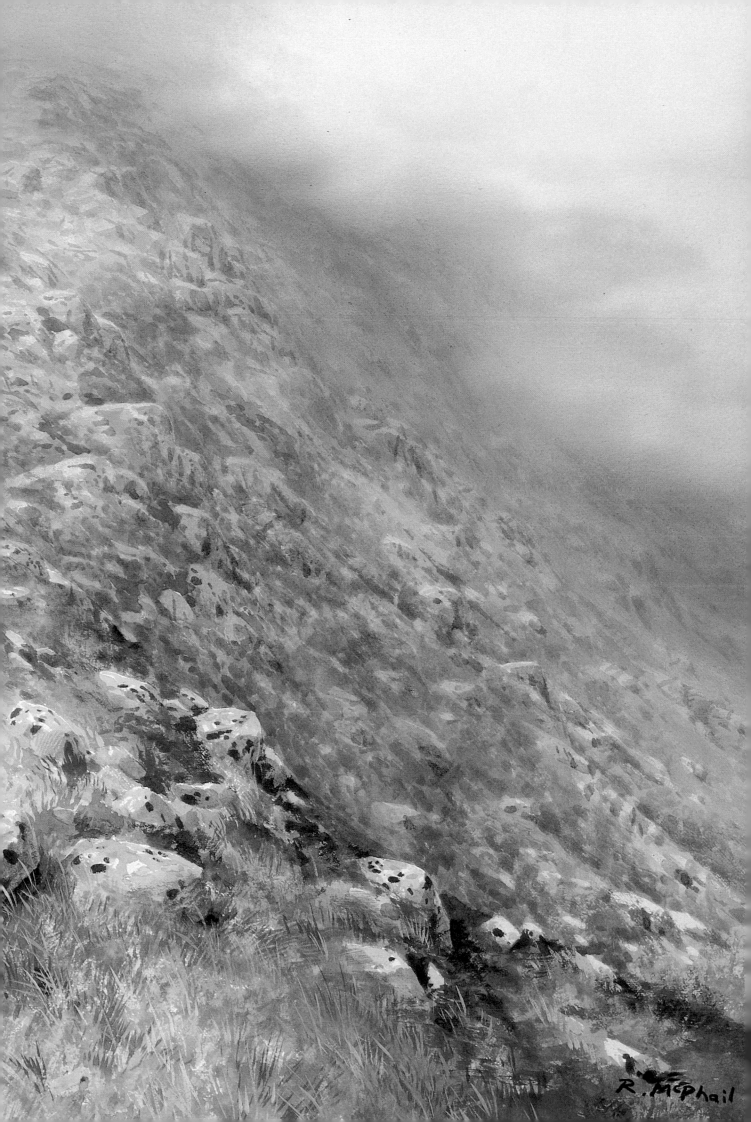

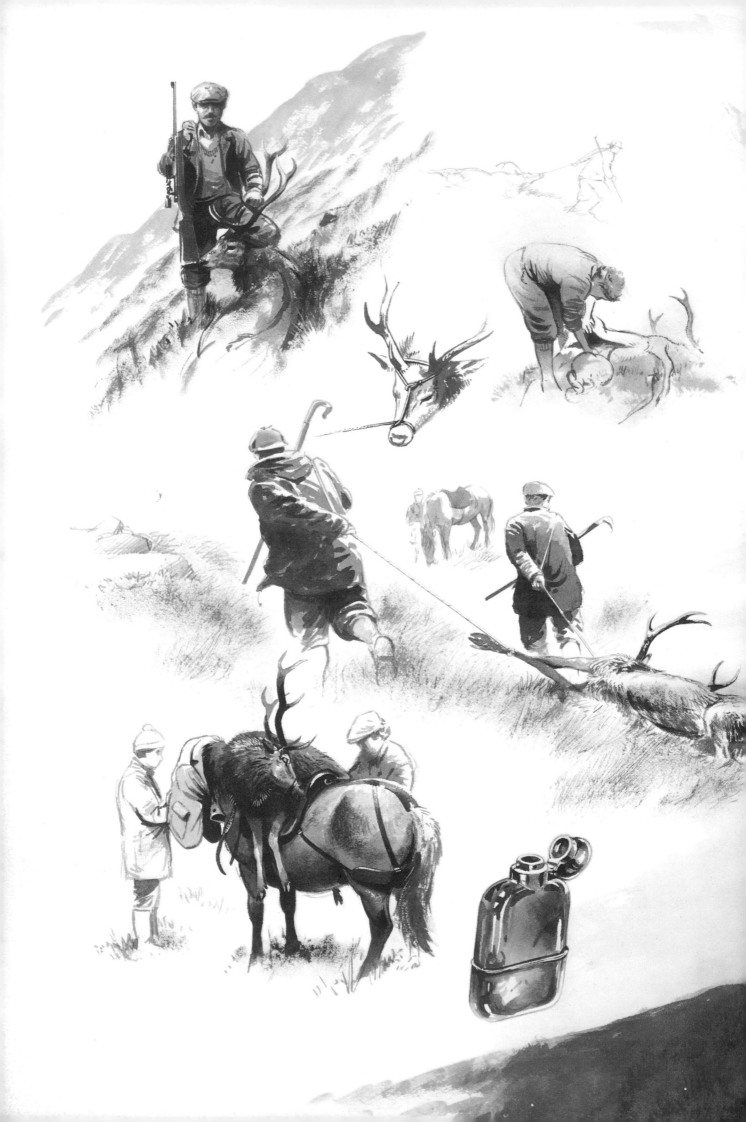

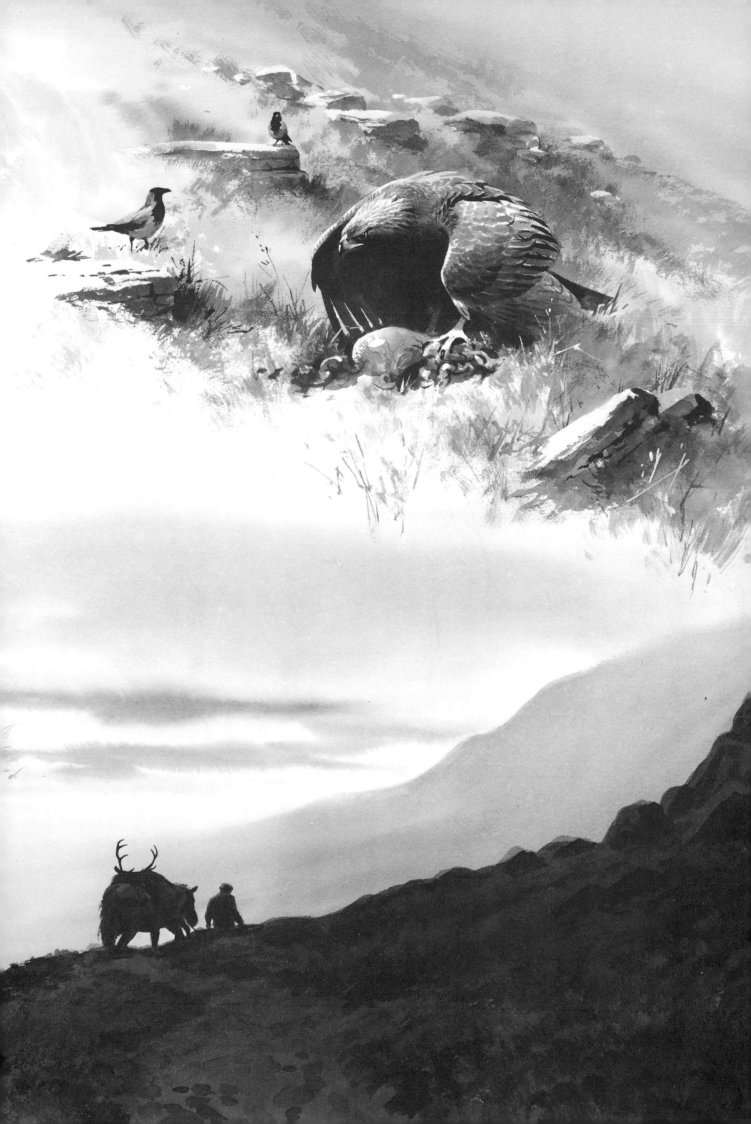

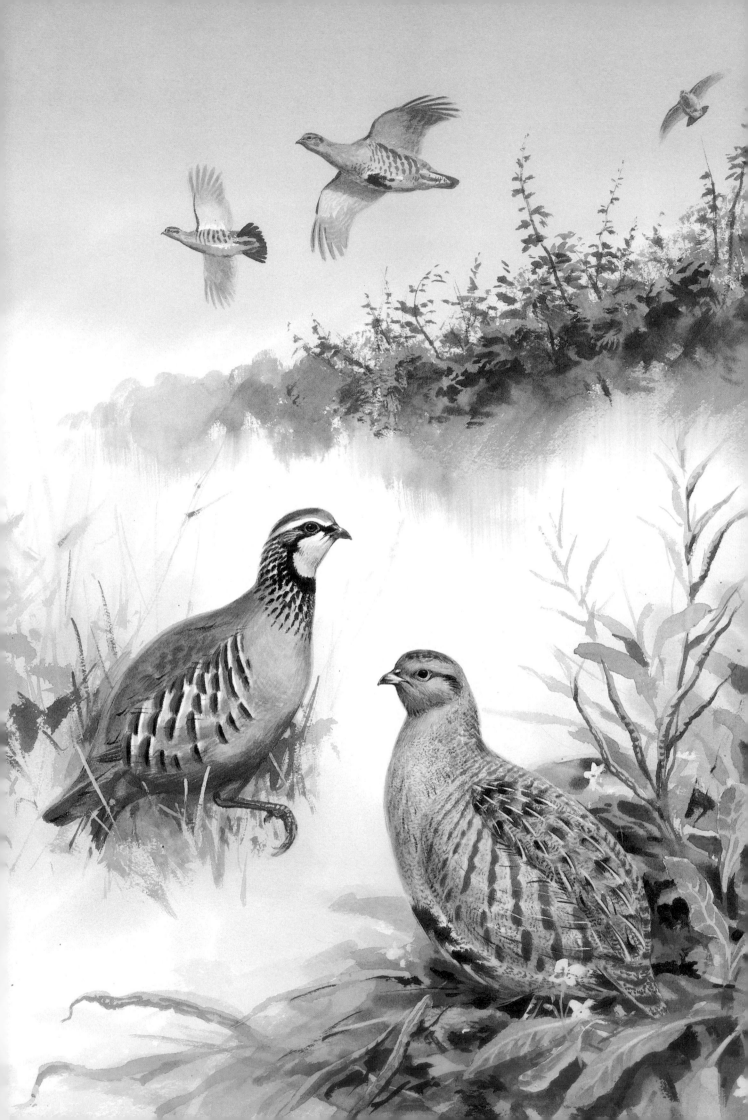

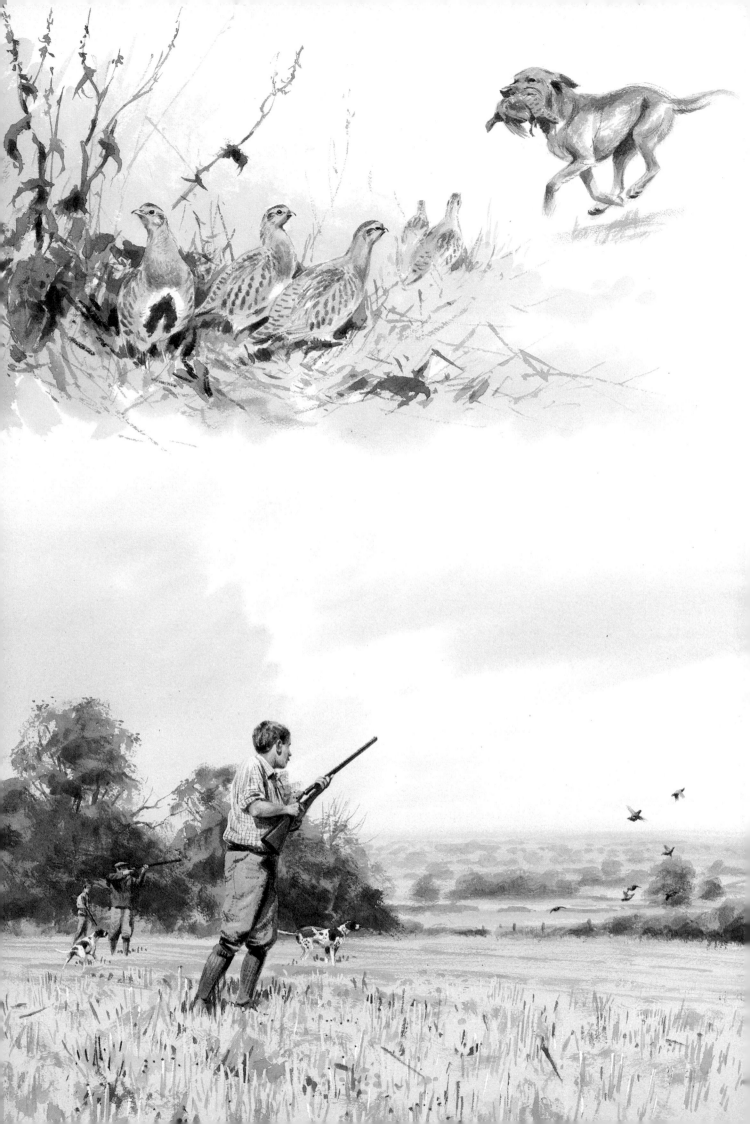

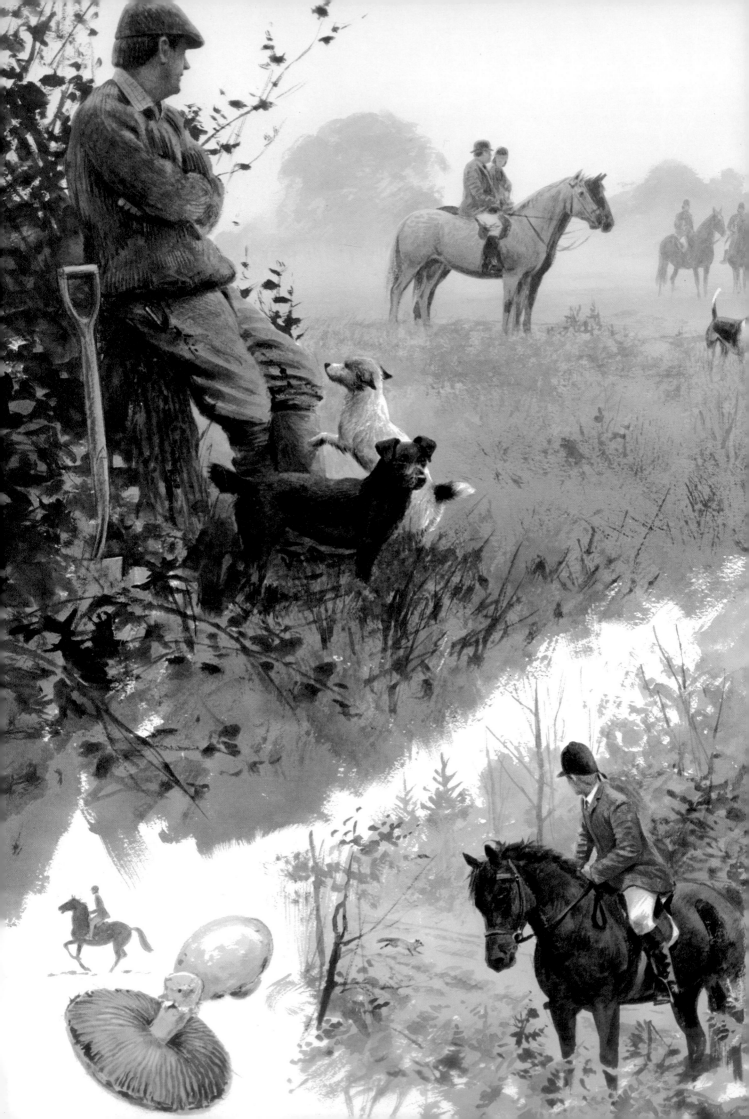

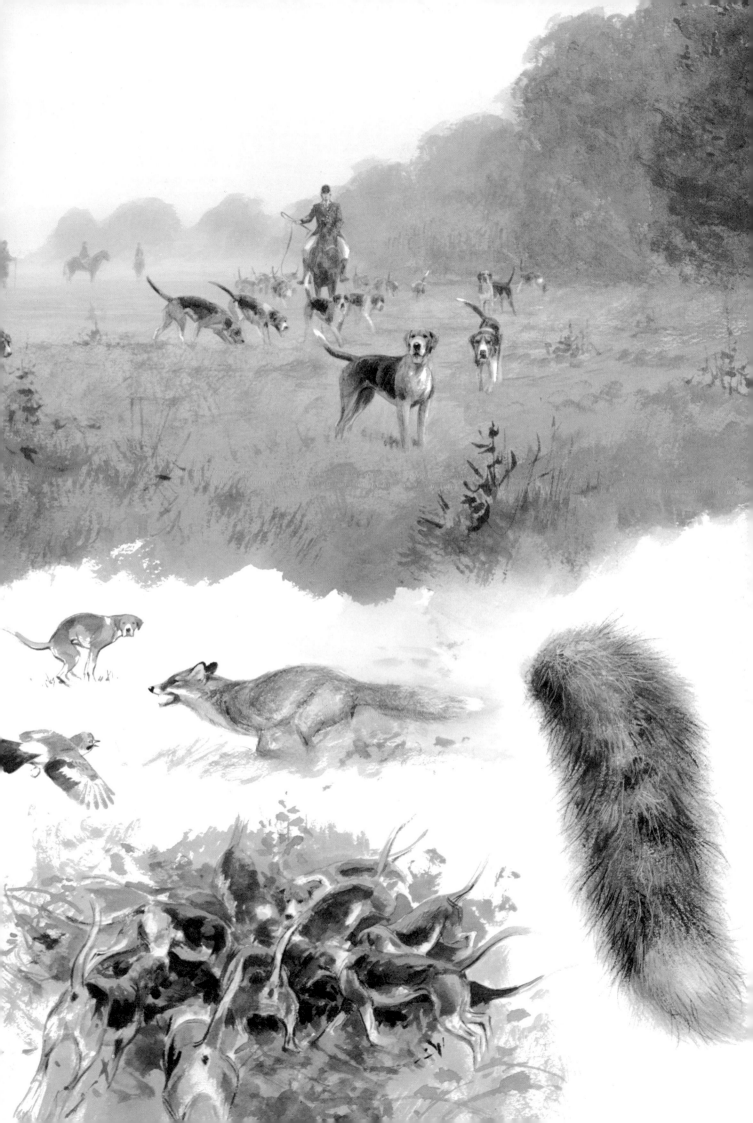

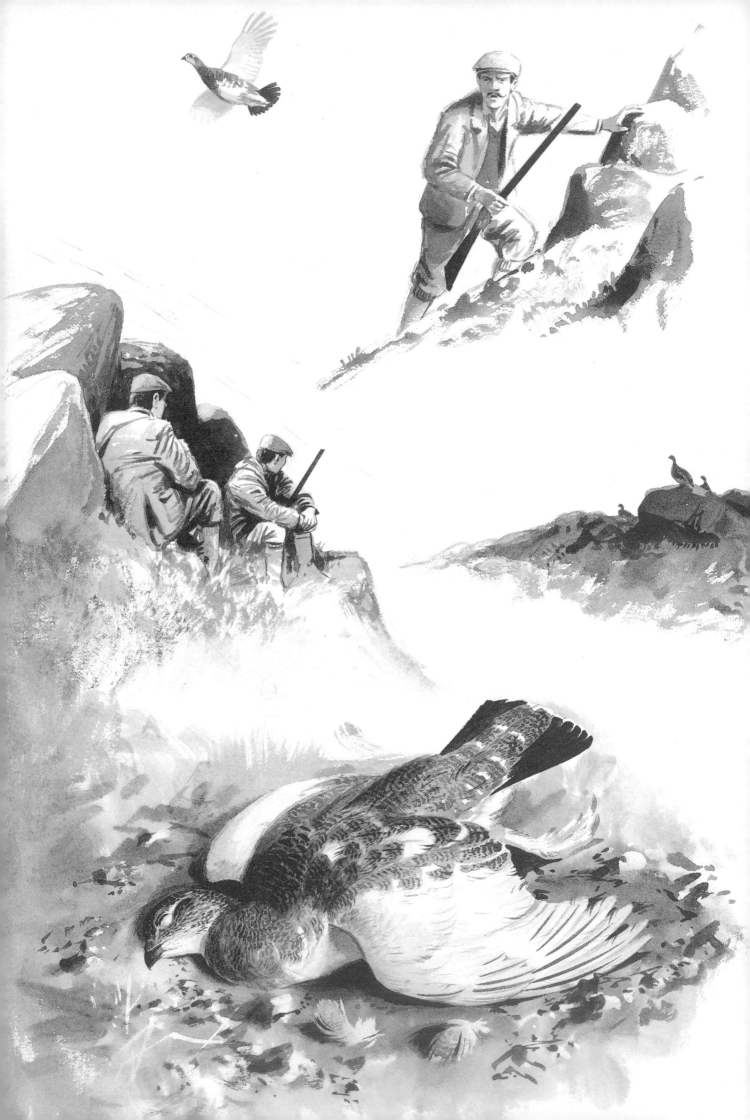

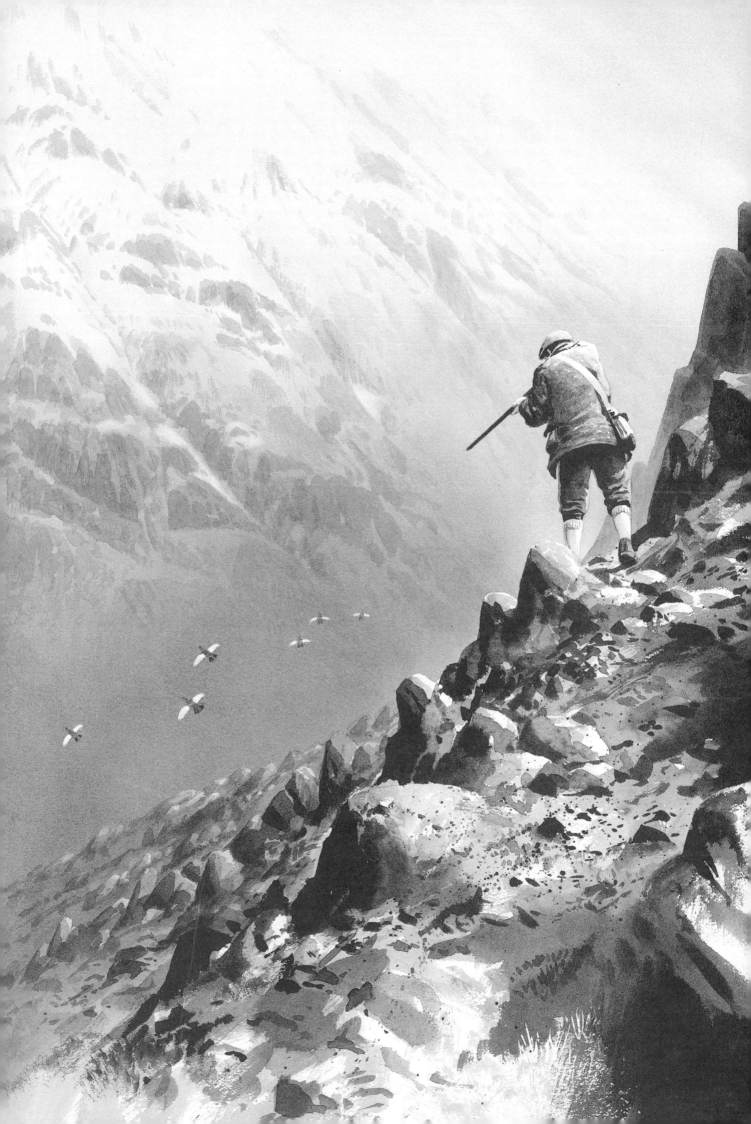

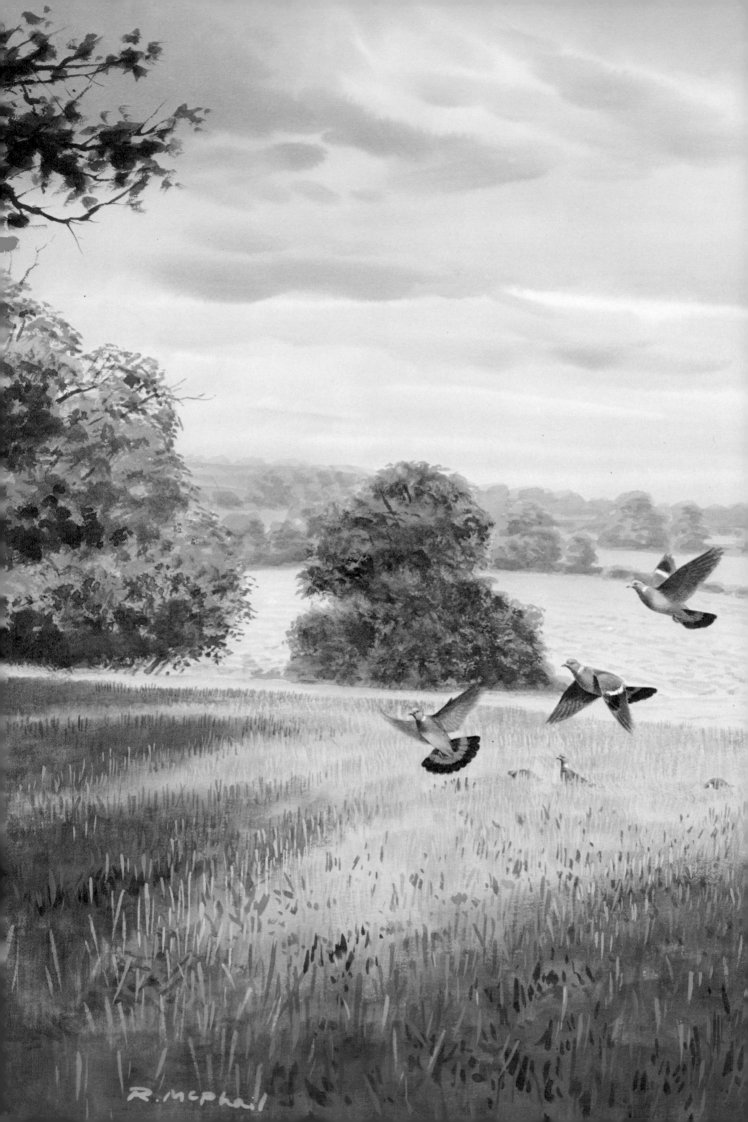

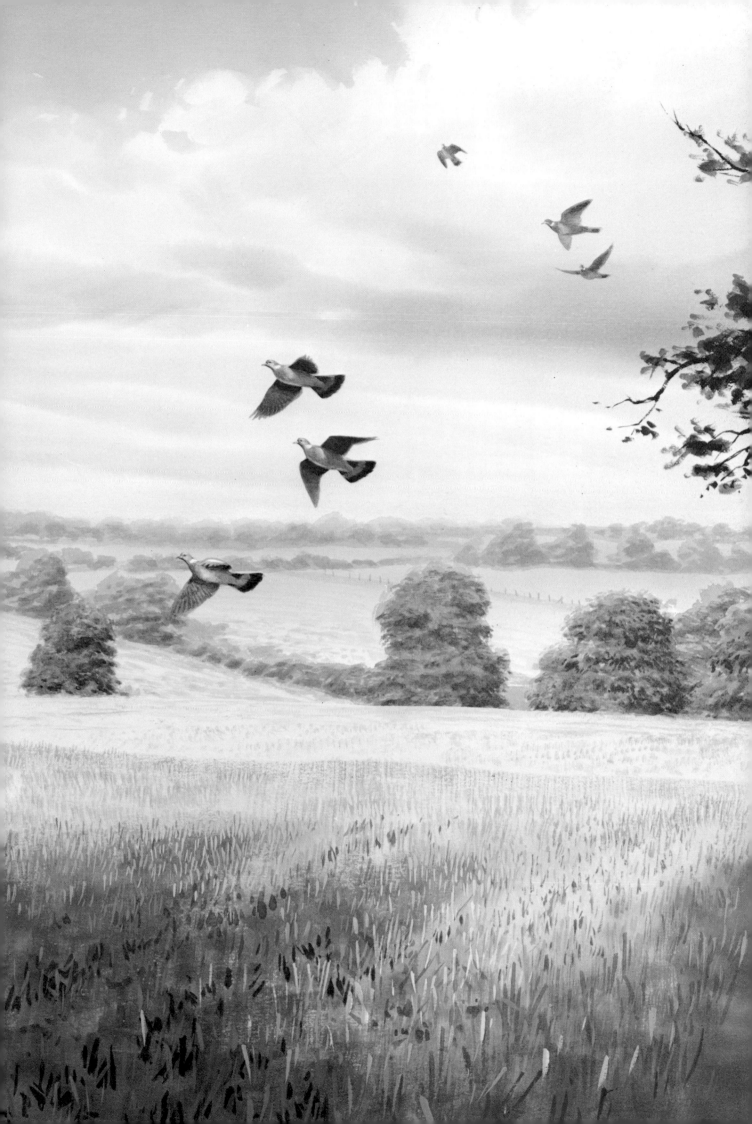

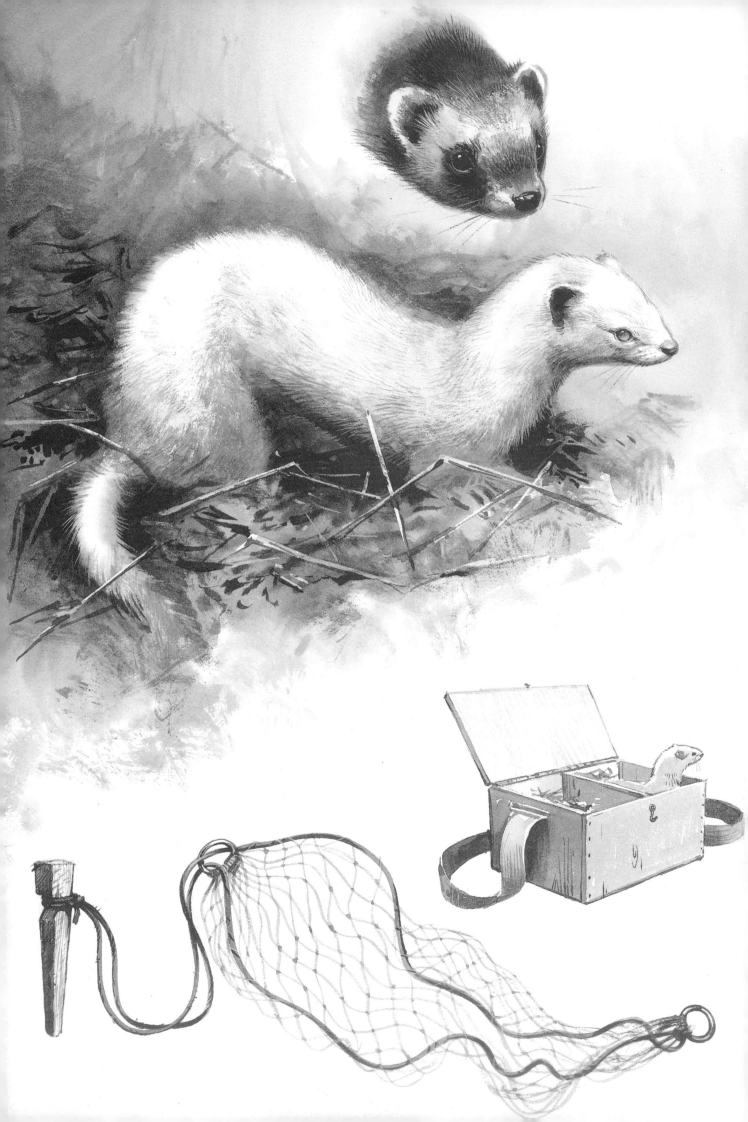

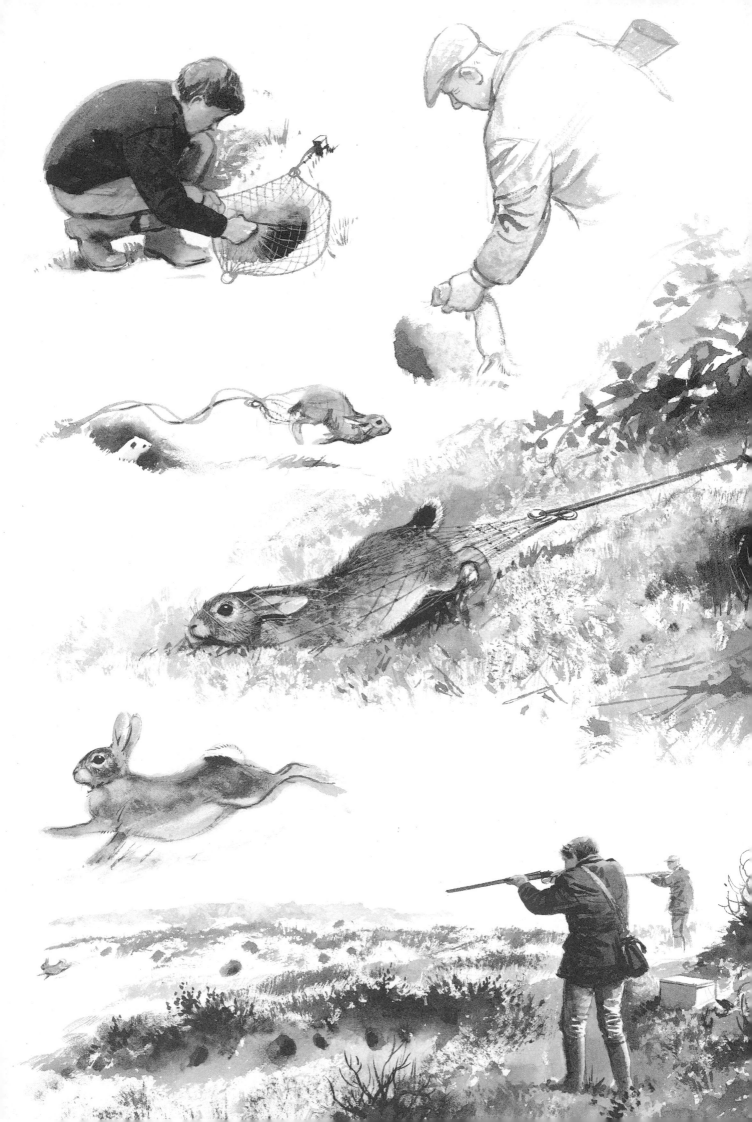

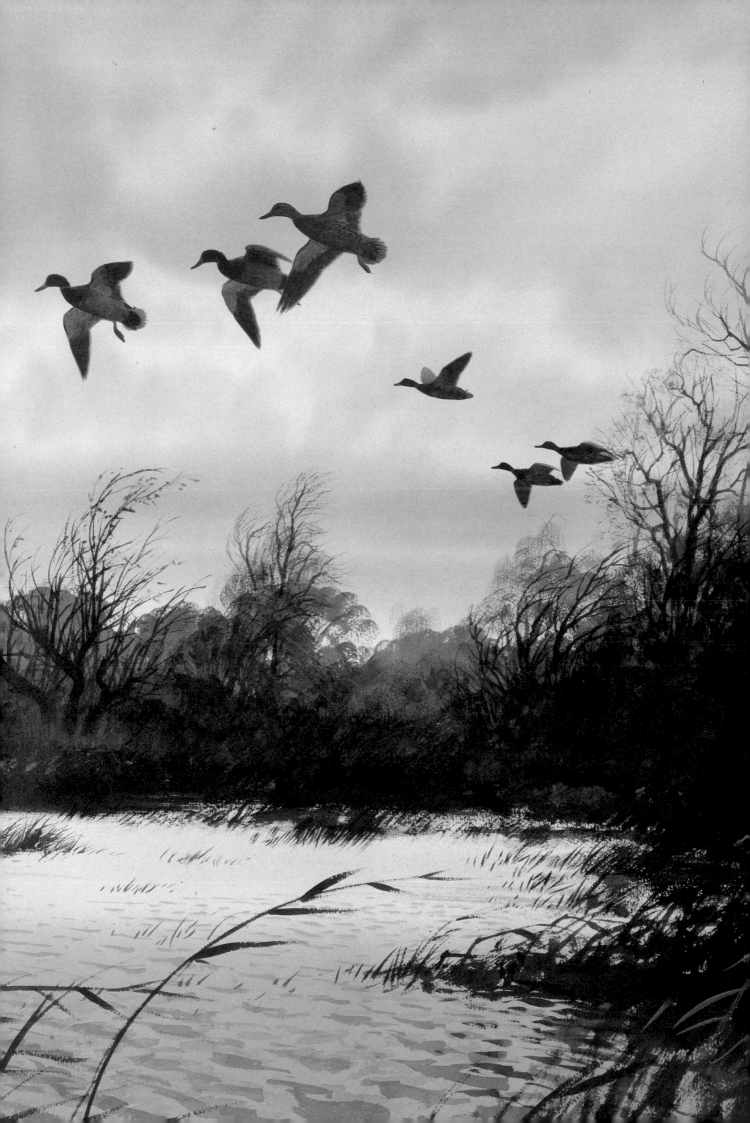

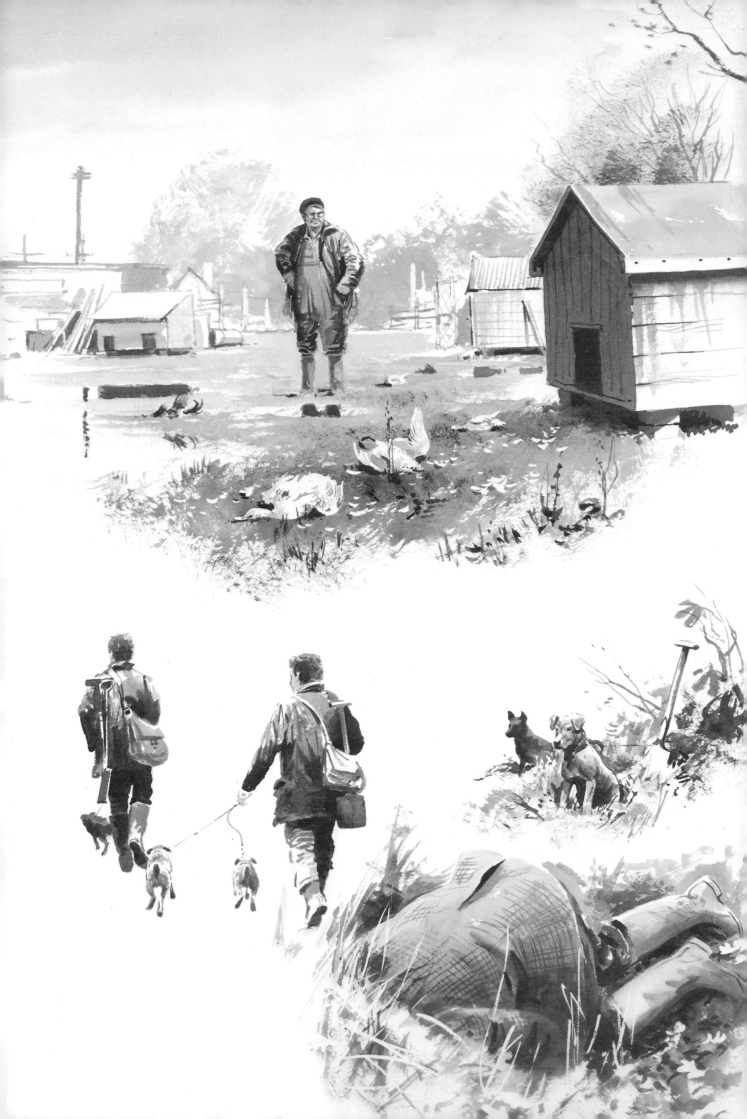

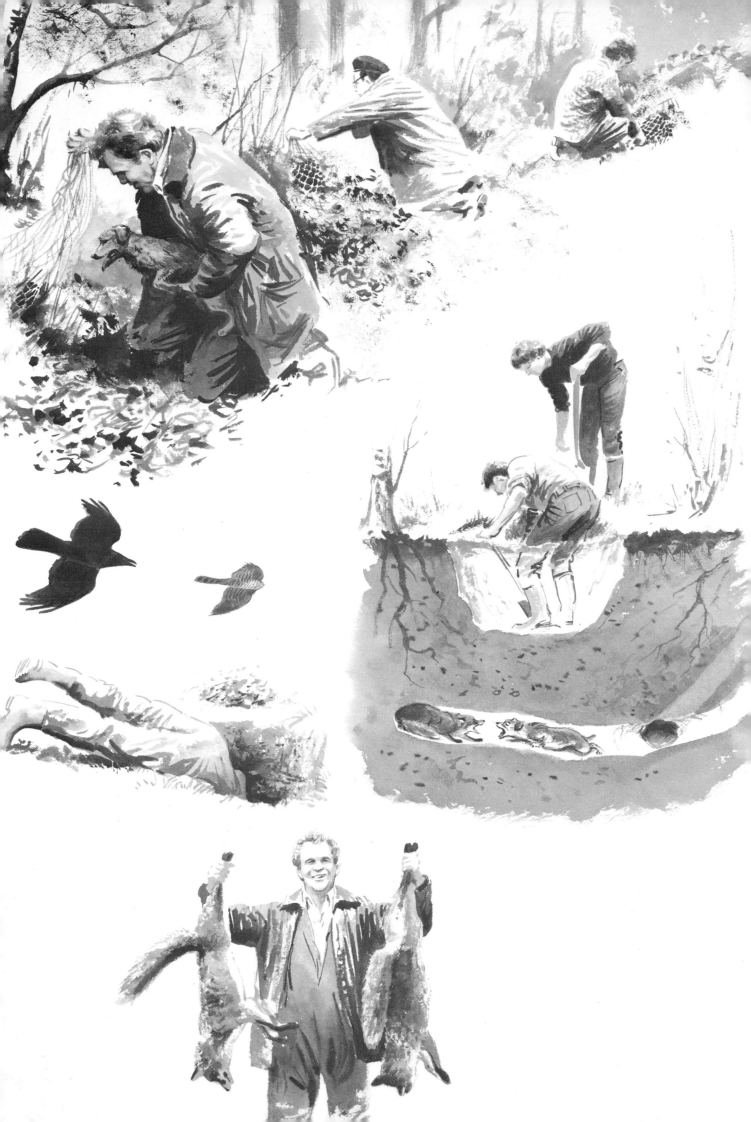

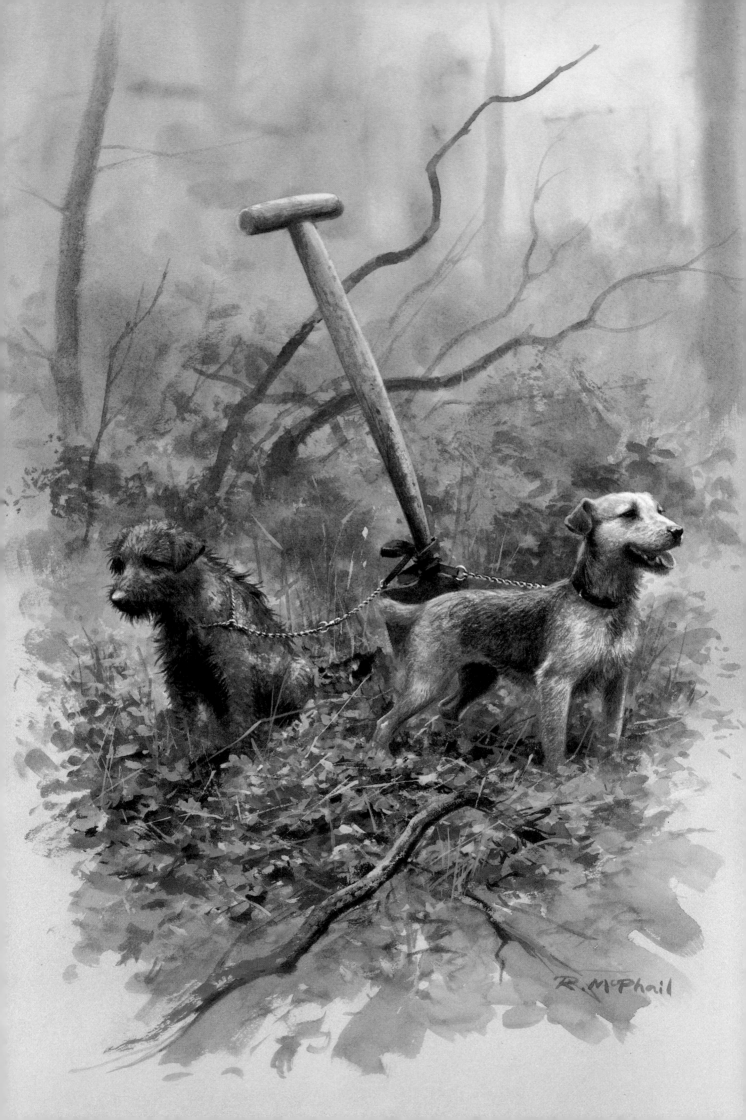

WINTER

The first week in November is the traditional time for Opening Meets, though many hunts now bring the date forward into October. But whatever the month it is still the most dramatic of all our fieldsports, a spectacle which has caught the imagination of artists, writers and poets for three hundred years.

The red and black coats, the glossy, well turned out horses, the dappled hounds create a breathtaking pageant against the muted greens and browns of the winter landscape.

It is a sport crammed with drama, excitement and with an element of danger. The sight of a well mounted field, perhaps in the Shires, taking the fences as they come, is one never to be forgotten. It is a sport which is thriving as never before, as can be witnessed by the vast crowds who come to view the hunt, in all its traditional glory, on a Boxing Day meet.

It would be difficult to find a fieldsport more removed from hunting than the pursuit of duck and geese on the foreshore; the one a sociable, gregarious activity, the other solitary and withdrawn. The appeal of fowling is inescapable, an unrelenting magnet which draws man to desolate marshes and muddy wastes, to huge skies and pastel dawns, to cold, wet and, always, the irresistible lure of the bird life. It matters not that the bag may be a solitary mud-spattered teal or wigeon, sole reward for hours of arduous effort that began long before dawn, the wildfowler will have seen the start of the day in a place known only to a few.

Always there will be the lure of the duck and the geese. Packs of wigeon will flight the tidelines, the cocks whistling, the hens purring, as they twist and turn, now brown, now white, in the great vault of the sky. There will be teal like feathered darts ripping over one's shoulder at dusk, here and gone before one can raise the barrels. Always there are mallard, fat and idle on inland waters but streamlined and alert below the high watermark.

Field trials reach their peak in the winter. The first trials will have taken place in August and September over the grouse but once the pheasant season really gets under way, the retriever and spaniel societies are busily engaged running trials for all grades of dogs and handlers. It is a time-consuming and totally absorbing pastime, with the laudable aim of improving the standards of work and type amongst all gundogs, to assist shooting men and ensure that wounded quarry is collected. Trialing is, for many owners and handlers, a way of life; their world is closely knit and may appear sectarian to the novice, but in fact field trial folk are almost invariable friendly and willing to help the beginner with advice and practical assistance.

The long winter evenings can bring some consolation to the fly fisherman who enjoys creating his own flies; with vice, coloured threads, hooks and packets of feathers, some gaudy, others subtle, he can tie flies to his heart's content, all the while dreaming of the spring and summer days by cool waters. Some of his feathers and furs may have been obtained from kind shooting friends willing to donate flank feathers from partridge, teal or mallard, squirrels' tails or hares' ears, others will be dyed red, blue or yellow, the brighter, more gaudy colours for the salmon.

Birds are a common link, a thread that runs through both angling and shooting, for few who

follow these sports can be unaware of the bird life that surrounds them and lends such variety and charm to the countryside. Bird-watching can become totally addictive and in its most extreme form is seen in the "twitchers", the bird-watching fanatics, who may descend on a patch of hitherto peaceful countryside as the news of some rare vagrant from abroad filters round their network. Most bird-watchers, however, take a more tranquil approach, some content to note the birds of their garden or local lakes or reservoirs, with an occasional trip to one of the RSPB reserves or perhaps the Wildfowl Trust at Slimbridge where the rare and exotic mingle with the wild and unusual.

Not all bird watchers would be prepared to acknowledge the vital role played in the countryside by shooting, yet it is a fact that were shooting to be banned many of the game coverts which provide such sanctuary for a variety of wild birds would be destroyed in the interests of agriculture. It is a delicate balance which can all too easily be disturbed.

The placid joys of bird-watching are in stark contrast to the rugged excitement of fell hunting. A sport, yes, but also a vital service to the hill farmers of the Lake District. Sheep are their livelihood and the depredations caused by hill foxes in the lambing season cause serious inroads to stock and income. Hunts are on call 'till lambing is over and the danger past, always ready to turn out when news of a lamb-killer is received. The names send a tingle down the spine of any ardent fell hunter — Melbreak, founded in 1807, Eskdale and Ennerdale, the Lunesdale, the Coniston, the Ullswater and, perhaps, the most famous, the Blencathra, John Peel's hunt, many of whose hounds are said to trace their pedigree back to his hounds.

Fell hunting requires only stamina, a stout pair of boots, good binoculars and a determination to try and keep up. The attractions of seeing a fox and watching hounds work amidst magnificent, breathtaking scenery, draws keen hunting folk to the Fells each season. It is a unique way of life which ensures both sport and a benefit to the hill farmer whose lambs are always at risk in the spring.

The pheasant plays a vital role in game shooting in Britain; adaptable to all but mountainous conditions and accepting even the most harsh, wet and windy climate — pheasants are reared and thrive on the Isle of Lewis! — it is the ideal sporting game bird and an adornment to the country scene.

Driven pheasants can provide difficult to relatively simple shooting, but it is generally agreed that the high, curling pheasant with the wind in its tail will test the best of guns.

The great joy of pheasant shooting is the sense of comradeship and camaraderie, epitomised by the good relationship between guns, keeper, pickers-up and beaters, all of whom are working in a common cause. To be involved with an efficient and well organised shoot is a great privilege.

There can be few shoots where the cry of "woodcock forward" does not send a ripple of excitement down the line of guns. A difficult bird in cover as it weaves through the stems, in the open the 'cock is a comparatively simple shot. Mysterious in its arrivals and departures, glorious in its blend of soft autumn browns, the woodcock has a blend of special magic and is much sought after.

At the end of the day the kitchen must figure prominently in our sport. Little should be wasted, for the birds we shoot, the fish we catch and the deer we stalk are the finest of foods. The justification for our sport lies on the table and nothing, from the humble woodpigeon to the red deer, should be squandered.

That fish of the winter streams and rivers, the grayling, with its delicate scent of thyme, is not to be scorned on the table; keen grayling fishermen declaring it to be the equal of, or better than, trout; even pike, another fish of the cold, bitter meres and lakes, when cooked in the French fashion, with a tasty sauce, is worth a freezer-full of plastic-wrapped, tasteless white fish.

Pigeon, too, are excellent fare and now, in late winter, when the covert shoots are finished, is the time for roost shooting and sport of a very high order.

Winter can be cruel. For the red deer in the Scottish Highlands it is a period of extreme conditions, the harsh frosts and heavy snows weeding out those poor and aged beasts which have not been mercifully culled. Some estates will see to it, where possible, that some winter feed is provided to help the herd through the bleak months. For predators, though, the fox, eagle and raven, winter brings its own harvest and there will be little left of the carrion when the snows have eventually melted.

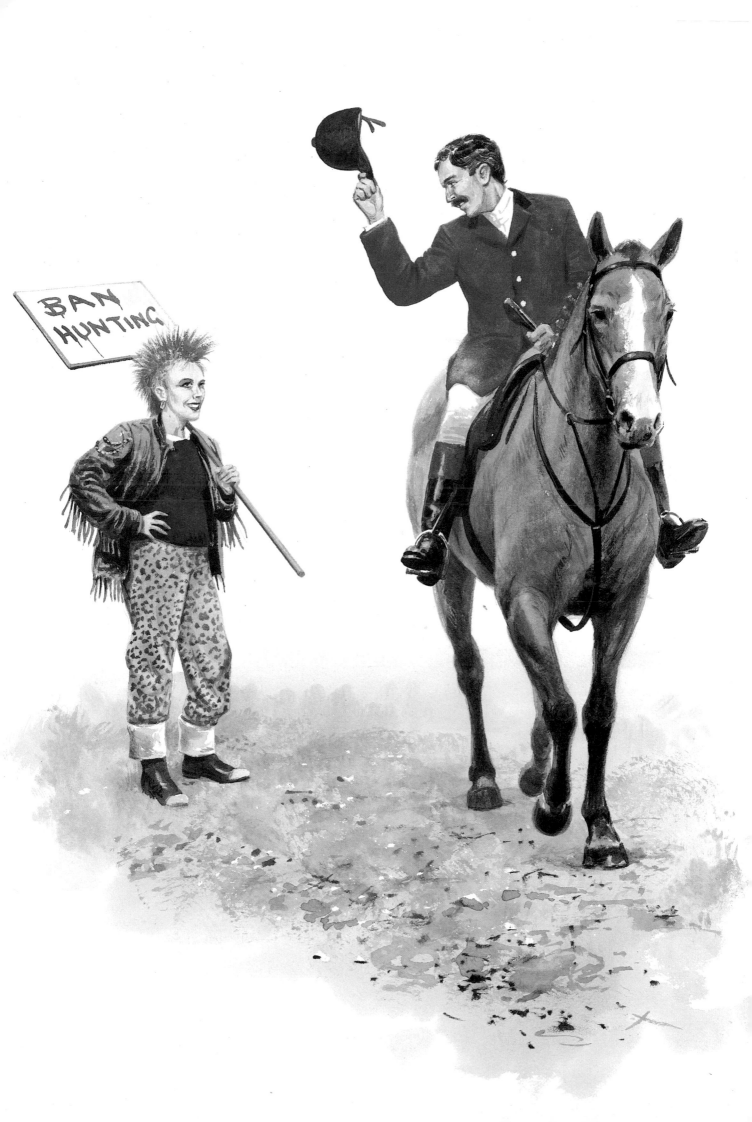

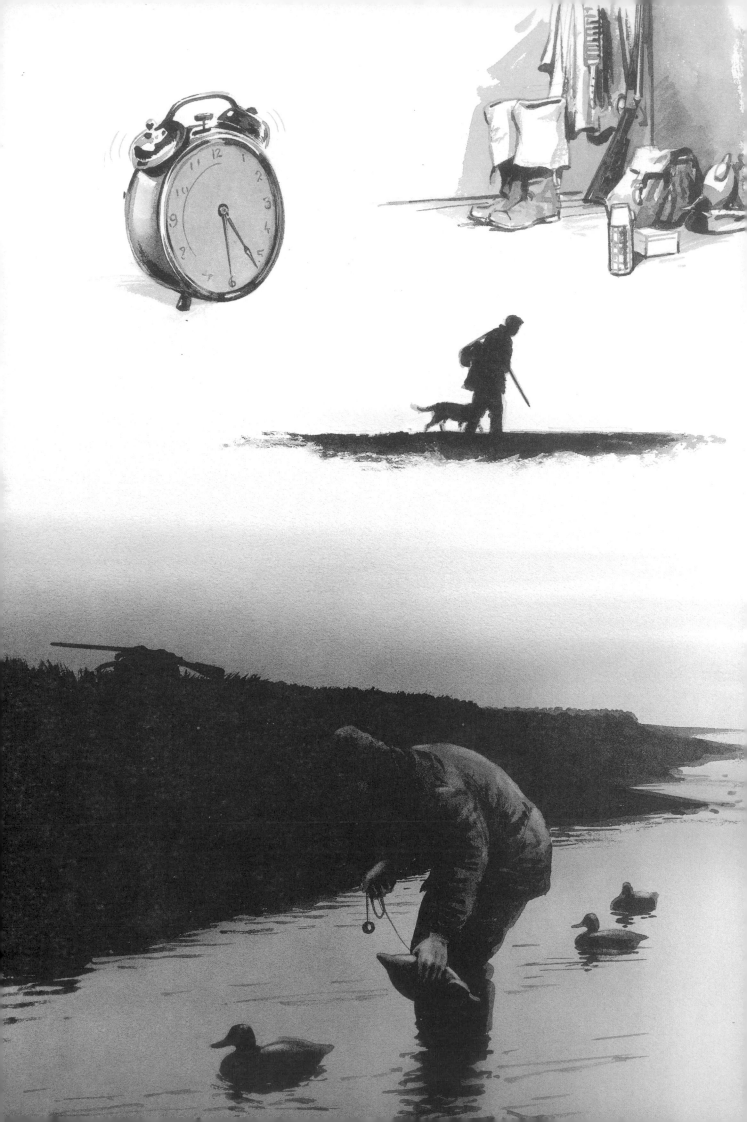

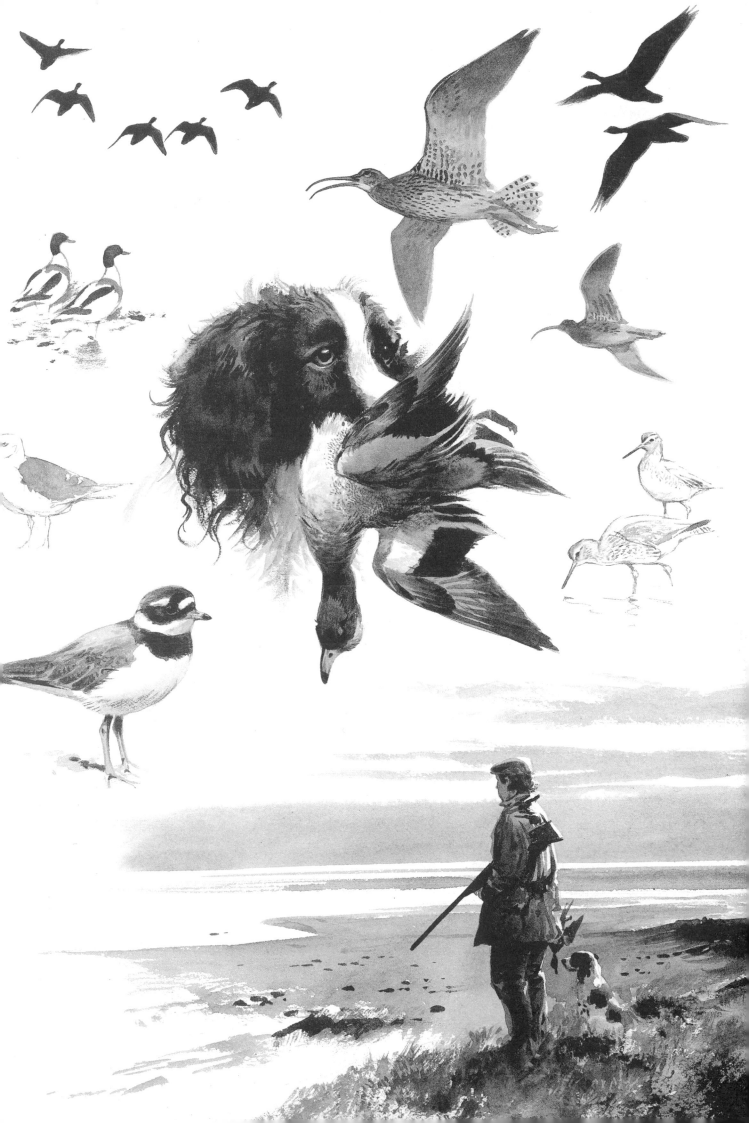

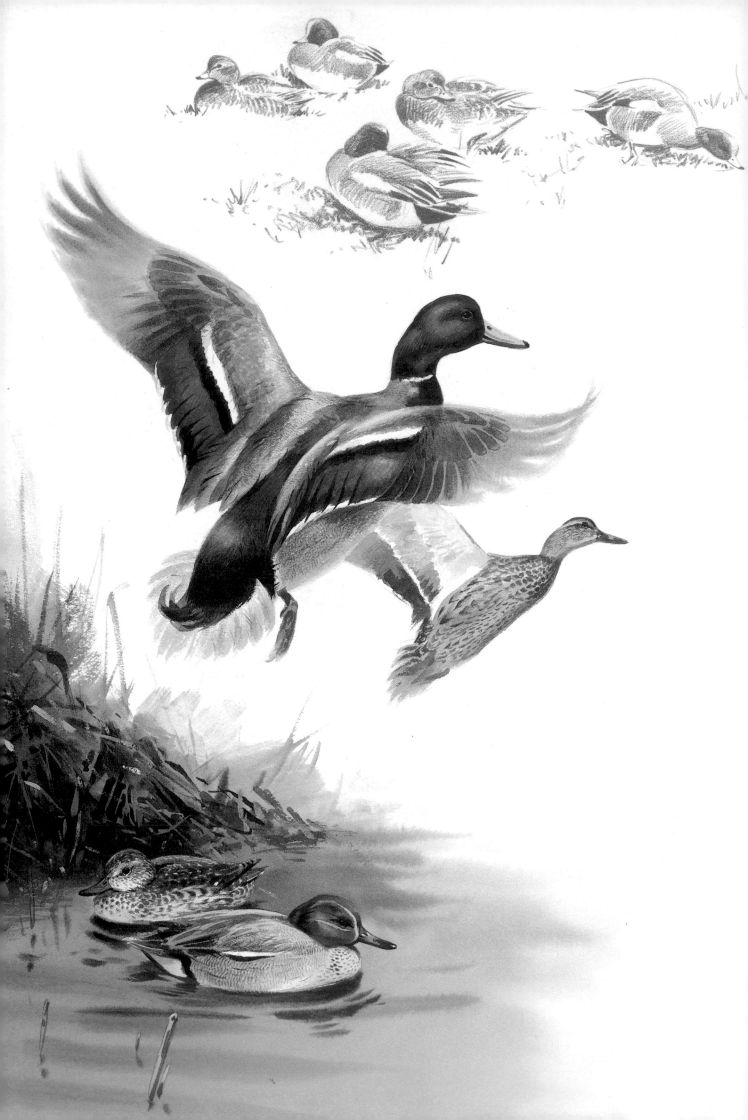

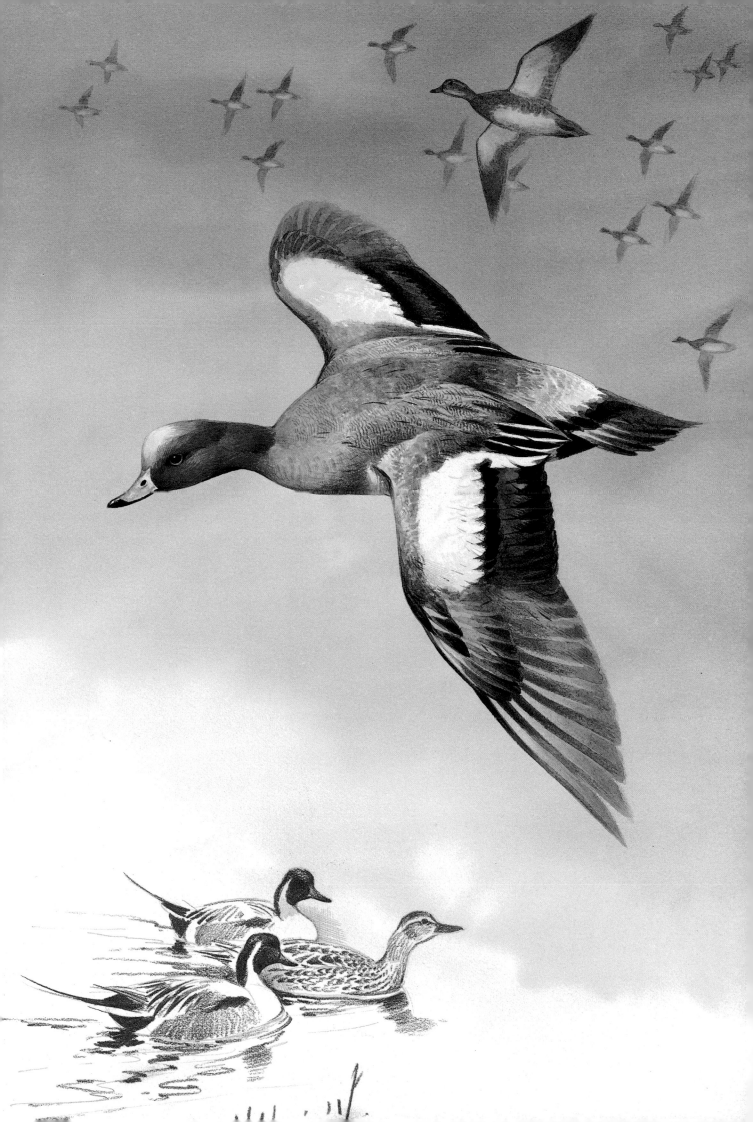

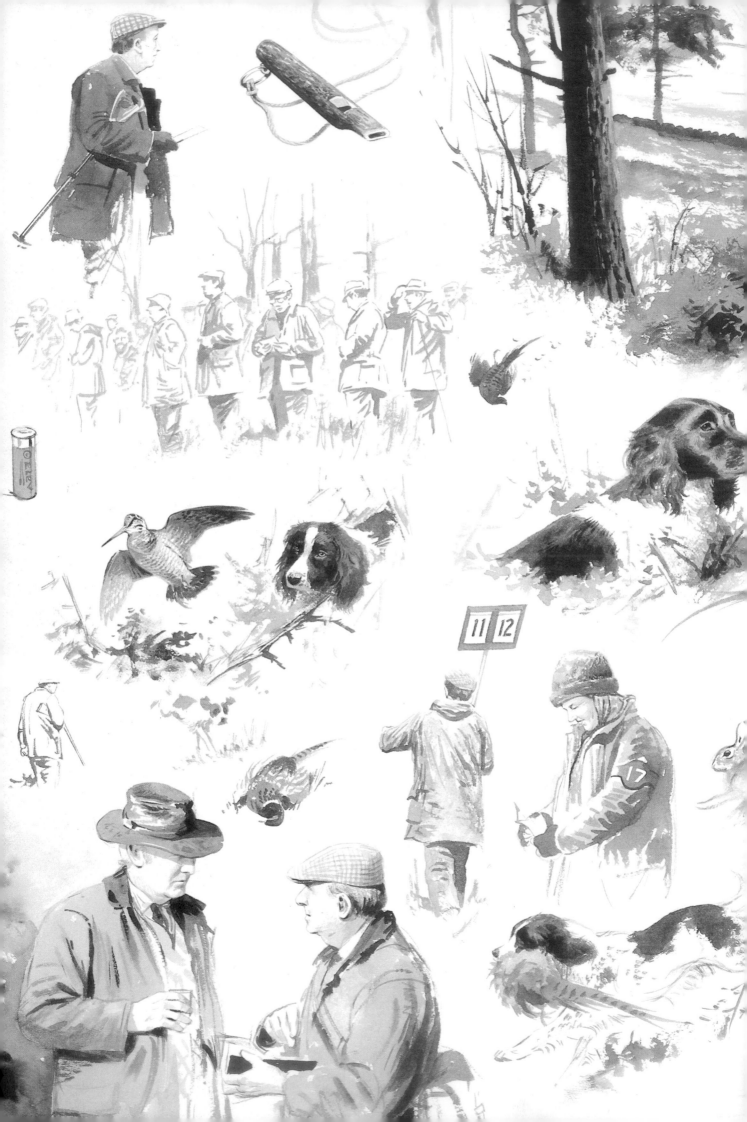

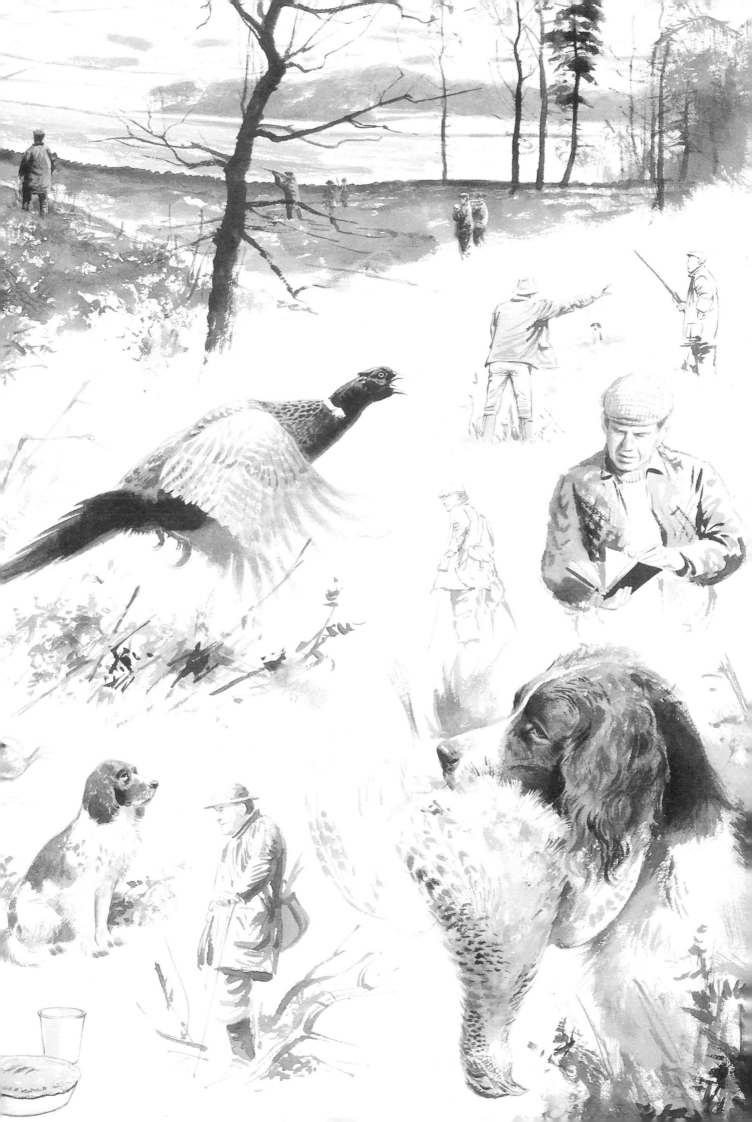

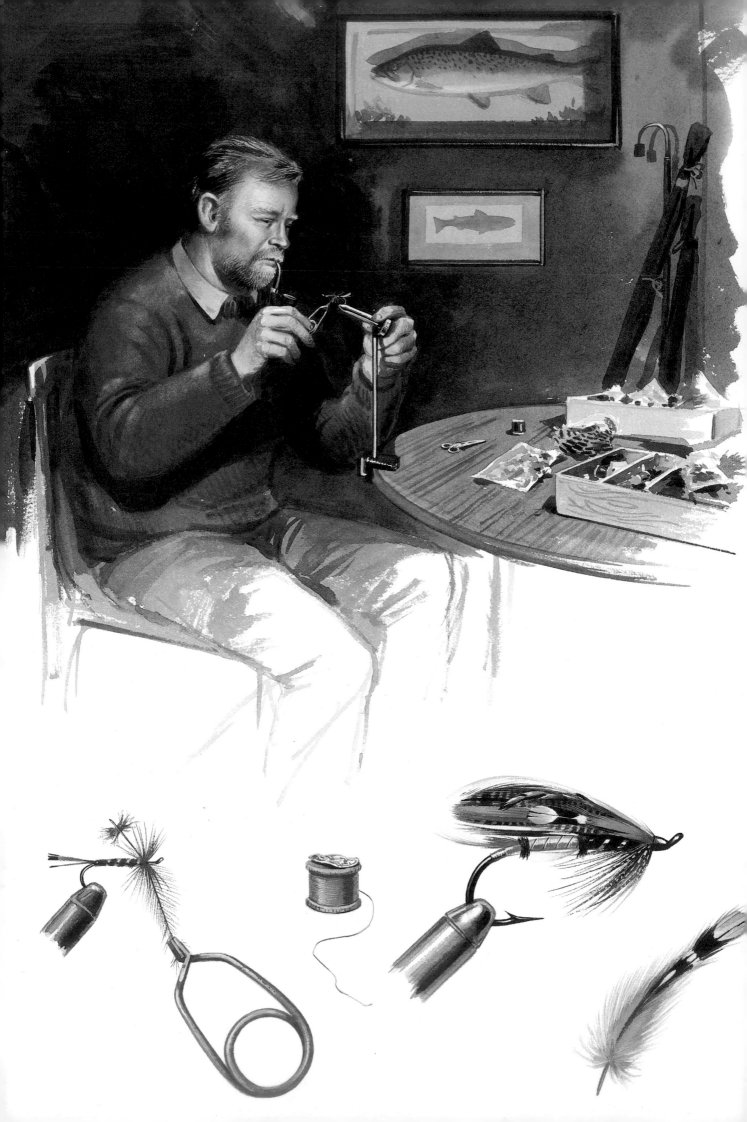

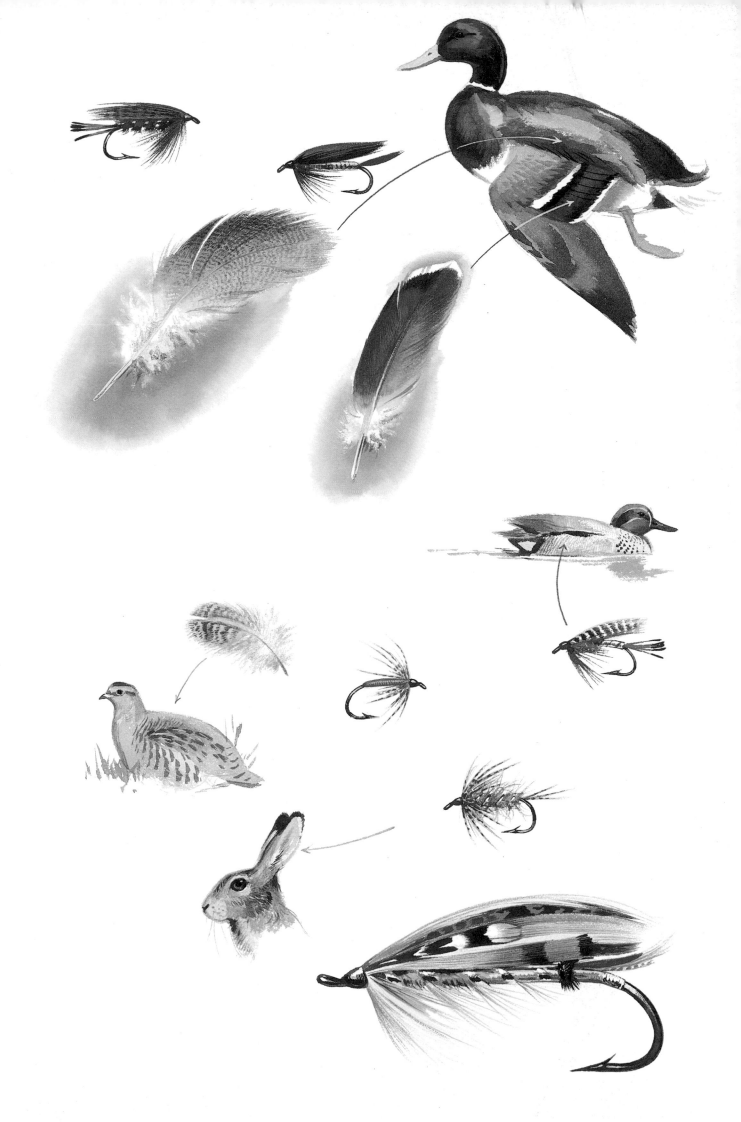

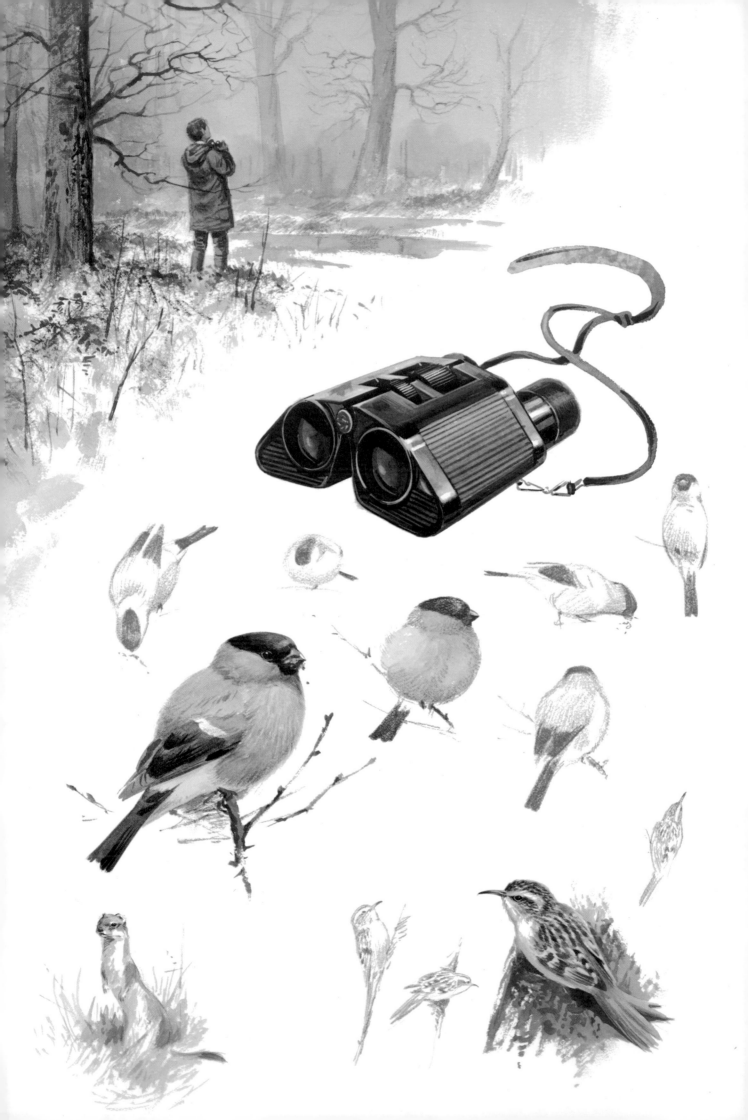

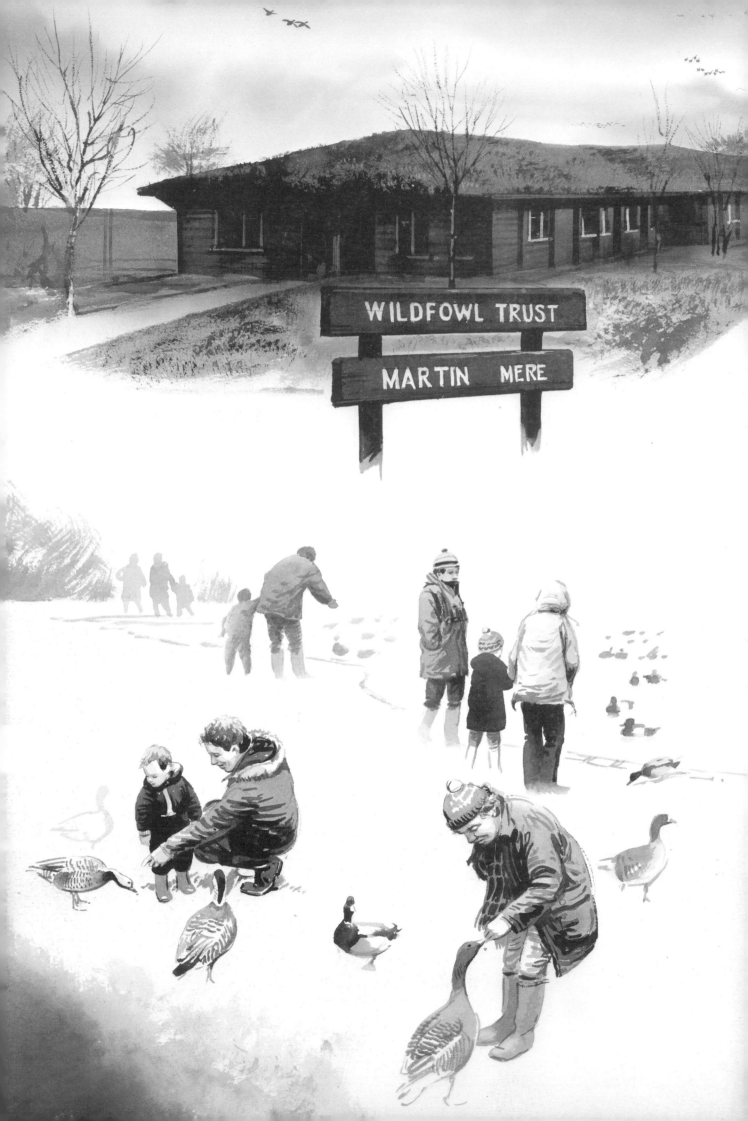

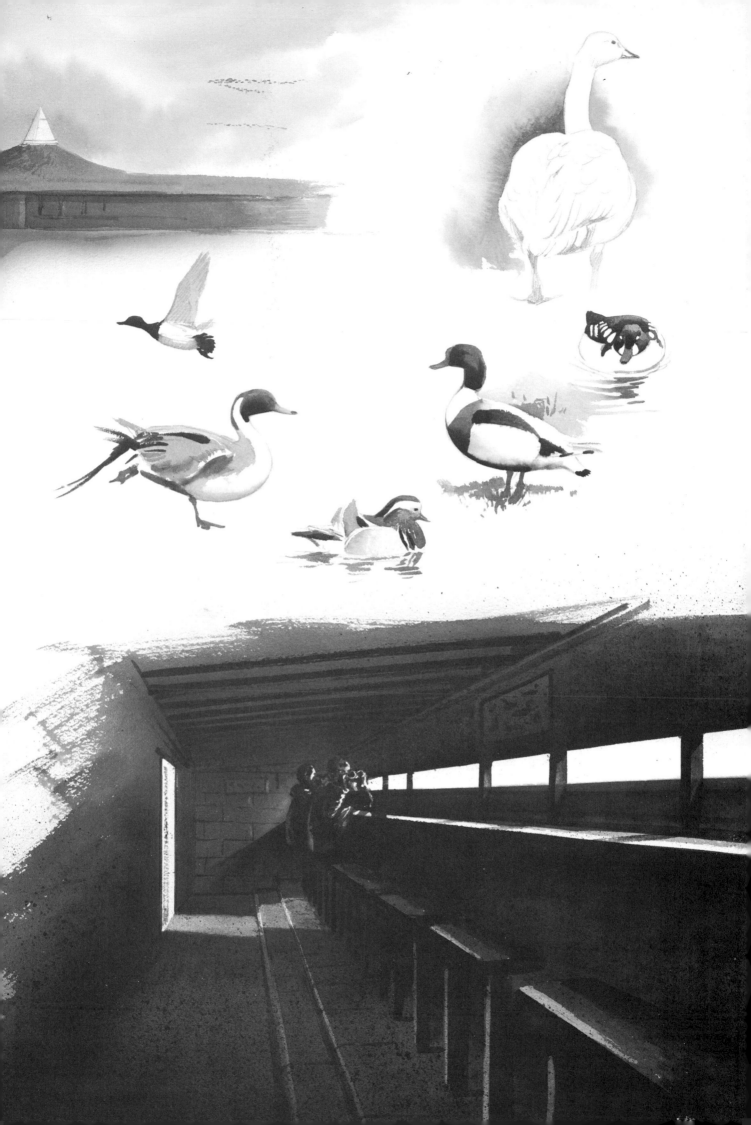

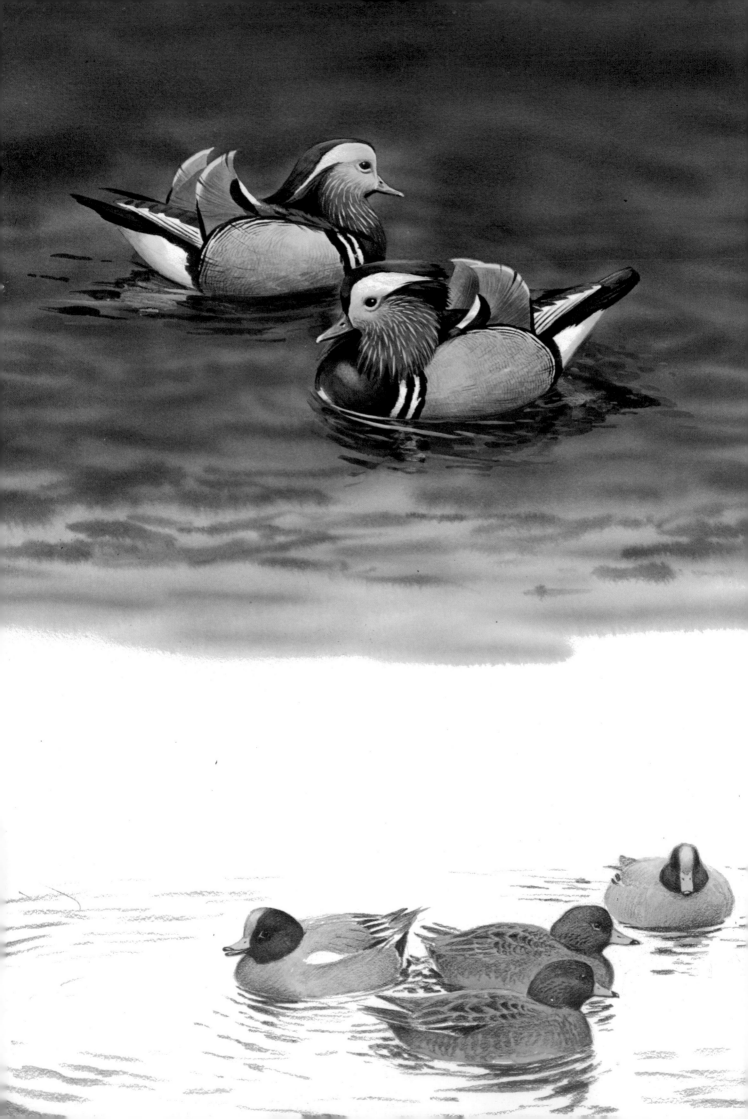

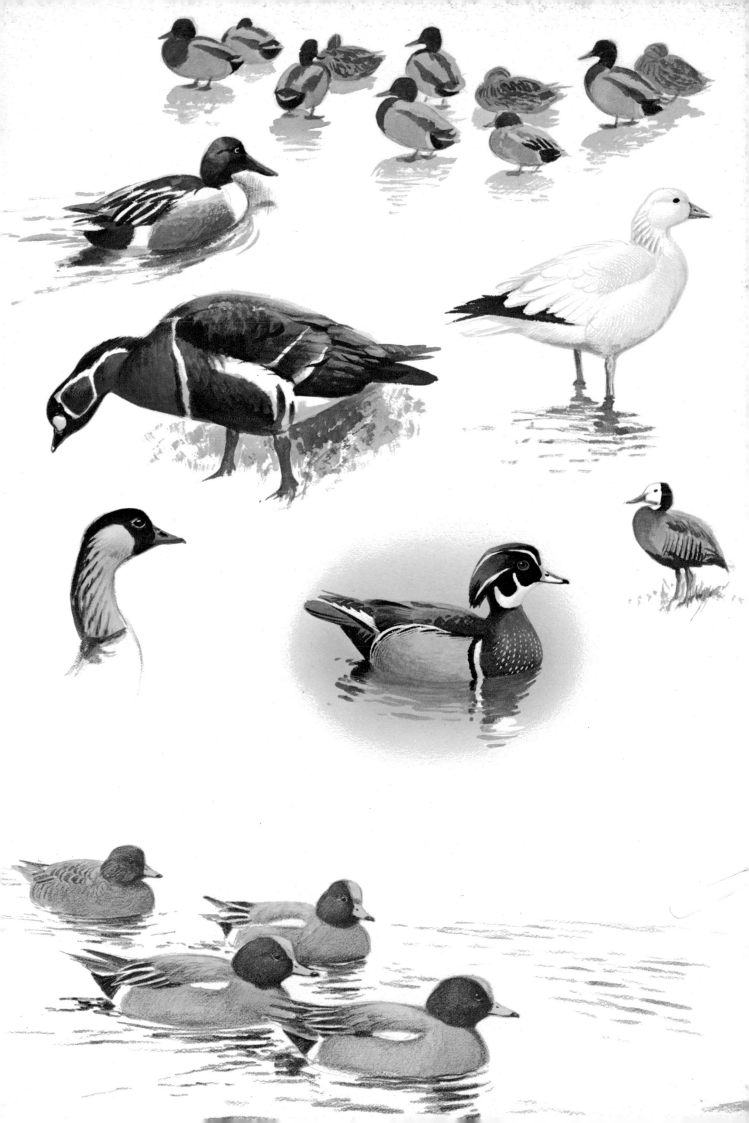

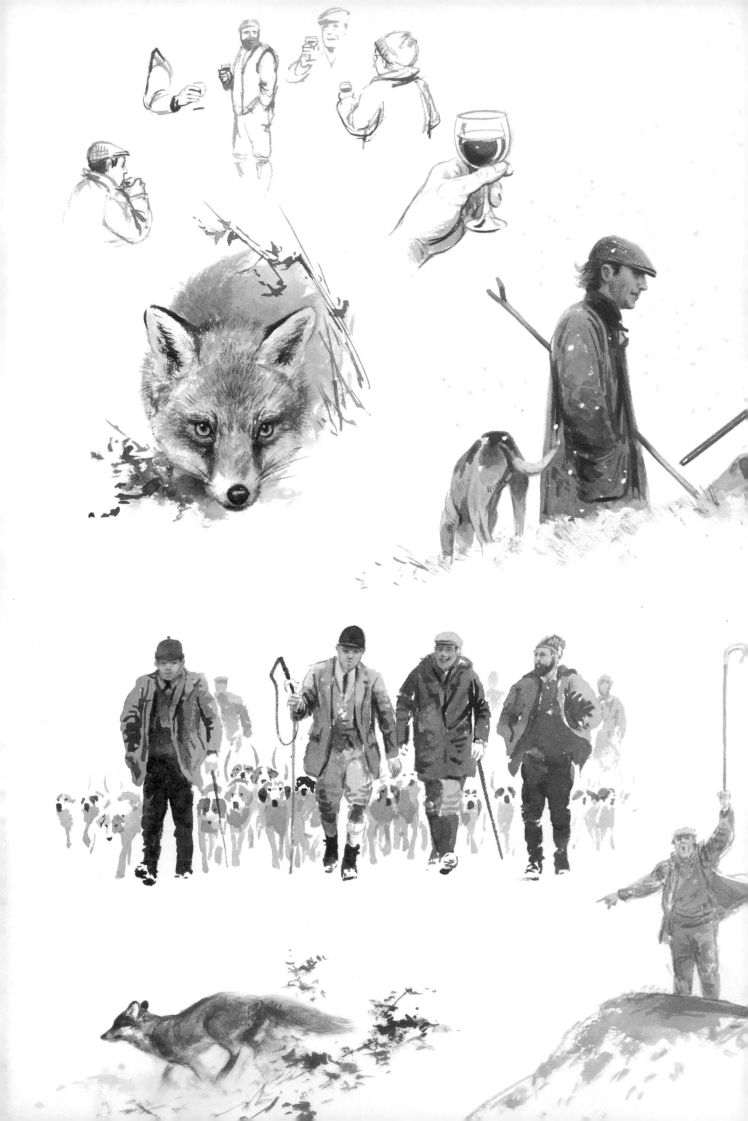

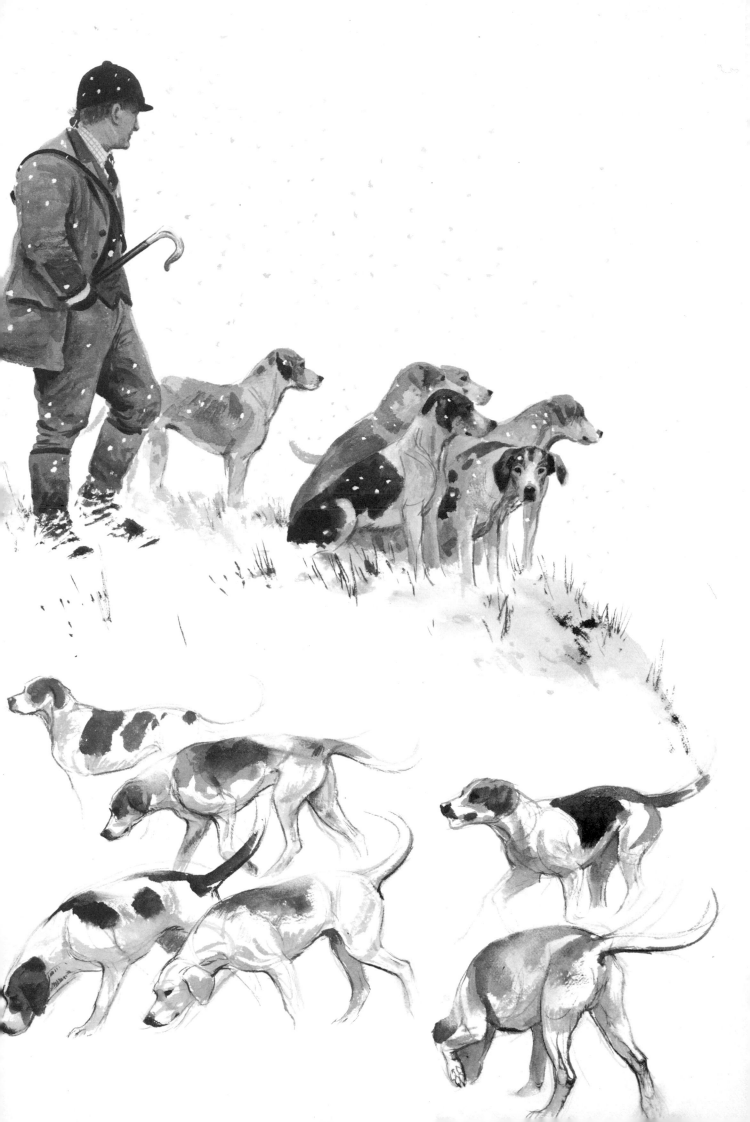

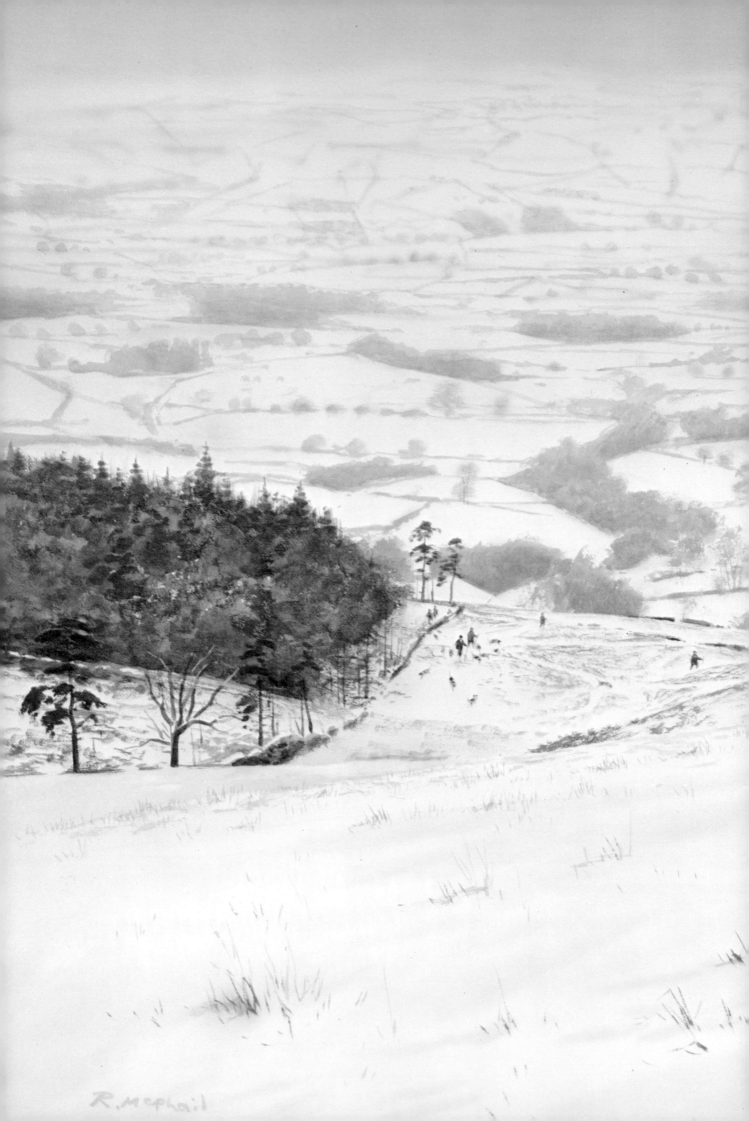

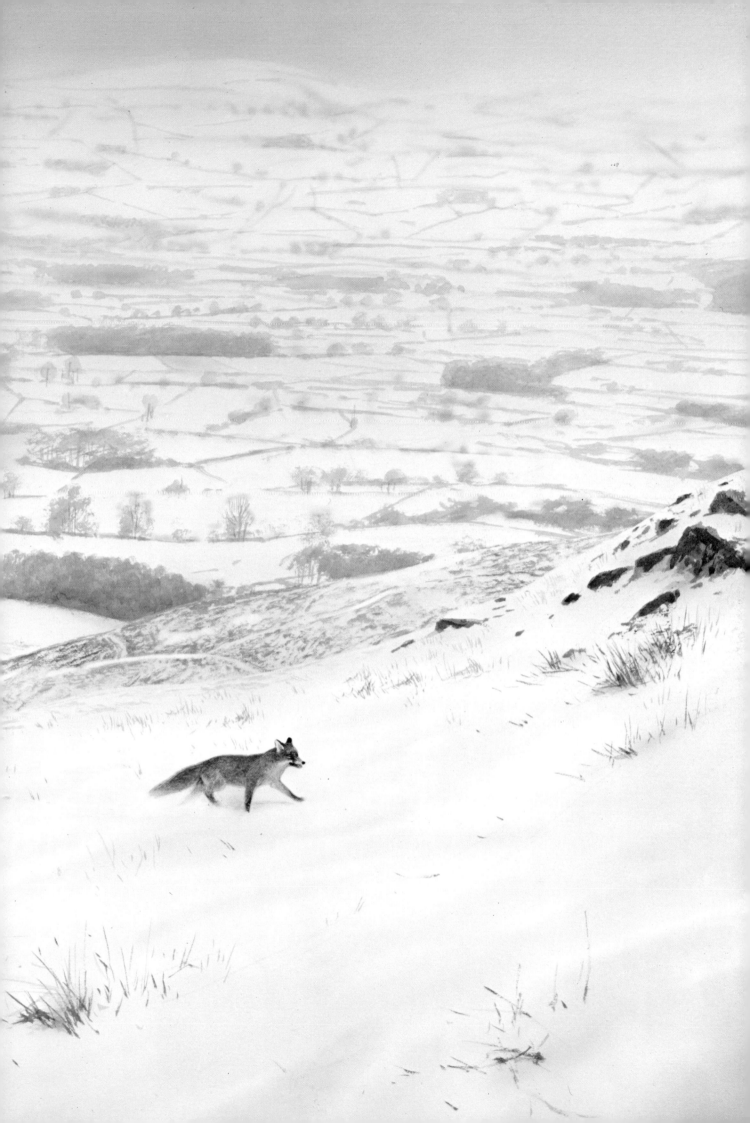

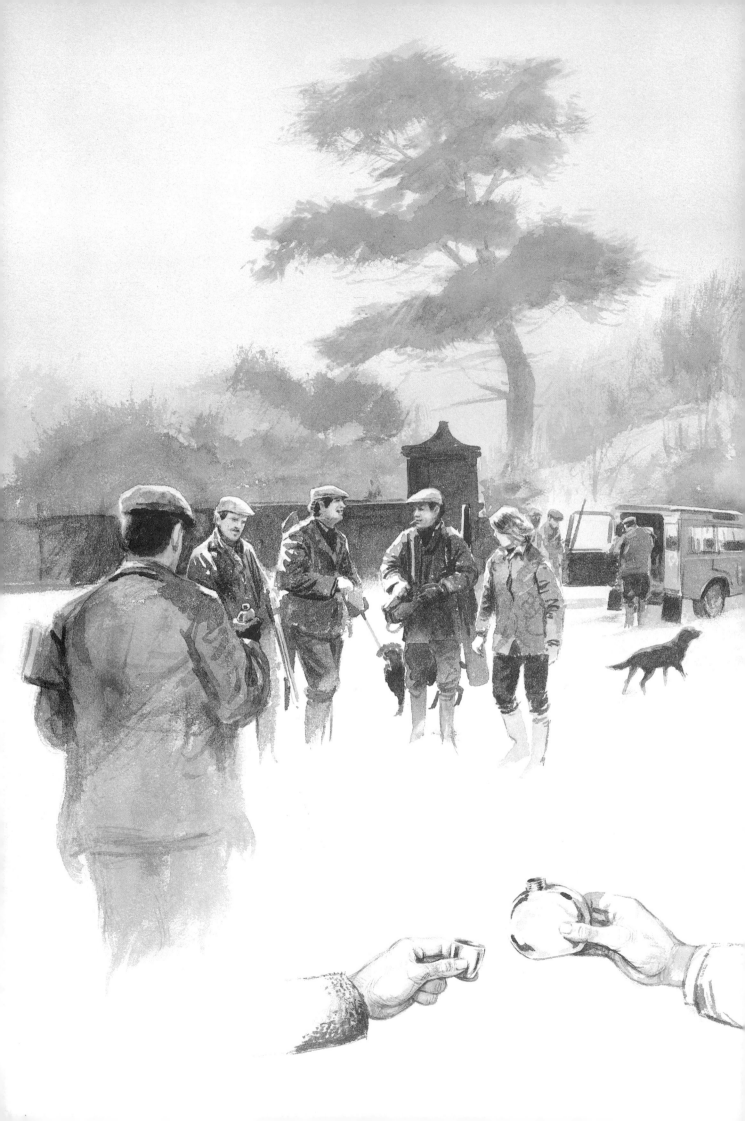

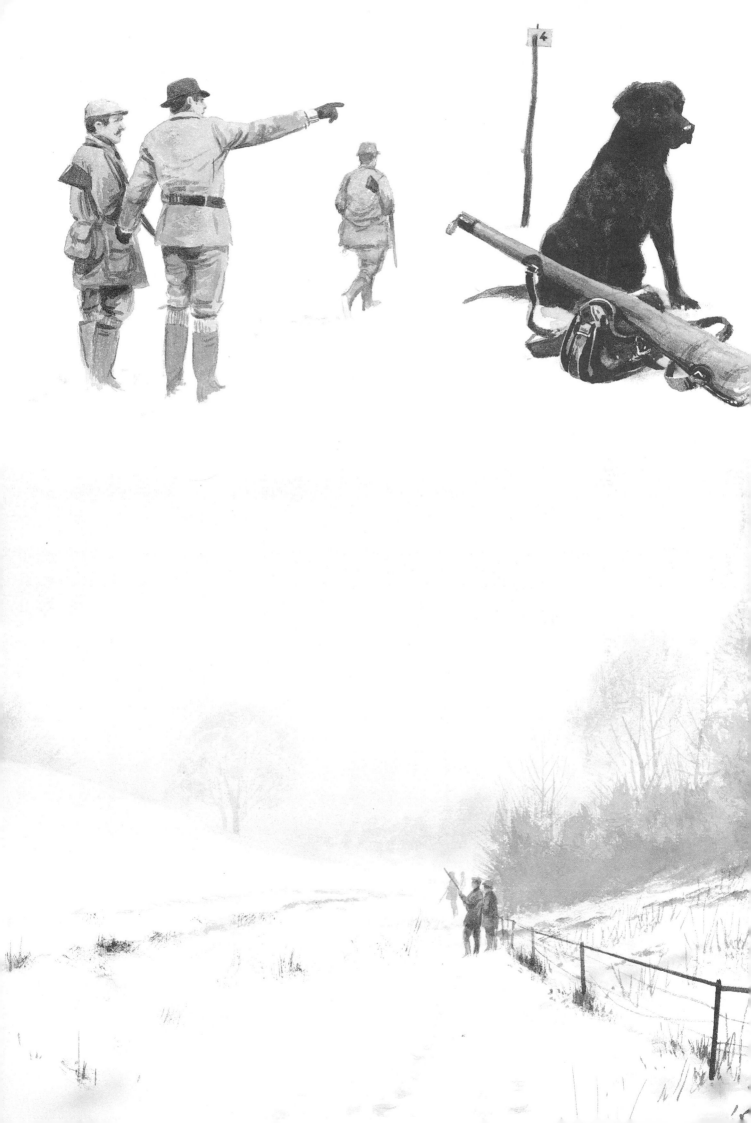

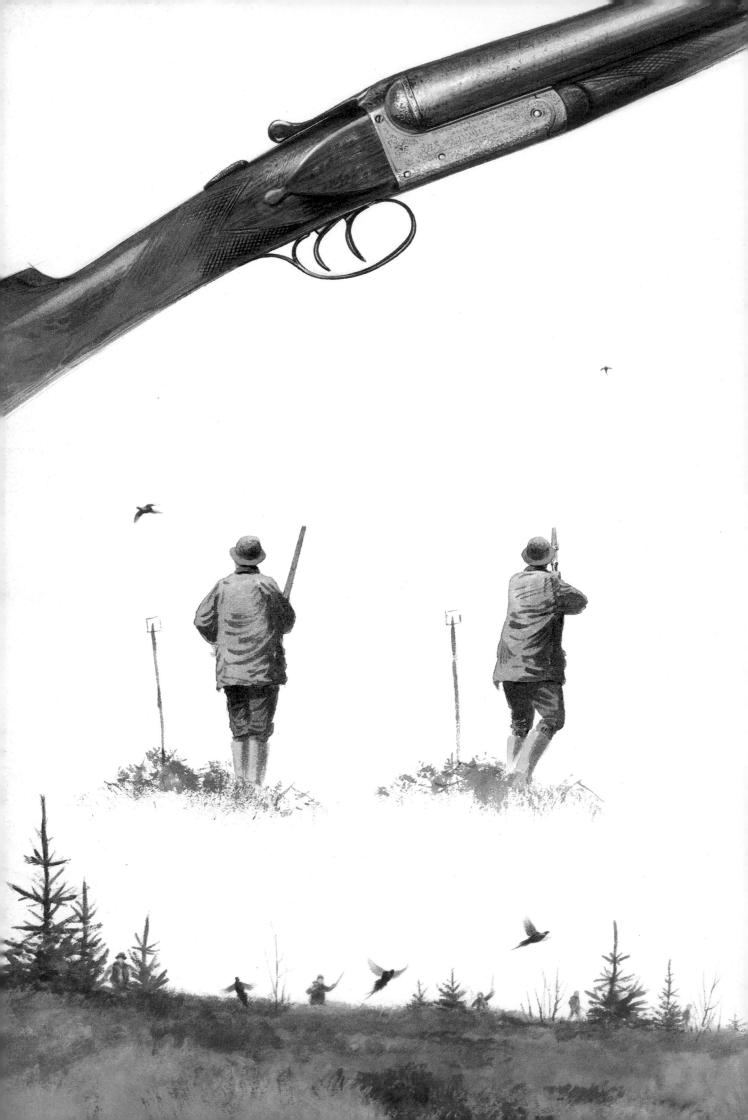

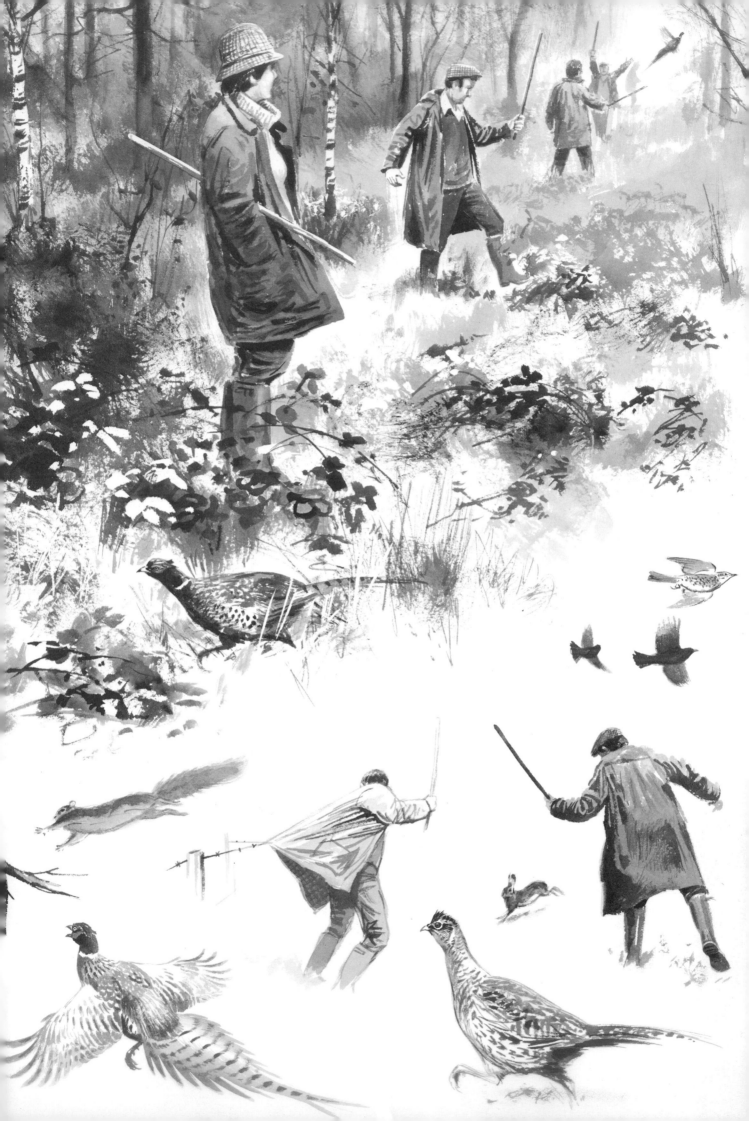

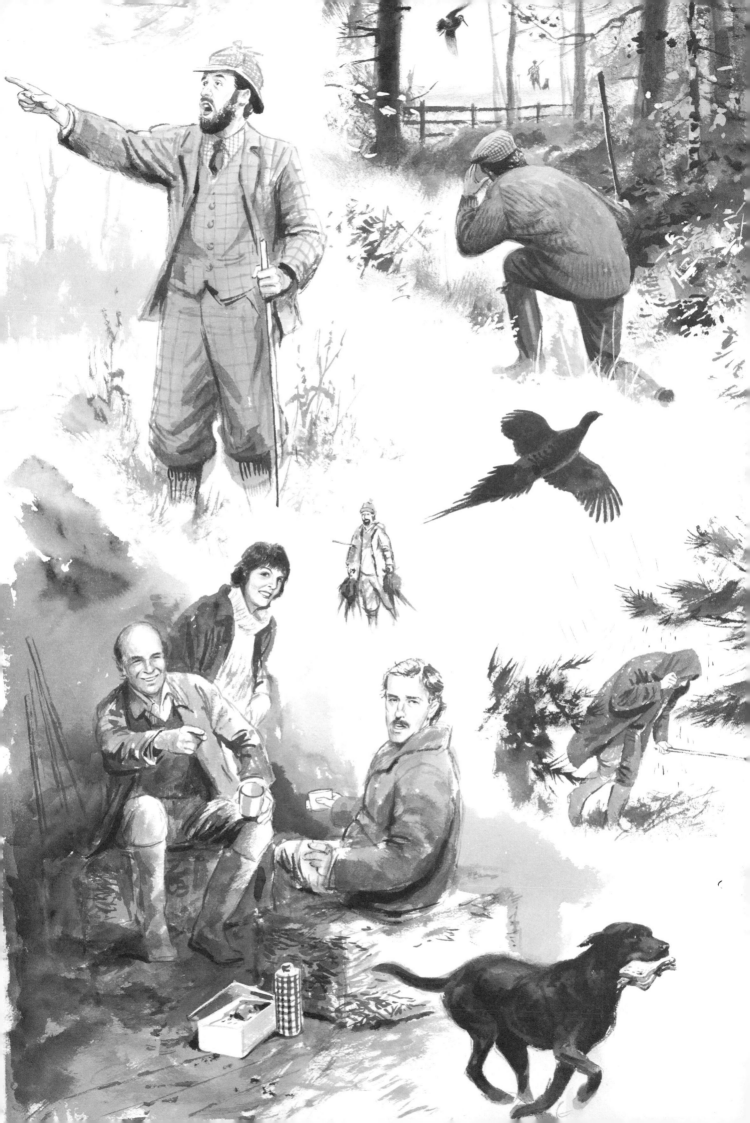

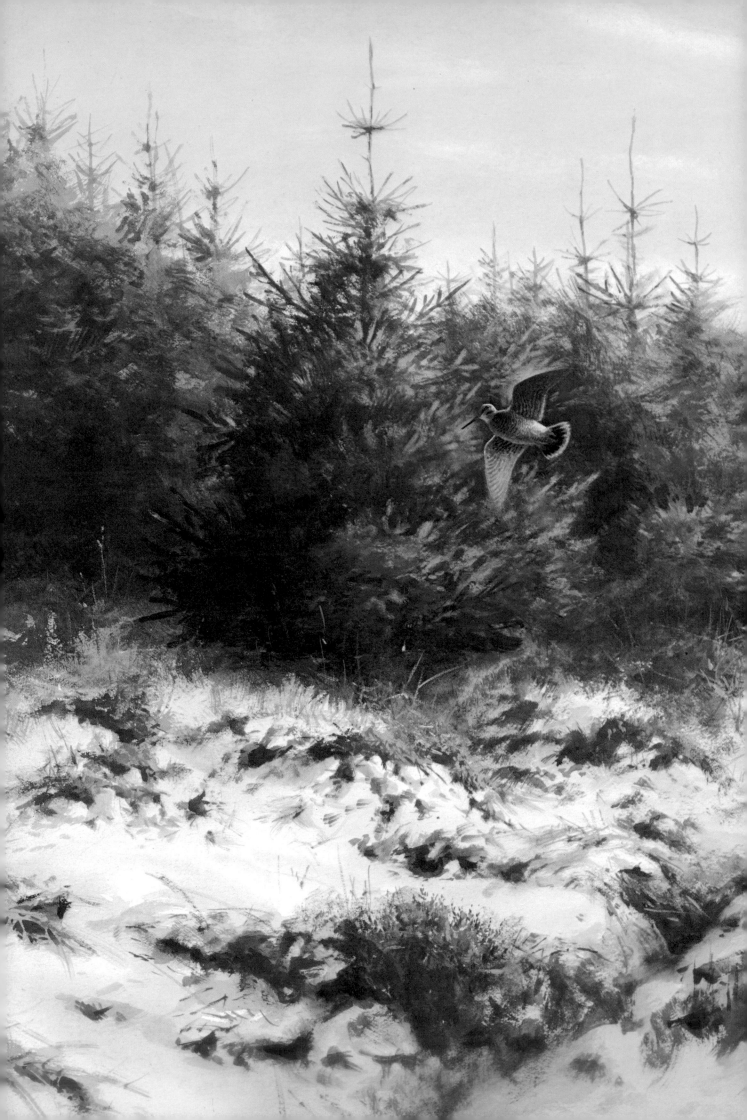

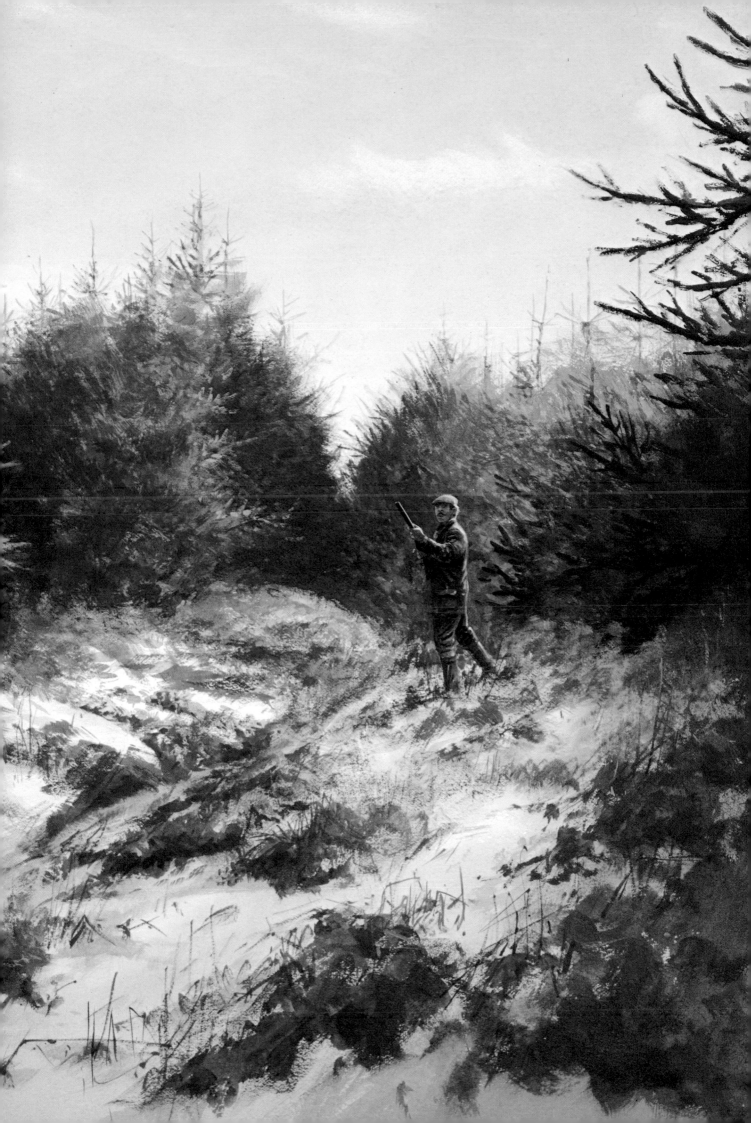

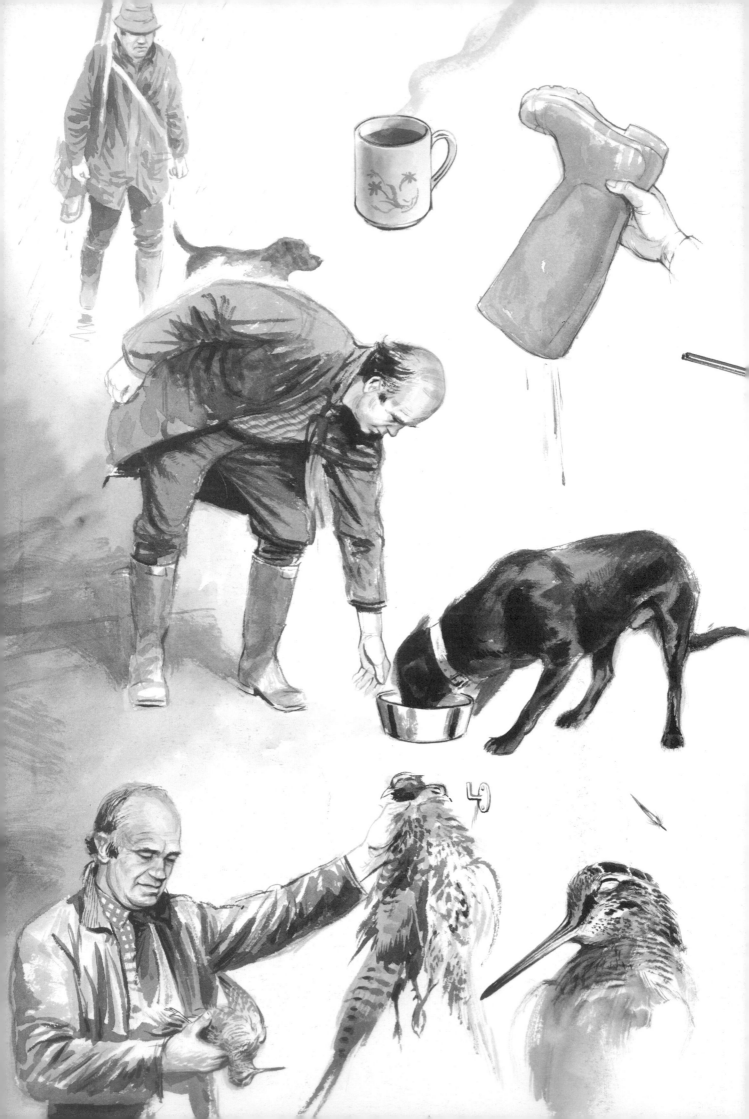

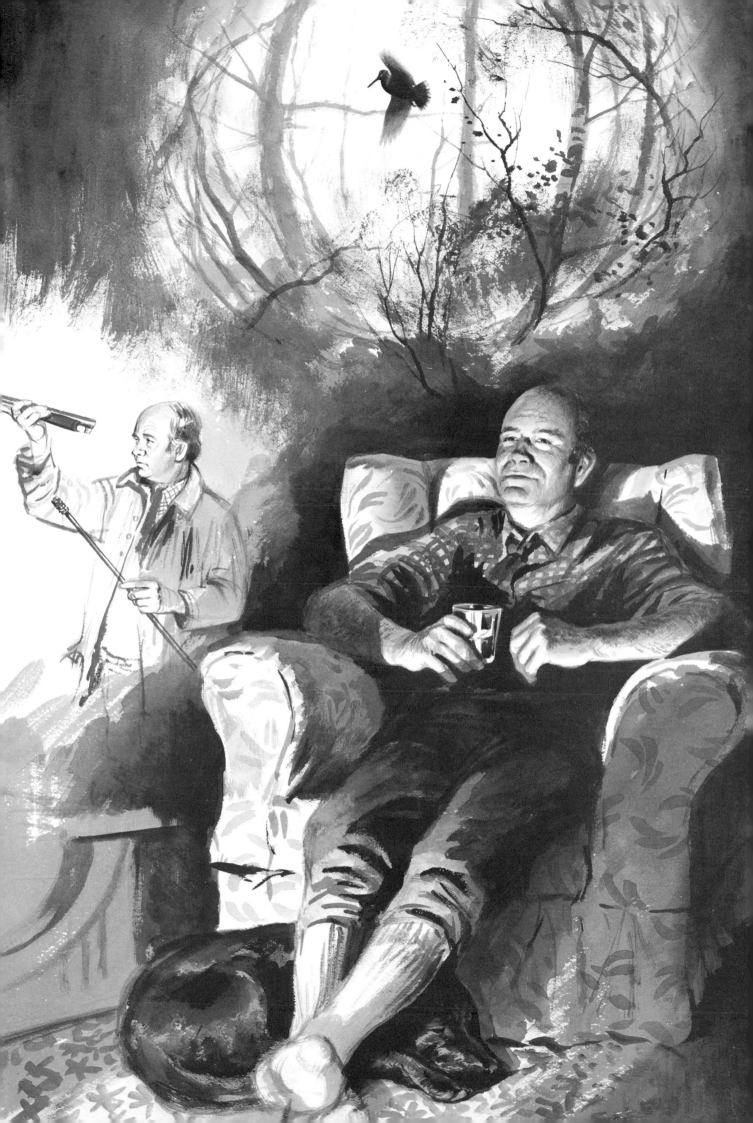

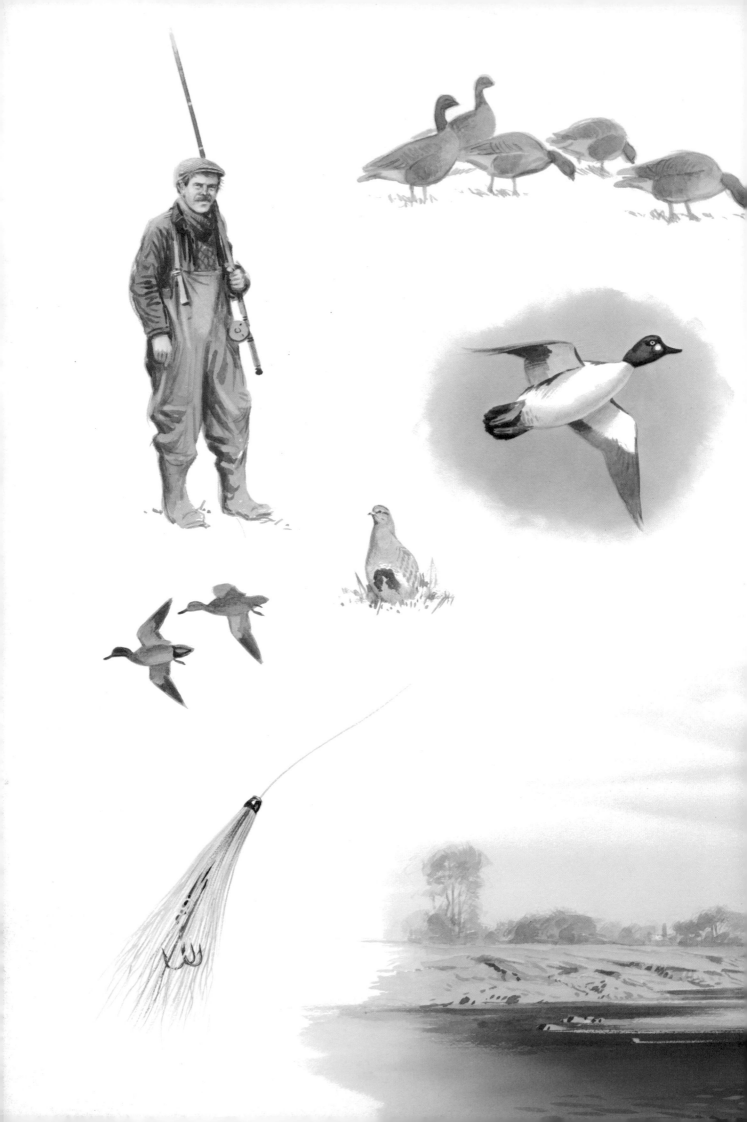

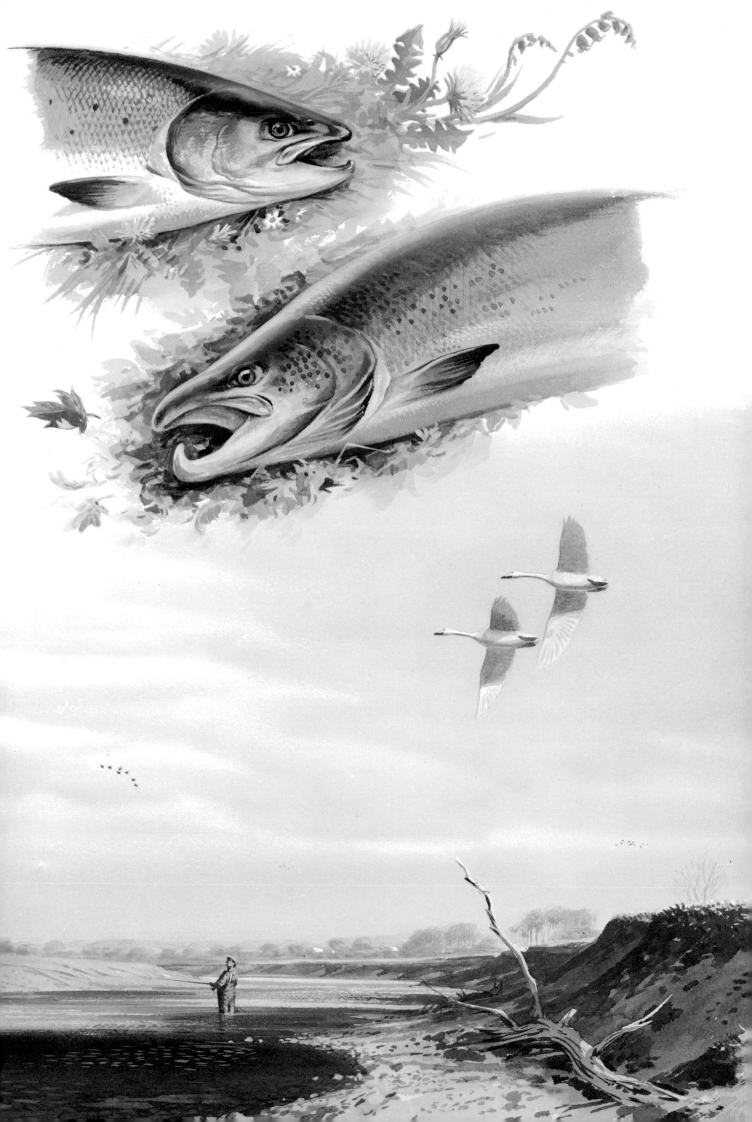

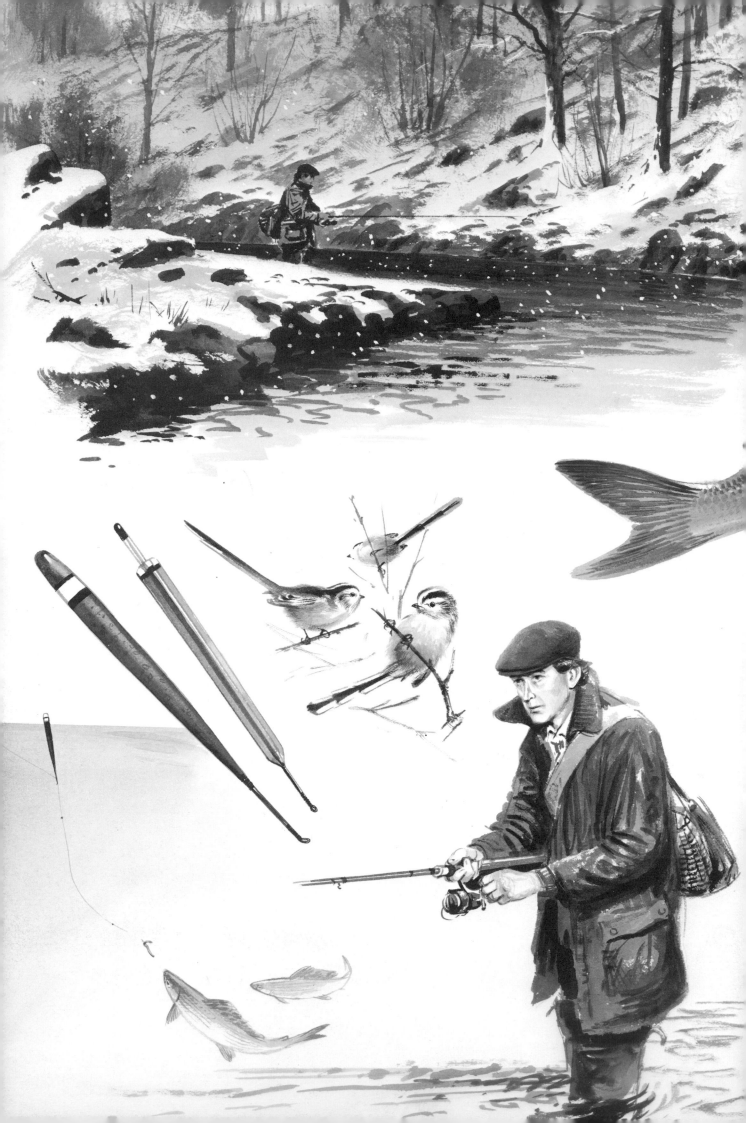

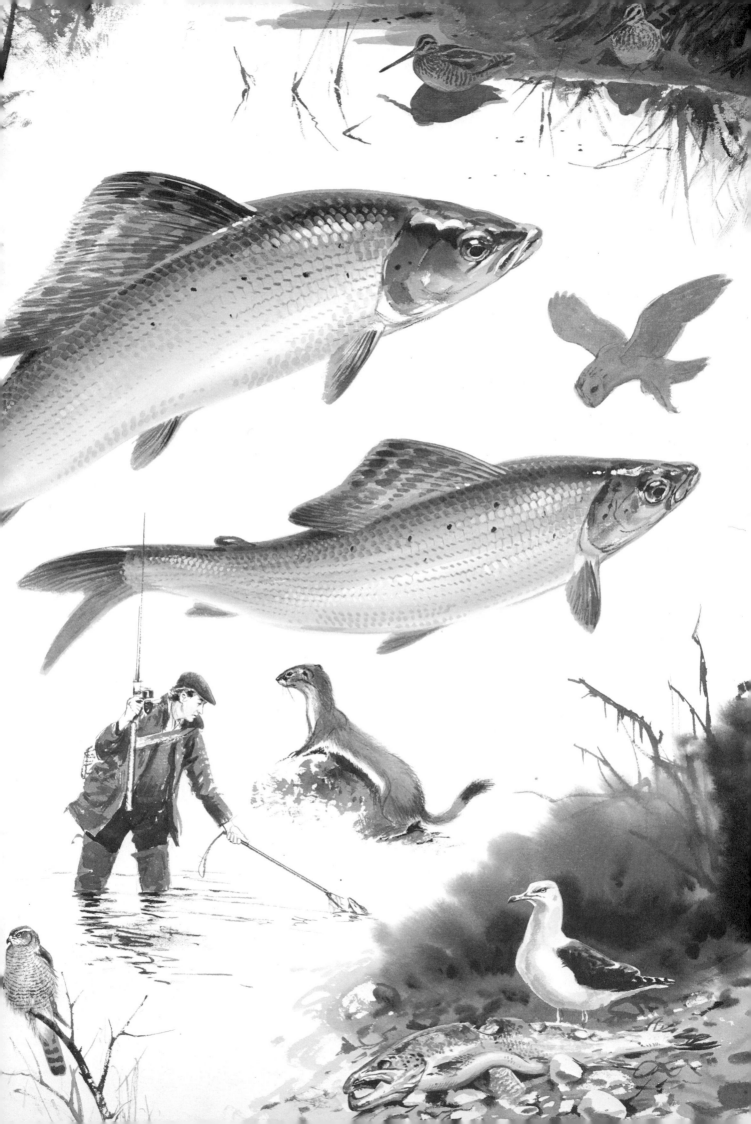

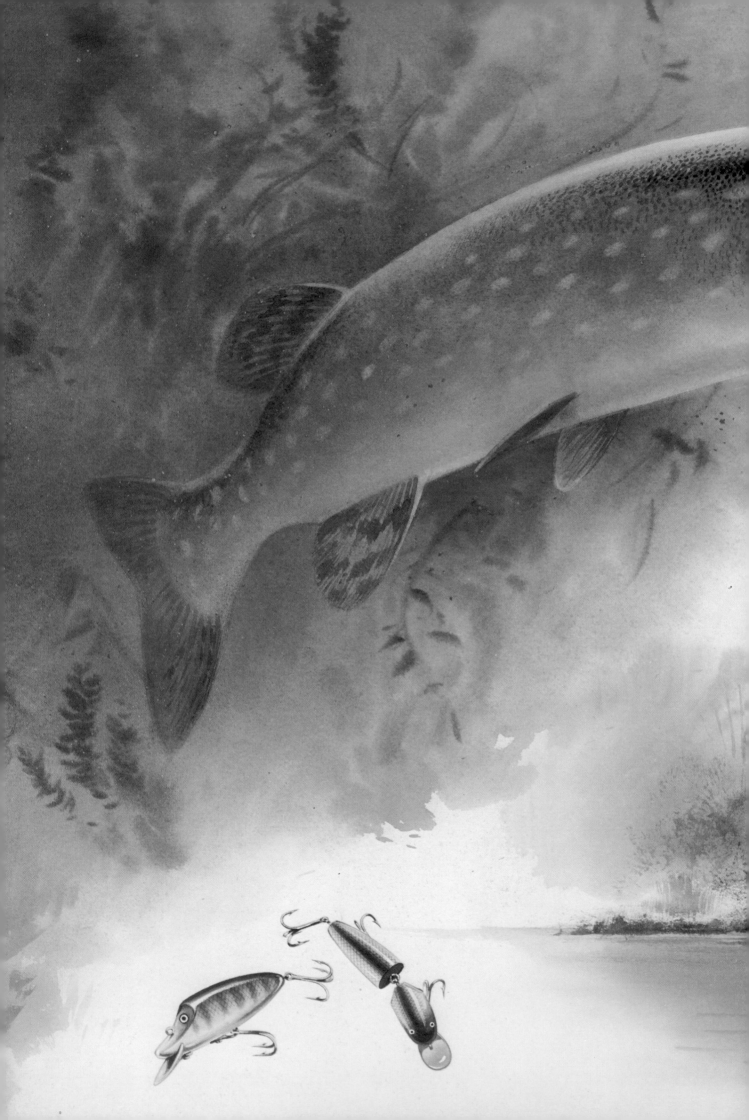

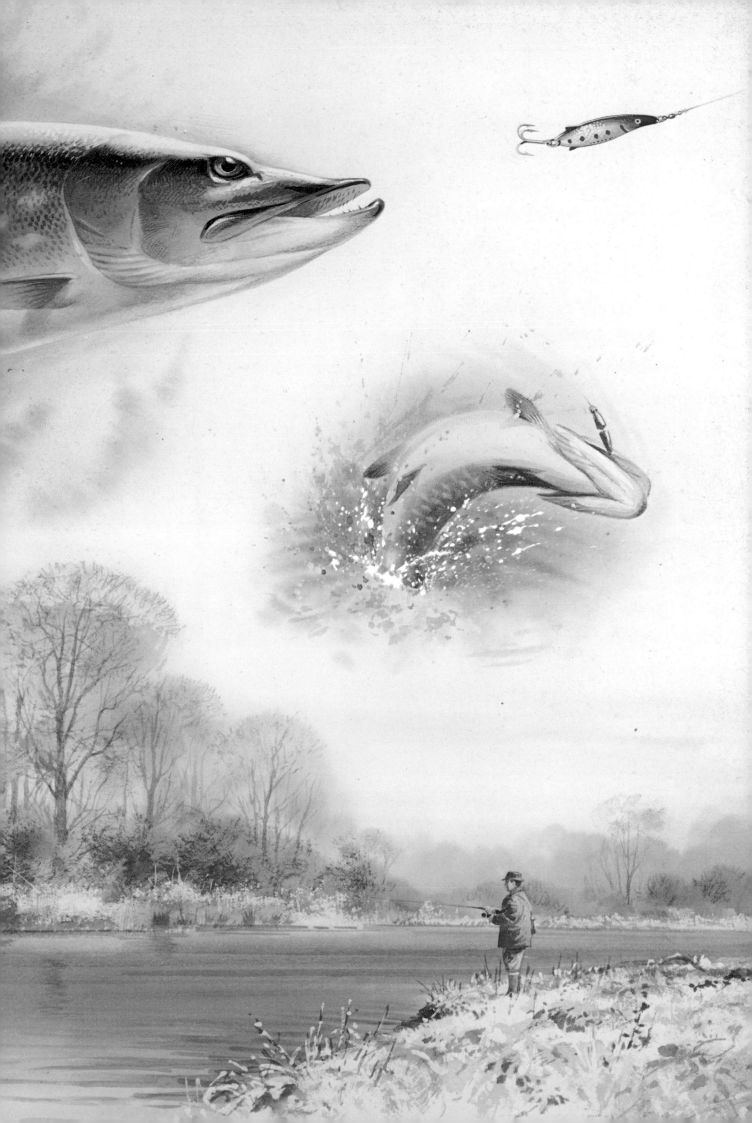

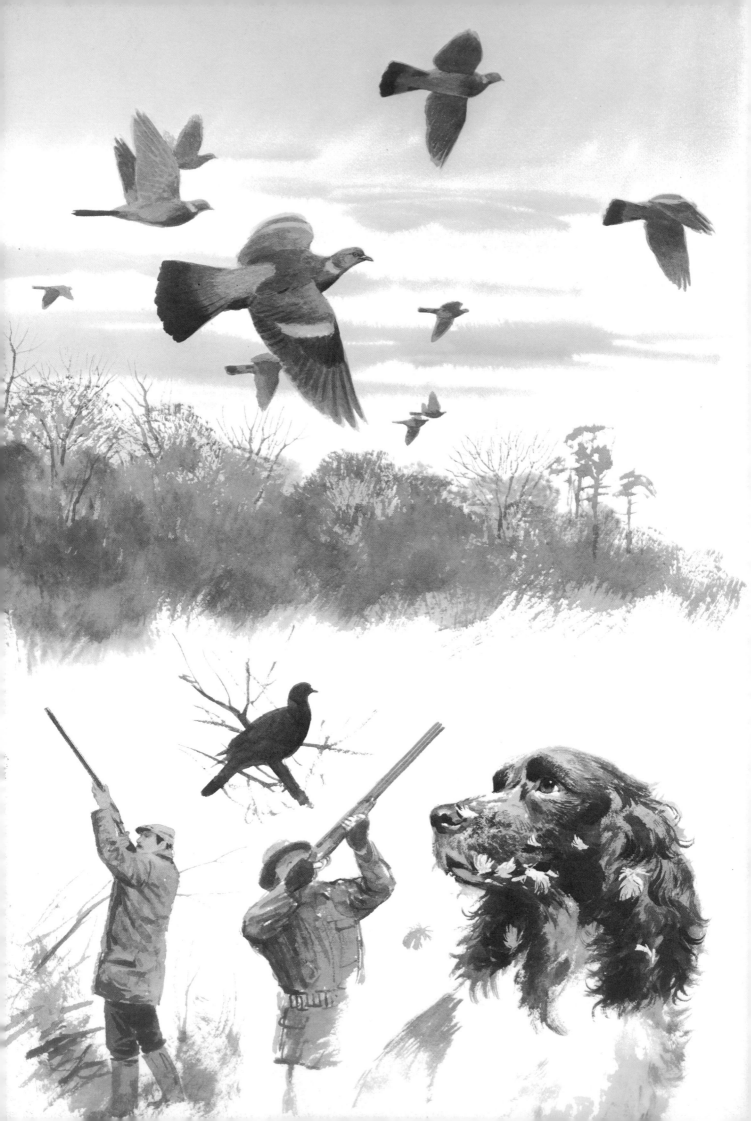

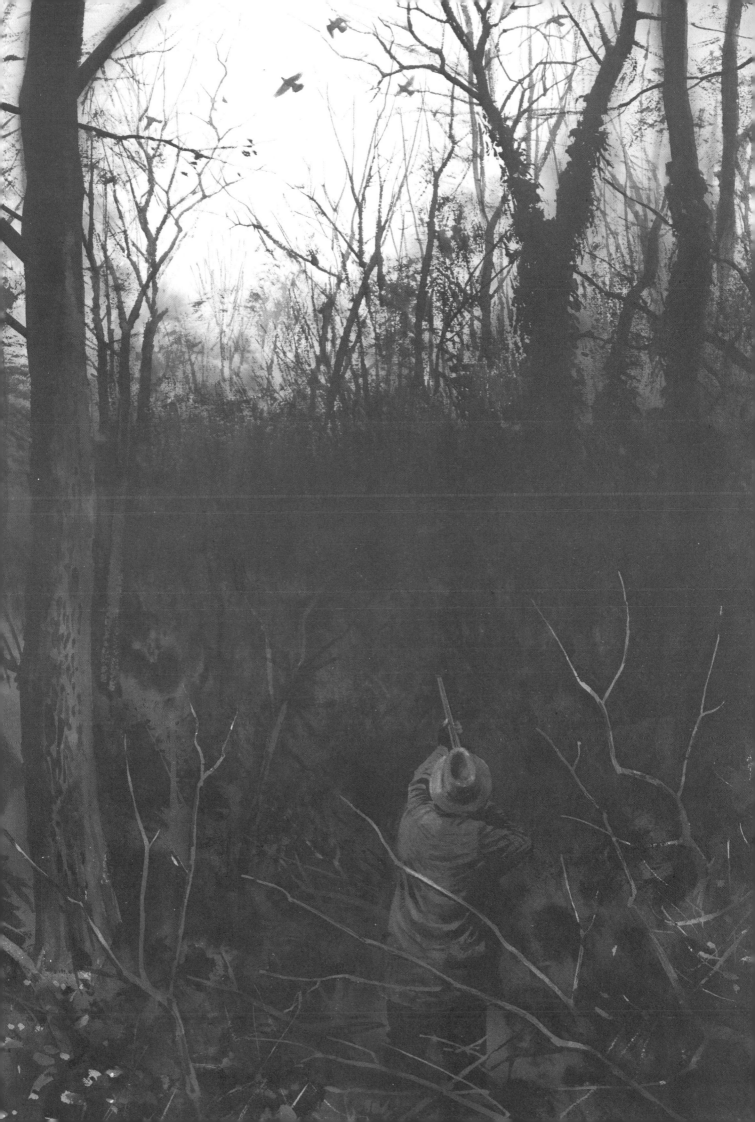

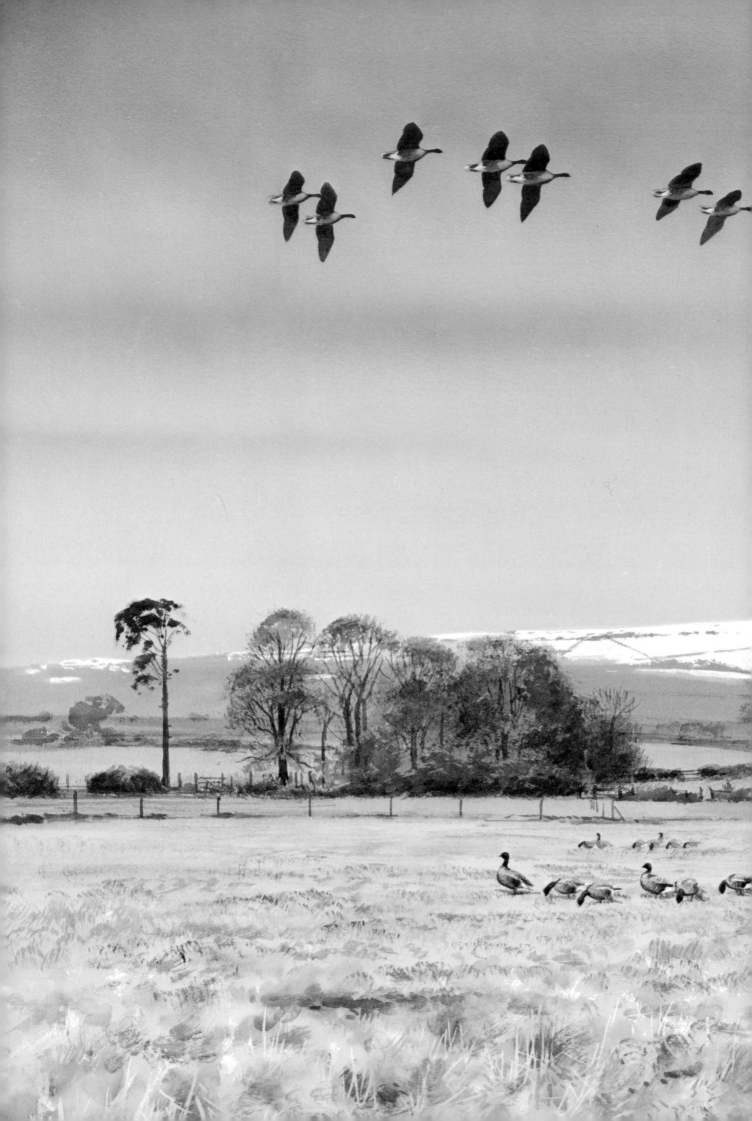

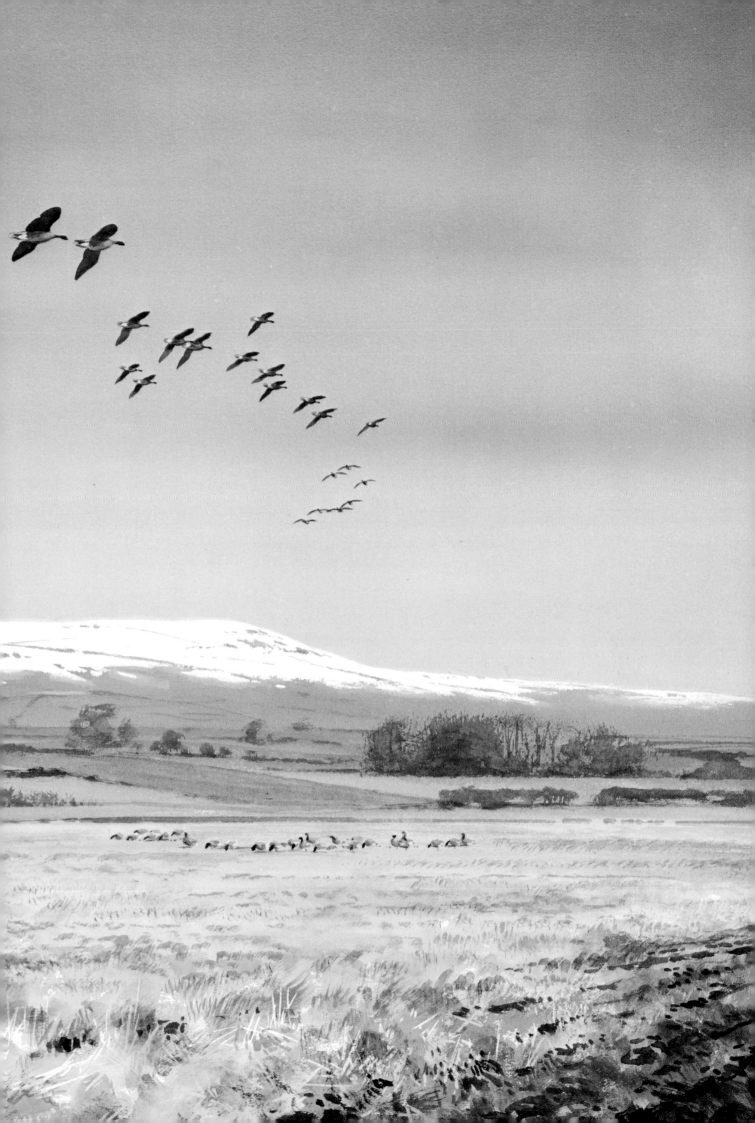

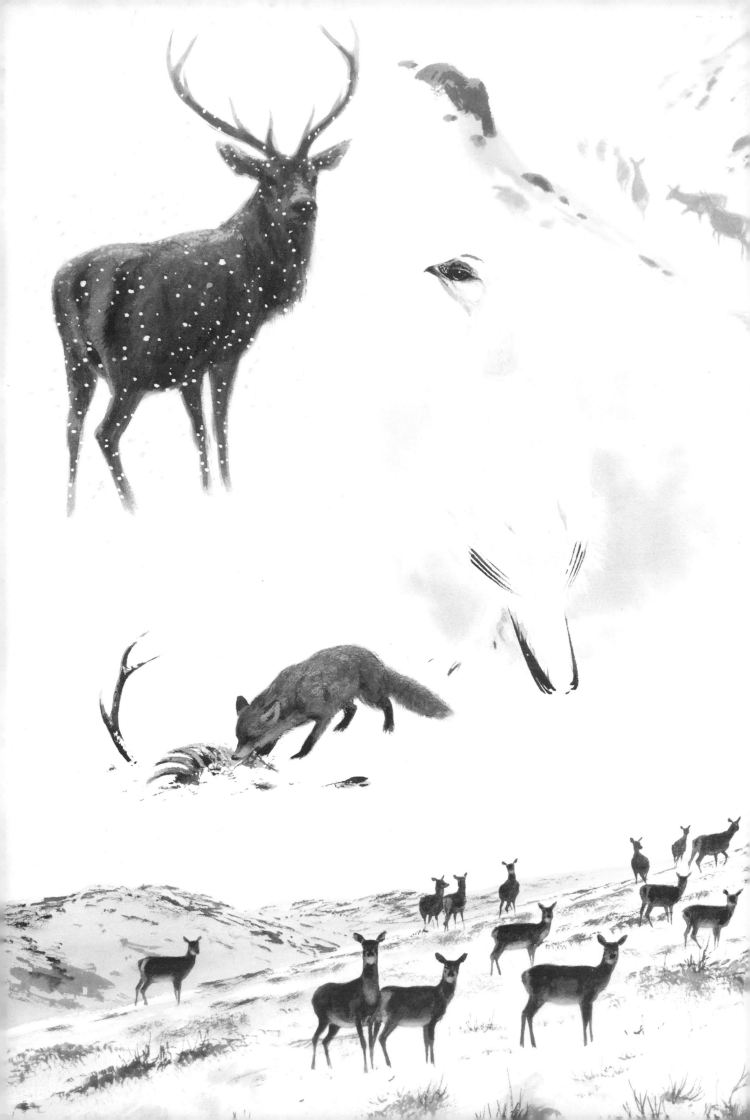

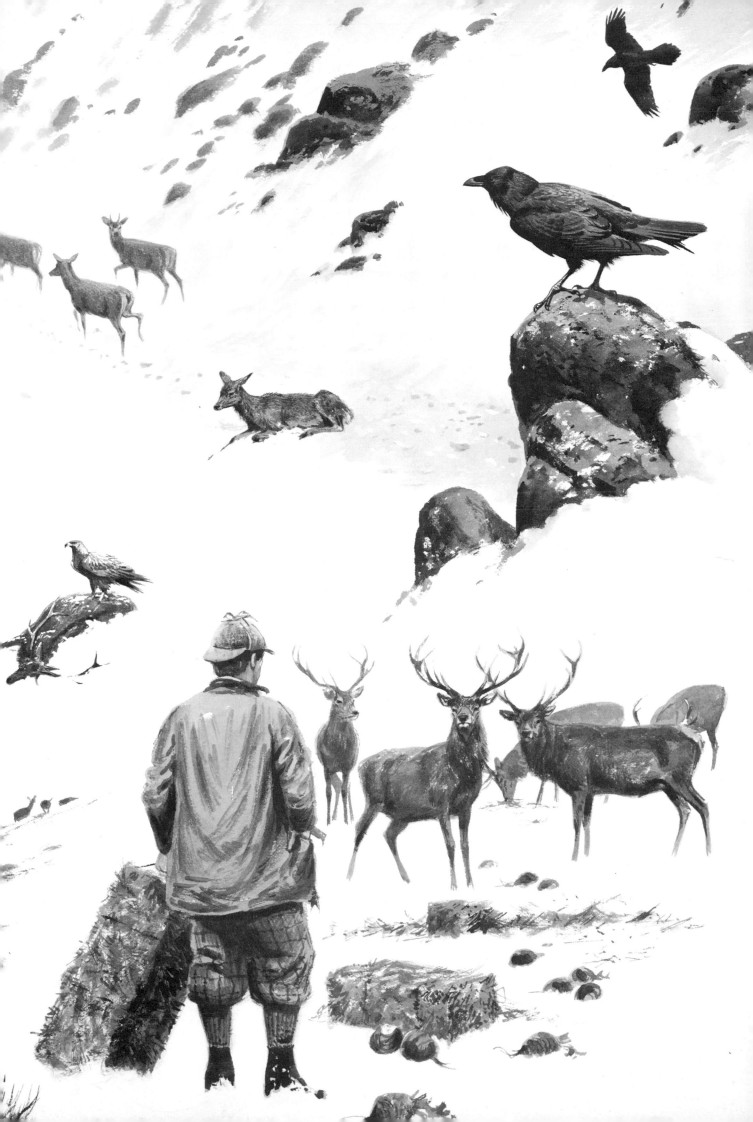

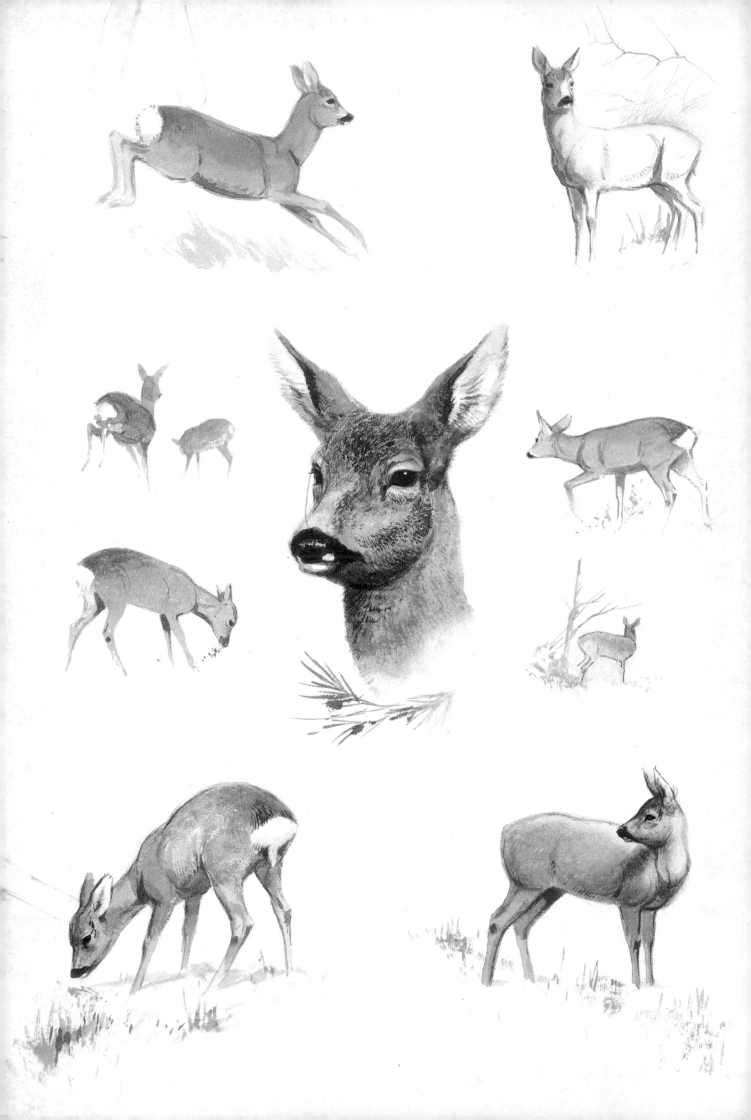

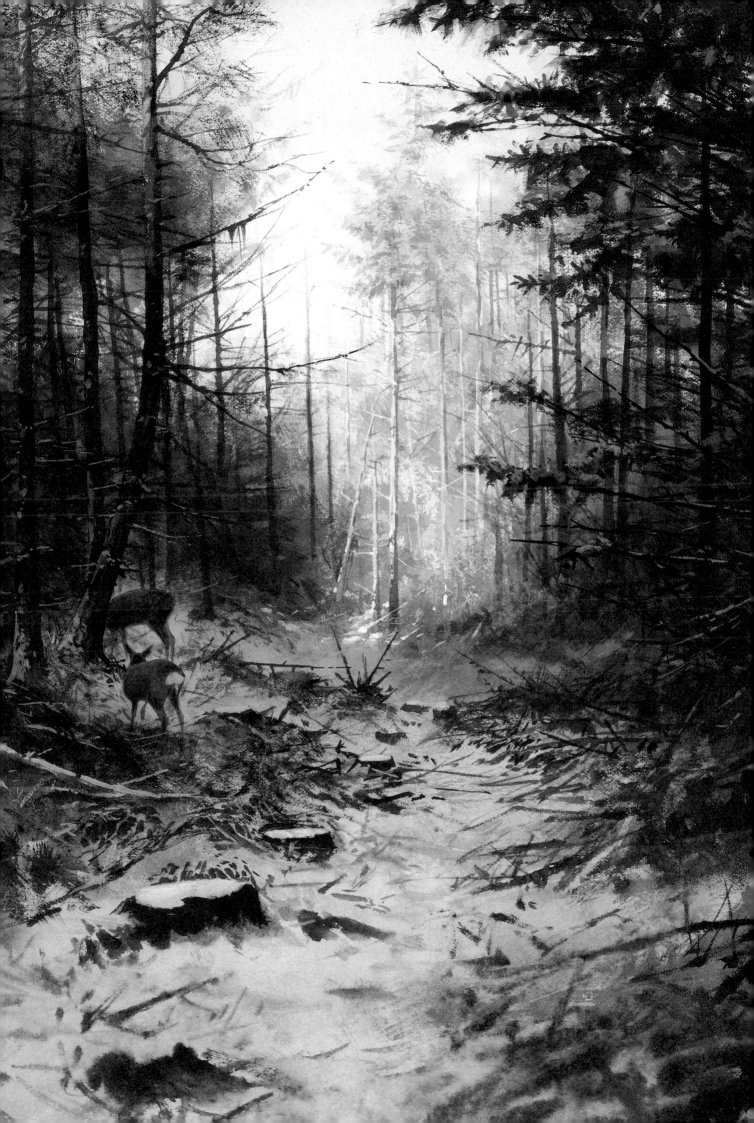

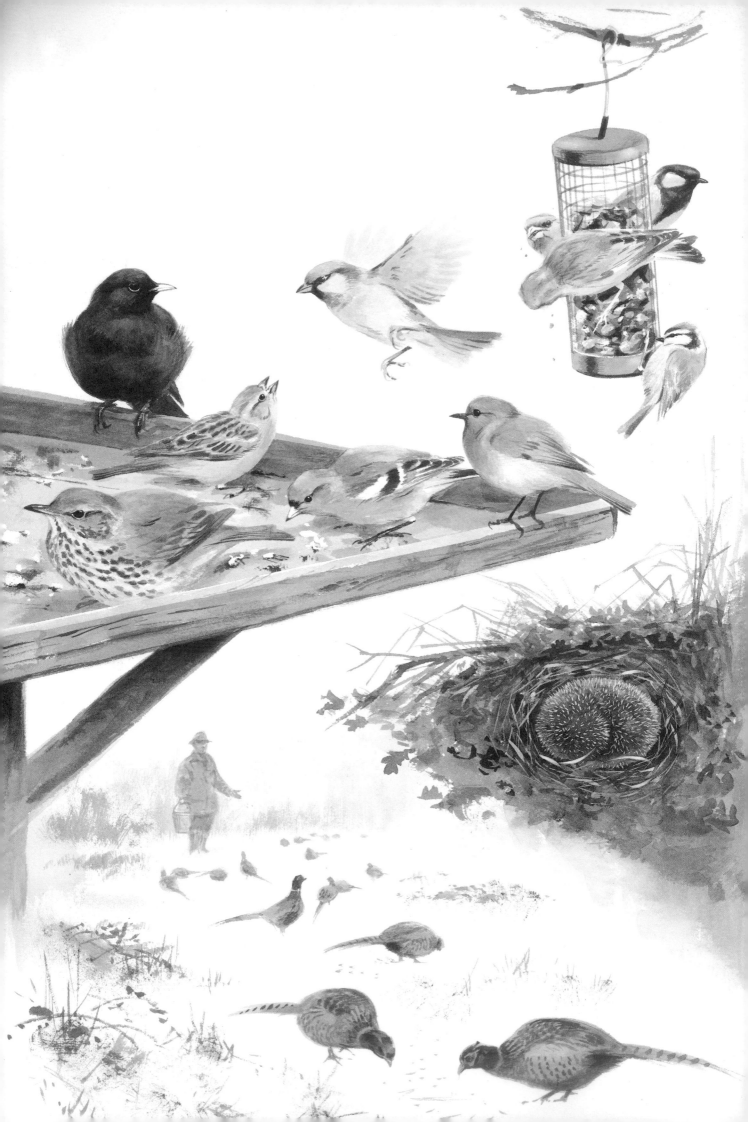

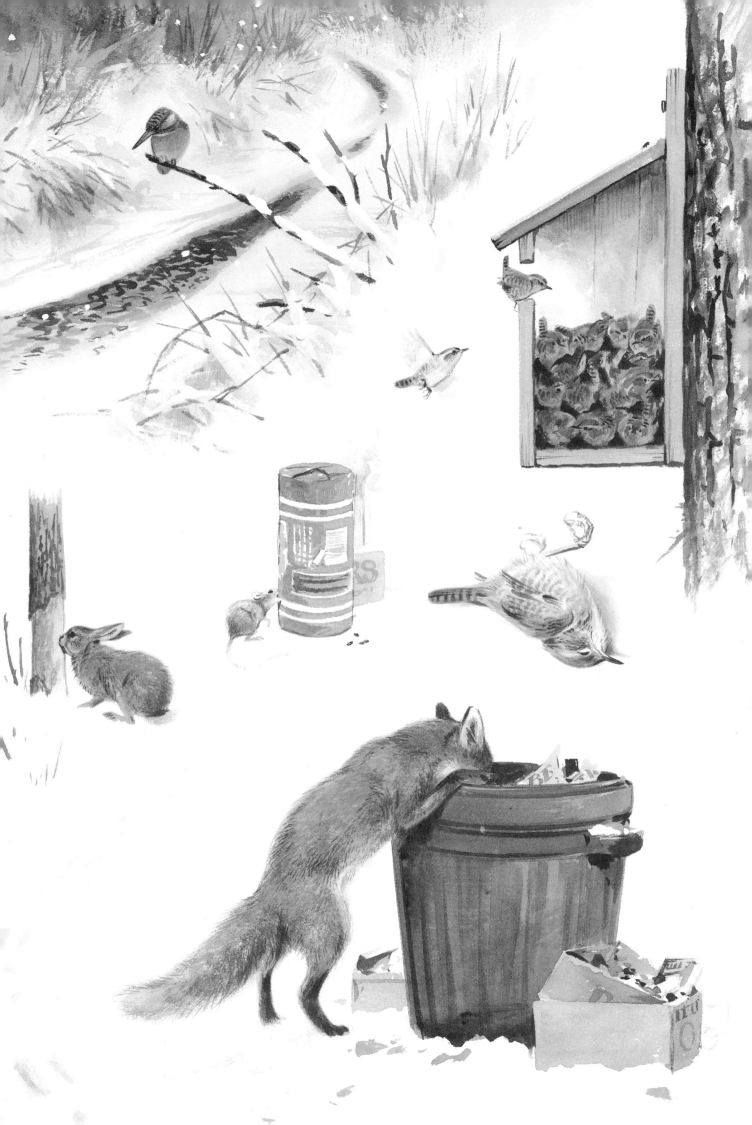

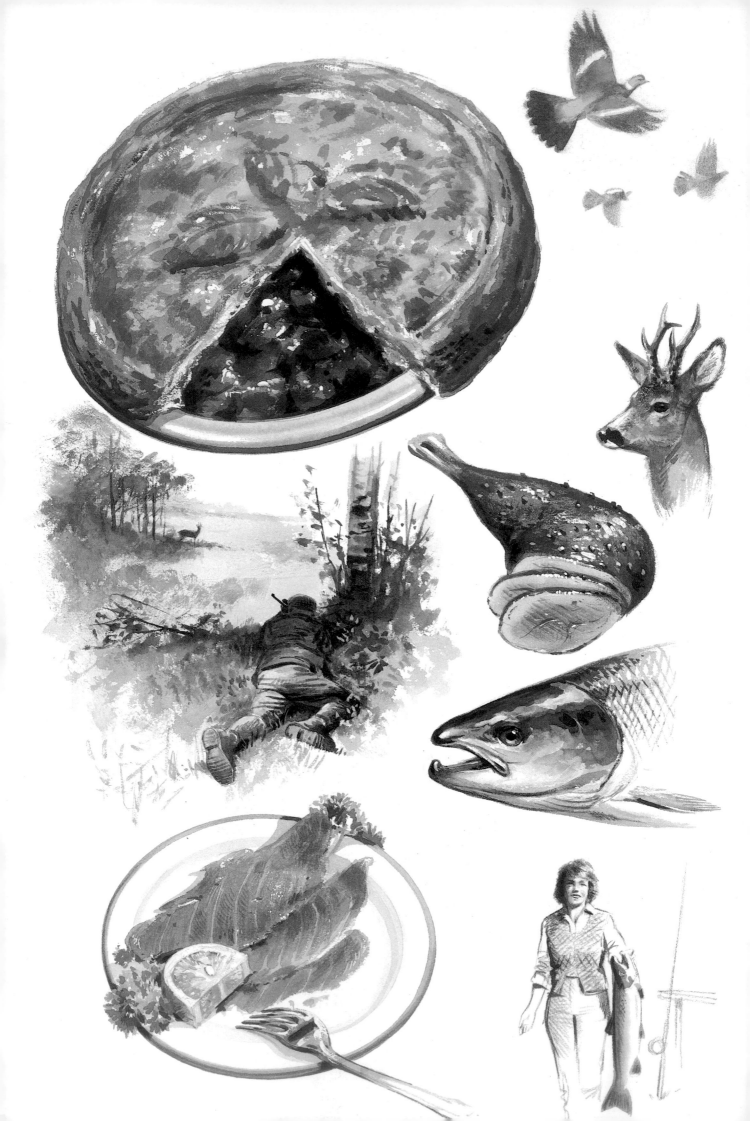

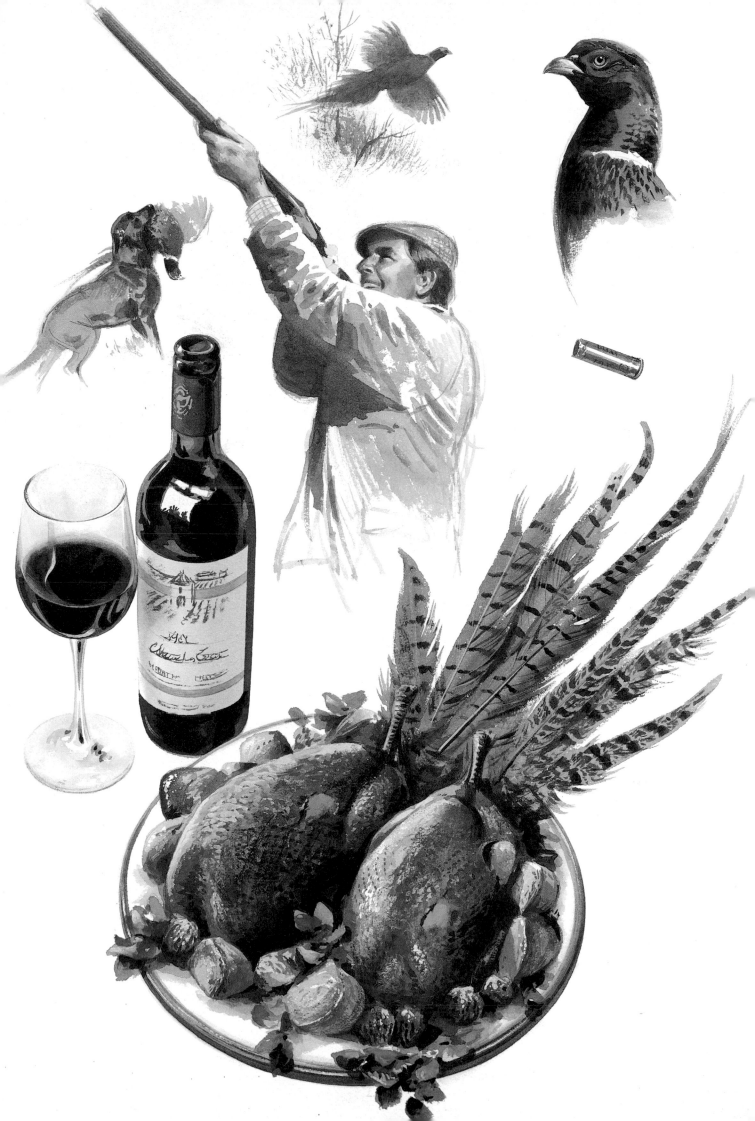

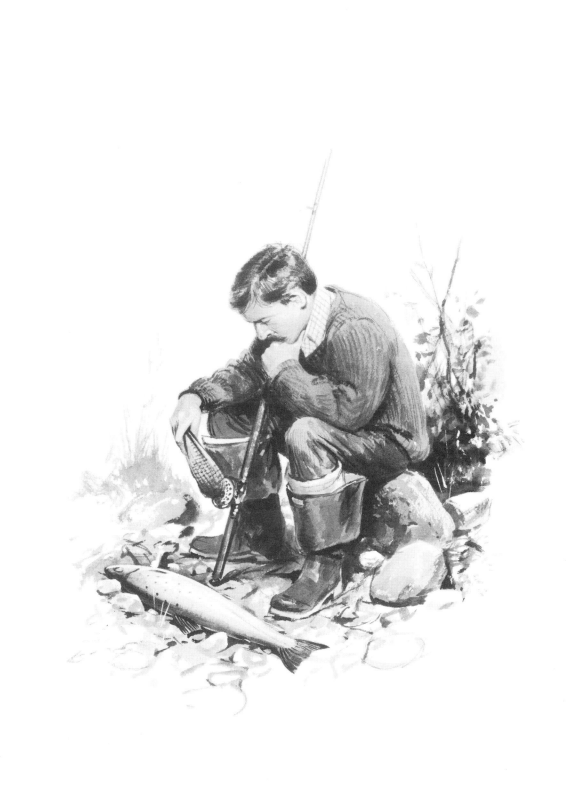